BIG★BOX
REUSE

THE MIT PRESS CAMBRIDGE, MASSACHUSETTS LONDON, ENGLAND

BIG★BOX
REUSE

JULIA CHRISTENSEN

MIT Press books may be purchased at special quantity discounts for business or sales promotional use. For information, please email special_sales@mitpress.mit.edu or write to Special Sales Department, The MIT Press, 55 Hayward Street, Cambridge, MA 02142.

This book was set in Caecelia by Graphic Composition, Inc. Printed and bound in Spain.

Library of Congress Cataloging-in-Publication Data

Christensen, Julia.
 Big box reuse / Julia Christensen.
 p. cm.
 Includes bibliographical references.
 ISBN 978-0-262-03379-4 (hardcover : alk. paper)
 1. Department stores—Remodeling for other use—United States. I. Title.
 NA6227.D45C46 2008
 725'.21—dc22
 2008007043
10 9 8 7 6 5 4 3 2 1

CONTENTS

ACKNOWLEDGMENTS

I am grateful that I have so many tremendous people to thank at the beginning of this book. It takes a village, and I am glad that mine includes the following cast of characters.

First and foremost, I would like to thank my family for their enduring support and involvement in this project, especially Becca Christensen, Bill Christensen, Virginia Christensen, Susan Keene Christensen, Betsy Keene Nelson, and Emily Rae Keene. You are all experts on big box reuse.

At The MIT Press, thanks go to Roger Conover, whose wisdom and patience is invaluable. Also, thank you to Kathy Caruso, Patrick Ciano, and Marc Lowenthal.

Thanks to all the innovative big box renovators who took the time and energy to share with me what they've done with the place.

Thank you to each of the individual donors and art collectors who have bought work from this project, the institutions that have invited me to lecture about this project, and the myriad of friends and strangers who have offered couches and Internet connections over the years. Each of these seemingly small acts have collectively propelled and funded the research, resulting in this book. Thanks also to Oberlin College for support.

Thanks especially to the following readers, whose feedback is manifested throughout these pages: Rick Prelinger, John Schlichtman, and Chris Taylor. Thanks also to my friends Christina Amini, Nina Baldwin, and Susannah Slocum, who all read and gave me substantial feedback over the course of this writing.

Thanks to my thesis committee at RPI for helping lay the groundwork, my advisor Kathy High (this one's for Saturn), Tomie Hahn, and Frances Bronet. Thanks also to my friend Matt Coolidge, who acted as my "outside advisor" on the thesis committee,

and who has remained supportive throughout, along with the Center for Land Use Interpretation.

For one reason or another, the following people must also be acknowledged: Anne Barnes, Chris Brown, Nao Bustamante, Carrie Dashow, Lauren Feeney, Fred Frith, Niki Haynes, Cameron Hickey, Penny Lane, Cat Mazza, Jarred McAdams, Branda Miller, Reina Mukai, Pauline Oliveros, Maggi Payne, Rich Pell, Steve Rein, Sarah Schuster, Courtney Scott, Igor Vamos, Gail Wight, Nanette Yanuzzi-Macias, and Adam Zaretsky.

Much of this book was composed while looking out of a certain window in Troy, New York. So I must pay homage to those old buildings, the cracks in the road, the rock bands, the ice cream stands, and the lucky crows (with their excellent point of view).

INTRODUCTION

Palaces become churches, churches become museums, and museums become corporate office buildings. Looking out my window, I can see an old brick factory that has evolved into an apartment building full of "lofts," a vacated gas station that currently operates as a Chinese food restaurant, a performance venue in what was once a camera shop. Adaptive reuse is happening all around us, as it has been since people began constructing this built environment upon the Earth. A stroll around your neighborhood will reveal adaptive reuse on most every block. Each building has its own personal timeline, its wealth of forgotten histories and contexts, each use somehow informing the next while altering the building in its wake. The structures we build have many stories to tell, generations of uses, scores of leases or deeds, an impressive share of successful enterprises, and a share of failed businesses too.

The dictionary describes reuse as "the act of using again in a different way after reclaiming or reprocessing." The first part of the definition undoubtedly infers an action, since the word "using" most literally refers to doing something. But the words "reclaiming" and "reprocessing" are exciting in a different way, because they also refer to a conceptual act—a decision, an imaginative, creative moment. Reclaiming a structure, or reprocessing it, is an action that also must occur in the minds of the people who are enacting the reuse. In other words, the building itself does not necessarily have to change nearly as drastically as its image has to change in the imaginations of the beholders.

This book is about the reuse of vacant "big box" stores, the large, freestanding, warehouse-like buildings that have become prominent in the built landscape since the mid-twentieth century. The reuse of these buildings seems unlikely, with their directly

corporate associations and their aesthetically bland hulk. The buildings exude an ephemeral quality, imparted by the frequency with which corporations vacate the structures, and yet the deadweight of an empty big box building does not simply go away. Thousands of empty big boxes can be found right now all across the country, a vast network of abandoned construction, stretching from sea to shining sea.

In the twenty-first century, communities across the United States are adapting these buildings for new uses, just as people have always reused the buildings in our midst. It is educational—and quite enlightening—to attempt to place the big box reuse phenomenon in the continuous timeline of development in the United States, contemplating not only where the phenomenon has come from, but also where it is leading, and what the future landscape holds. Communities continuously reconnect their needs and activity flow to the landscape, and by subsuming these abandoned big box buildings, they attempt to make them useful within their lives after the retailer has vacated the premises. The result is that we are beginning to see museums, community centers, churches, and other civic groups moving into adapted abandoned corporate big box structures.

This book explores big box reuse on three interrelated levels: (1) the pragmatic and practical act of how these buildings are actually reused; (2) the reuse of the infrastructure that supports these buildings and their global retail operation, including the parking lot, surface streets leading to the lot, and in fact the national highway system as it has been harnessed to support a global network of big box buildings; and (3), perhaps most important, we will explore the conceptual act of the reuse of big boxes. This last aspect focuses directly on the people who have reprocessed or reclaimed the space, leading to their decision-making processes as they overtake a big box to fulfill their needs. In other words, this book is every bit as much about people as it is about buildings.

Each of the chapters in this book is about a nonretail site (with the exception of chapter 10, which is about a chain of flea markets in a string of vacated Wal-Mart stores) that once operated as a Kmart or a Wal-Mart store, two corporations that have made a drastic impact on the global economy. Throughout the course of this research project, I have documented the reuse of big boxes developed by a number of companies, including Ames, The Home Depot, and Best Buy. All of these corporations are contributing to the escalation of America's big-boxed landscape. The decision to focus only on buildings developed by Wal-Mart and Kmart in this book is because Wal-Mart and Kmart buildings have drastically changed the trajectory of development in our cities and towns, in that they have historically been the most commonly constructed and abandoned retail big boxes throughout the United States. The extensive vacancy of these stores means

that there is more spatial potential in the structures developed by Wal-Mart and Kmart than by the other big box developers. By examining the reuse of these sites, we get a glimpse of what our future might look like as we continue to adapt these buildings into our everyday nonretail lives. We also cull a compelling portrait of this moment in the development of our built environment, which inevitably speaks of our culture, of our activities, of our lives. There is a cultural shift at hand, as groups such as schools and senior resource centers "supersize" and find big box buildings more and more useful for their own operation.

Infinite paradoxes are embedded in the process of reusing a big box, each touched upon by the people in these stories, through their words and actions. First there is the paradox of how communities in the United States are recontextualizing this corporation-specific development through primarily nonretail adaptation and reuse. Environmentally, big box reuse offers quite a paradoxical quagmire; despite the blatant environmentally harmful construction of a big box building, reuse is a powerful tool in the fight against the increasing dangers of sprawl. For every building that is reused, another building does not go up. And then there is the overarching cultural phenomenon: each case study in this book tells the story of a big box reuse site that the renovators deem "successful," "creative," and "resourceful." And, indeed, as you read the case studies, you will probably agree. Humans are incredibly resourceful when there is a need at hand, and it is no surprise that groups of creative people across the United States are successfully turning vacant greyfields into vibrant nodes of community activity. But questions persist: Is this what we want our future landscape to look like? Schools, hospitals, churches, museums, and flea markets, all within the same structure, built by the same handful of corporations, right around the turn of the millennium?

We very often engage in critical discussion about salvaging historic buildings in our midst, waning downtowns, and important historical structures. There are also organizations currently attempting to maintain buildings that are perhaps still new enough to fall through the cracks of historic preservation initiatives, such as the International Working Party for the Documentation and Conservation of the Buildings, Sites, and Neighborhoods of the Modern Movement (DoCoMoMo). But by considering constructions of the very recent past that often go unnoticed, like strip malls and retail centers, we stumble upon hidden histories, unseen forces that are altering the landscape without critical thought or collective foresight. Examining the big box building provides a wealth of information that will help us steer the future of our landscape with more informed decision-making processes.

The yearly construction of hundreds of big boxes has been so encompassing that it is hard to conceive of where they came from, who owns them, who designs them, and who is responsible for them. Big box buildings are most commonly associated with retailers who developed the industry of one-stop shopping—Wal-Mart, Kmart, and Target among them. But these retailers are not the only corporations to construct big boxes. A myriad of companies have followed suit, supersizing into the big box typology, including the more specifically merchandised "category killers" (like The Home Depot, PetSmart, Barnes & Noble, and Staples), grocers (like Kroger's, Albertsons, Trader Joe's, and Whole Foods Market), warehouse clubs (like Costco and Sam's Club), and outlets (like Big Lots). The twenty-first century retail districts of the United States are loaded with big box buildings. The onslaught of these structures has increased continually since 1962, the year of the first Wal-Mart, Kmart, and Target stores. Despite big box–related unrest among a growing number of communities throughout the United States, big boxes continue to loom in our cities and towns, in the countryside, and off the exits of highways. Big box issues relate to the goals and relationships of a myriad of developers, government officials, city council members, and citizens in each and every big box implementation. In its vacancy, the big box exhibits far-reaching impact of those initial goals. The case studies that follow this introduction point to a myriad of impacts that a big box building creates for its host community. Most of these implications were certainly not considered when the retailer (and the developers, government officials, city council members, and citizens) first approved the construction. It is often difficult to know which of the parties responsible for initiating the big box is responsible for dealing with its vacancy, or these long-lasting effects—impacts that are revealed throughout the stories in this book.

It is also difficult, apparently, to even define the big box. At the beginning of my research, I interviewed people across the country about what a "big box" actually is, and got a huge range of definitions from interviewees from place to place. The specifications of a big box vary among locales so that ultimately big box definitions (and, therefore, big box laws) are strictly regional and local. For instance, in some towns a big box building is a retailer with more than 50,000 square feet of retail space, and so big box laws apply to any store that fits that bill. The next town up the road might have a definition with different specifications so that a big box building is a 200,000+-square-foot building, and so their big box laws apply only to those larger structures. Some towns define a big box as only Wal-Mart stores, or as only Kmart stores, so that particular retailers evade building codes other retailers cannot evade, in the same locale. The fact that the building itself

has such a varied definition makes the structure difficult to regulate or track on a national level, since planners and city councils are simply talking about something different in different places. Big box retailers do not make attempts to clear up these ad hoc definitions, since they find freedom in the chaos.

At this point, an accurate definition of a big box is possible: a large, freestanding, one-story warehouse building with one main room, ranging from 20,000 to 280,000 square feet, used initially for retail purposes.

Because of the lack of national regulations or standardization regarding big boxes, the buildings have appeared with varying frequency across the country. This is partly because the initial business plans of Wal-Mart and Kmart were a little different in terms of their market, in that Wal-Mart was trying to cater to a rural market, and Kmart filled in the big box gaps in larger towns and urban areas. Wal-Mart's rural market mission was to bring bargain items to towns whose populations could not access such goods without driving a distance to bigger cities. This is a crucial point in understanding the reliance on the big boxes that has developed in rural areas, especially in the South and the Midwest, where Wal-Mart staked its initial market in the early 1960s. Accordingly, the original Wal-Mart buildings from the 1960s and 1970s are generally found today in rural areas of the southern and midwestern parts of America, orbiting around Bentonville, Arkansas, Wal-Mart's headquarters. Kmart, now based in Troy, Michigan, initially had a stronger presence in larger towns and smaller cities, and even in larger cities as well. (Kmart merged with Sears Holding Corporation on March 24, 2005, and it is now controlled by that company.) Kmart is still the only big box retailer with a presence in Manhattan (although category killers have become present in Manhattan, including Staples, The Home Depot, and a Barnes & Noble on nearly every other block).

It is important to note that, across the board, big box buildings are generally not being vacated because the companies have lost business in a certain location, or because the business model has not worked. Rather, big box buildings are being vacated because the retailers are expanding to larger structures, usually within a mile of the original structure. This is especially true of Wal-Mart. At the time of this writing, the Wal-Mart Real Estate website (www.walmartrealty.com) lists 253 Wal-Mart-owned empty buildings available for lease, all ready for future use (exhibiting the Wal-Mart corporation's land use power, as one of the country's largest commercial landlords). Twenty-six of these buildings are in the state of Texas, fifteen are available in Tennessee, thirteen in Oklahoma, twenty-one in Ohio, and sixteen in Illinois. There are no buildings listed in the states of Vermont, Maine, Oregon, Montana, or Washington, again, exhibiting the

regions of the country most affected by this phenomenon. This list does not include the hundreds of vacated Wal-Mart retail buildings owned and controlled by countless other real estate companies across the country, only those owned and controlled by Wal-Mart. And of course, these are only vacated Wal-Mart buildings, so when we include Kmart, The Home Depot, Kroger's, and so forth, we are clearly looking at thousands of empty buildings from coast to coast. You can probably think of a few in your immediate region, right now.

For the most part, people are not happy about the existence of the vacant sites, and in fact, most people are utterly confused. Over and over again I have heard this question: "What do we do with that building, how do we even begin to think about it?" When a community is first dealt the blow of a vacated big box, residents' eyes do not light up with visions of a new school, hospital, or go-kart track being fitted into the structure. Townspeople usually agree that the empty building is a terrible hole, an eyesore, even though they may have been ambivalent when the retailer had first moved to town. Increasingly, towns are exercising their right to force the corporations to build retail structures with adaptive reuse in mind, so that renovation is simplified—and, of course, towns do have the option of simply banning the store from coming into the community in the first place. Increasingly, cities, counties, states, are making new laws to manage the entrance of big box retailers into their communities. In July 2007, the state of Maine, for instance, signed what is being called the first state law that would prevent big box retailers from descending upon towns without significant proof that their presence would in no way be economically hazardous to the community's existing businesses.

Anti–big box legislation is constantly still voted down in states other than Maine; in California a similar law was shut down simultaneously in the summer of 2007. The number of big box stores has increased exponentially yearly since 1962—the big box issue is waxing rather than waning—despite widespread unrest over their presence.

Take a look at Wal-Mart's track record, as shown in table I.1. Through the massive addition of supercenters rather than discount stores (a jump from 721 to 1,980 supercenters between 2000 and 2006), Wal-Mart's square footage has grown exponentially. For most every supercenter that is built, a discount store is vacated, left behind. The growth rate of the big box stores, despite unrest and fights against retailers, especially Wal-Mart, is a clear sign that the battle is more complex than simply a fight between retailer and consumer. This book looks beyond the direct relationship of the consumer and the corporation, and into a myriad of dynamics surrounding the big box land use issues as they are happening on the ground, in our communities. Exploring how communities meet the

	DISCOUNT STORES	SUPERCENTERS	SAM'S CLUB	NEIGHBORHOOD MARKETS	UNITS OUTSIDE THE UNITED STATES	TOTAL WAL-MART STORES	PERCENTAGE INCREASE
1975	104					104	
1980	276					276	265%
1985	745		11			756	273%
1990	1402		123			1525	202%
1995	1990	143	428		346	2561	168%
2000	1801	721	463		1004	3989	156%
2006	1209	1980	567	100	2285	5289	132%

TABLE I.1 Wal-Mart building types and the number of each, 1975–2006

challenge of reusing the big box leads us to understand how big box buildings affect our lives as community members, both locally and globally—not only as shoppers, but as students, educators, doctors, senior citizens, artists, drivers, curators, pastors, and priests. This book focuses on the reuse of these buildings and their infrastructure as a means of looking at the how big box issues bleed into our civic lives in the United States once a retailer has left behind a structure.

So far, activists and lawmakers are focused mainly on curbing the economic impact of the big box retailers, the first clear impact of such global power. But the fact is, there are many issues affected by the presence of big box buildings, beyond the consumer-related impacts.

For instance, it is crucial that we consider the environmental impact of the structures that house the stores. This environmental impact is first apparent at the site of the big box itself, with its acres of impermeable parking lots and rooftops, both of which cause liquid to run off into surrounding fields and streams. Implementation of the structure

simply removes miles of green space. The balance of the immediate ecosystem is disrupted, as fish fight to live in polluted creeks and birds begin to nest in the rafters of the big box. But the environmental impact affects more than just the land directly impacted by the stores. Big box buildings are entirely reliant on the auto-centricity of life in the United States, and the sites are practically inaccessible and impossible to navigate without the use of an automobile. The stores are inoperable without this connection to the road, to the highway, which leads to the distribution center, where truckloads of merchandise are brought from the boats at the seashores, every hour of every day. A global system of traverse is carved out on the land, with big box buildings acting as the nuts and bolts that hold the web together. Likewise, the big box is always made accessible among the local roads within the town, offering convenience to the car-driving consumer. This harnessing and cultivation of the car culture is a crucial component in the environmental crisis we are currently facing. In fact, the system is so reliant on our current transportation system that if gasoline were taken out of the big box equation altogether (without any comparable fuel alternative), the entire system would self-destruct.

Another related major concern is that big box land use restrictions are far-reaching, controlling land long into the future, so that land use decisions being made now regarding big boxes will have a powerful effect on how American towns are developed and shaped in the future. Often, big box retailers sign leases on land for decades or centuries. Thousands of empty buildings will never be torn down, simply because the retailer will continue to pay the mortgage in order to keep the building empty. An empty building staves competition off of the parcel, which is one contributing factor to the phenomenon of the empty big box.

Maintaining vacant sites is part of the giant land conquest going on among big box retailers. When a big box retailer shuts the doors of one building and moves across the street to a new building, it is generally true that it is because it is actually cheaper for the company to build an entirely new store from scratch than it would be to interrupt business at the old building in order to renovate. But there is also the fact that when the retailer closes shop and builds across the street, it has just doubled its land use control in the area. Empty big box buildings can be thought of as products that act as placeholders for real estate. Often, big box retailers include rules in the deeds of buildings that determine the use of the space in the future too. I visited a church in a renovated Wal-Mart building where the church administrators mentioned that the deed of the property clearly states that the building may not be used as a Kmart building for one hundred years in the future.

A library, on the other hand, is not in direct competition (yet) with Wal-Mart. So it may move in and do whatever it wants to the building. The library is not an unlikely reuser of a big box building, and in this research, civic institutions have emerged as the innovative renovators of big box buildings, ten of which you will read about in this book.

The ten case studies presented here are divided into four parts. Part I: Center is about big box reuse in terms of gravity, regarding city infrastructure and organization of the community's activity. Although big boxes are generally constructed in what is considered to be the "outskirts" of town, the stories in this section look at how these buildings have become a "center" over time. Part II: Network contemplates the larger network of big box buildings, and how parallel big box sites can actually be viewed as networked nodes, especially within the current context of globalization and digital culture. Big boxes do not just stand on their own, but rather are a part of a multisited corporate event, and the networked nature may also be absorbed by culture. Part III: Design presents examples of design issues that come up within the reuse of the big box, causing us to question how the design of these buildings affects culture, and how this affected culture impacts the redesign of the buildings. Part IV: Future is about the future fabric of the built environment in relation to big box buildings.

The case studies were all documented on-site, and these stories were told to me at the "ground level" by a variety of community members in each town I visited. Stories are ephemeral, and, perhaps like the very uses that operate in the walls of these structures, stories are not forever. For that reason, let this book be a snapshot, a glimpse of a moment in the development of the United States. But do not assume that this moment is isolated, and that it does not have far-reaching implications. Big box reuse is a cultural, architectural, urban, and encompassing phenomenon—possibly an unavoidable wave of the imminent global future.

At this point, humans have fully wrapped the Earth in the fabric of the built environment, draping the planet in buildings, roads, parks, wires, and towers. Constructions upon the Earth hold spatial memory of activities past, built markers of the events of human history encased in cement, stone, wood, steel, and glass. This built environment can be examined like a timeline, a reflection, built proof of human activity. By examining the evidence, we gather an insightful portrait of culture.

We are what we build.

Constructions on the Earth are also a great instigator of change. What we build perpetuates a feedback loop, determining activities of the future. Altered activities cause buildings to shed their intended purposes, and they take on new uses, they acquire new

memories, new associations. Dirt paths are paved, cobblestone streets are preserved, and highways are carved out of horse trails, determining how people navigate the man-ufactured exo-surface of the planet. Communities ultimately alter their routines to align with the built environment that surrounds them.

And so, what we build determines who we are.

Reuse, as an act, infers three tenses of time. In order to reuse a building, we must con-sider the past: where we have come from and how the building became situated in our environment. Reuse also makes us aware of our present decisions, the needs at hand, as we reprocess and reclaim the structure for its new use. But most important, reuse—and I hope, this book—will cause us to think about the future. In the future, archaeologists will look to the built environment of our time for clues about our activities and culture, just as we have looked to the ancient built environment to access histories past. These future historians will notice a period at the turn of the millennium when thousands upon thousands of practically identical buildings were constructed simultaneously in the United States.

What do we want our built environment to tell them about who we are?

CENTER

Shopping is an integral part of life in the United States, so much so that the activity usually gets a whole "center" among the built landscape. The term "shopping center" rolls off the tongue with ease; we rarely think of stores as isolated entities but as part of a larger center dedicated to the activity. This has generally always been true, even back in the days of the downtown shopping district, which, despite its separately owned shops and nostalgically local appeal, was certainly a center used primarily for shopping. Throughout my research, the center implicates infrastructure (the surroundings that make the center central), and community (which inevitably forms when many people frequent the center, making it more central).

Shopping centers have been revamped in the United States in loose conjunction with updates to the transportation used to travel to the stores. The downtown shopping district was efficient for a society who walked or rode horse and buggy to the shopping center; the birth of the suburban shopping mall paralleled America's increase in automobile usage. In the twenty-first century, it is appropriate to say that automobile usage has shifted to automobile reliance, so that today in the United States the act of driving is practically inextricable from the act of shopping.

Shopping and driving are two activities that define mainstream life in the United States. As with any mass activity in this country, shopping and driving are reflected directly in the land use decisions that shape our towns, so that these habits are very apparent in the built environment. The feedback loop among shopping, driving, and development is clear. And this feedback loop is very much supported by the American government.

Governments have always taken agency in land use decisions. Determining the "highest and best" use of land is a reliable instrument for the development, maintenance, and engineering of the activities of people. As a result, around the world we see political philosophies spelled out upon the land. Fascist, imperialist, and communist buildings, for instance, all stand simultaneously upon this Earth. Built histories swaddle the planet, infinite timelines of political memory crisscrossing the land, composing the built fabric of governmental activities past.

In the United States, the government is based on the economic (and political) philosophy of capitalism, and as such, land use is often determined by the promotion of activities that uphold capitalism. This political philosophy is characterized by the creation of an economy that never stops growing, where, theoretically, there is no ceiling for the endless accumulation of wealth. Accumulation of wealth is the cornerstone of the American government, and so shopping—and inextricably, driving—is the dutiful way

inhabitants take part in bolstering the power of their government. It follows that land use decisions made in the United States will reflect this endeavor, the quest to shop endlessly, so that the economy constantly increases, forever.

The endless accumulation of wealth seems to be inseparable from the endless development of new places at which to shop, leading to tremendous construction upon the land. The paradox embedded within the dynamic relationship between wealth and construction is dangerous. Although the economy, theoretically, has no ceiling, our planet has a limited amount of land upon which to build. We are dealing with limited resources here, a major juxtaposition to the endless manufacturing of shopping centers currently happening in the United States.

The base component of the modern shopping center is the big box store. In the last fifty years, since our country began to rely so heavily on the automobile, the shopping center has once again been updated. It now consists of a number of giant stores with a shared gigantic parking lot. The structures that house these stores, the big boxes themselves, are designed to exhibit no aesthetic pretense, bare-bones buildings that deliver a bare-bones bargain. Classic big box retailers are characterized by their diversified merchandise, and a store like Wal-Mart or Kmart sells everything from baby food to oil to guns to pencils. This wide range of stock products allows the store to act as a "shopping center" in and of itself, offering everything that you might possibly need to buy under one roof.

These stores inevitably act as gravity centers. The big boxes generate thousands of car trips a day, especially in rural areas where there has never been a tradition of public transportation. It is no wonder that other stores gravitate toward the big box retailer, to take advantage of the traffic and the shoppers. Eventually, entire districts of big boxes emerge from the implementation of a single store. Movie theaters, restaurants, and more big boxes flock to the initial big box in the parking lot, which planners usually call the "anchor store." City councils are astounded at the sales tax revenue brought in by big box retailers, and they strategize building new infrastructure to keep up with the traffic the big box has created. It is not uncommon in today's American landscape to see an entire highway exit dedicated to the accessibility of big box buildings. Corporation-specific development—including public roads, public stoplights, public highway exits, and widened public roads, paid for by public dollars—makes these big boxes convenient. The more infrastructure the local government invests in the big box lot, the more accessible it becomes. As people begin to frequent the location, it becomes "central" to the community.

When the big box retailer moves out of the center of this activity flow, what happens to that centrality? The town has shifted to embrace the activity of the big box center: turning lanes have been implemented, highway exits have been put in place, stoplights are timed to direct traffic into a gigantic lot. So what activity will go on there after the corporation has left the premises?

We have seen the downtown shopping center absorbed by civic and residential life after the retail center was updated. We have seen the suburbs grow from a district devoted to manufacturing and retail into a district that includes residential and civic resources; most people in this country today live and work in the suburbs. And now, we are beginning to see that the big box center shifts as well, after the retailer has updated their mode of delivering the consumer experience from the classic big box to the larger, superstore typology. And we have no reason to think those stores will not eventually be abandoned too; in fact, that is most inevitable.

It is clear at this point that the urban structure does not only have one major nucleus but is operating in a multicentered way, so the big box center is not the only center of town. The town center has multiplied. There may be one medical center, where hospitals and doctors operate, a civic center, where a courthouse and jail operate, and a shopping center, where stores and entertainment operate. The diffusion and multiplication of the center is also related to the automobile, the fact that driving can now occur between errands, and that everyone needs to park outside any given destination. That is the one thing that all of these centers have in common—a parking lot. Every kind of center, be it for shopping, doctors, or court, is also a "parking center."

Urban planners have given a center of big boxes a title that is quite definitive in its description, and simultaneously, highly conceptual—"the power center." In urban planning jargon, this is the first time that the word *power* has been attached to the word *center*. What is this power of which they speak? Urban planners and economists, when using this term, generally are referring to the economic power that the grouping of big boxes has. Retailers stick together, feeding off the hundreds of thousands of car trips that are generated by the cluster everyday. An auto-wielding shopper is more likely to make a stop at Lowe's, marketers figure, if the IKEA and Wal-Mart shopping errands can be accomplished within the same stop, so they cluster together in the same parking lot. Sales tax collection in the power center skyrockets, private development continually ensues, and the local government supports the center with the development of more and more infrastructure, channeling tens of thousands of people through acres of parking lots and retail stores every single day.

Powerful, indeed.

But there is something auspicious about those words—power and center—when said together. Even after the logical economic explanation, they still hang in the air, dangling in all their might: power, center. Who does this power belong to, and who created it? Does a power center actually host a force of gravity that is collectively experienced, consciously or subconsciously, by communities? Beyond its original financial intentions, does a power center contain transferable energy that can be absorbed by communities?

The results are happening right now, underfoot, on the ground, in the United States. And so, without further ado, let us look at the case studies.

1.1 The Nelson County Courthouse in Bardstown, Kentucky, 1785–2002. This building acts as the center for downtown surface streets in Bardstown.

THE NELSON COUNTY JUSTICE CENTER

REUSED WAL-MART LOT
BARDSTOWN, KENTUCKY

The air enveloping Nelson County is thick with the scent of sour mash, fermented corn that has been boiling through the night, as the preceding fall harvest is processed into its new form, Kentucky straight bourbon. The scent of boiling, fermented corn is pungent and memorable, and it is at the core of the experience of Bardstown. The morning air is damp and dewy in Nelson County year round, the summer is slow with humidity, the fall air is crisp and moist, and winter's rocky mountain walls drip into stalactites. I grew up in Bardstown, and I remember inhaling the ancient wet corn ether on early mornings, the same scent that has lingered in the air there for centuries.

Bardstown is a rural town about fifty miles south of Louisville and was incorporated in 1785, seven years before Kentucky became a state. Several bourbon distilleries operate in Nelson County, making Bardstown, the county seat, the self-proclaimed "Bourbon Capital of the World," a title that draws tourists year-round. The county's initial population was drawn not only by bourbon production but also by religion. The first Catholic proto-cathedral west of the Alleghenies was constructed here in 1816. There is an active Catholic convent in Bardstown, as well as one of the world's remaining active Trappist monasteries, Gethsemane. Nelson County has been home to progressive spiritual thinkers throughout the centuries, with Thomas Merton at the helm.

The economy in Bardstown has always relied primarily on agriculture and bourbon. Since 1967, the year in which Bardstown passed a comprehensive historic zoning ordinance to preserve the hundreds of historic buildings,[1] the economy has also relied heavily on tourism. Tens of thousands of people flock to Bardstown every year to partake in its traditional Main Street charm. The city prides itself on being quintessential Kentucky:

horses meander under trees dripping with honeysuckle, home-cooked meals are served at centuries-old dining establishments. The bourbon bar downtown is stocked with all the town's glory, and there is a cannon hole in the wall upstairs allegedly administered by a wild Jesse James himself. Over three hundred buildings in Bardstown are on the National Register of Historic Places. Everything is immaculately preserved, with buildings sitting just as they have been for centuries.

The structure of the entire town is literally built around the majestic old courthouse. A concentric road runs around the building, and all the city's major roads jut out from this centuries-old structure, the axis of the town's activity. Bardstown's other structural hub is its primary tourist attraction, Federal Hill, more commonly known as "My Old Kentucky Home," which serves as Kentucky's state shrine. This preserved plantation is the image on the Kentucky state quarter, and it is the subject of the state song by the same name. It was central to Bardstown's traffic as a functioning farm in centuries past, and today it channels circulation as a tourist attraction.

Since the early 1980s, the town has seen the opening of three Wal-Mart stores, in quick succession. This means Bardstown has witnessed the abandonment of Wal-Mart's buildings twice, as the corporation moved into larger structures. As the corporation expands within the community, it has constructed entirely new buildings rather than adding on to existing structures, as is the common practice. Each big box building is much larger than the last; Wal-Mart is currently operating out of a 200,000-square-foot supercenter, sitting within a two-mile radius of the other two sites. Obviously, these big boxes are quite an aesthetic juxtaposition to the historic buildings that still stand proudly throughout the community. The big box buildings have caused the preservationists of Bardstown to think carefully about history, weighing the past with the present, considering the future. The identity of this town hinges hugely upon the histories embedded within the cobblestone paths and stone buildings, culturally and economically, since the city relies so heavily upon tourism. Maintaining that identity while facing the expansion of big box globalization is a major challenge for this town, like many unique small towns all over the United States. Preserving the aesthetic presence of a town initially built in the 1600s offers a crucial challenge for designers and historians, shop owners and mayors, preservationists and town residents.

"Our cultural heritage is at the heart of our community's pride and quality of life, and that includes our industry," says Kim Huston, president of the Nelson County Economic Development Agency (NCEDA). Part of Huston's unwritten role as a driving force in the town's economic development is maintaining the balance among the past, present, and

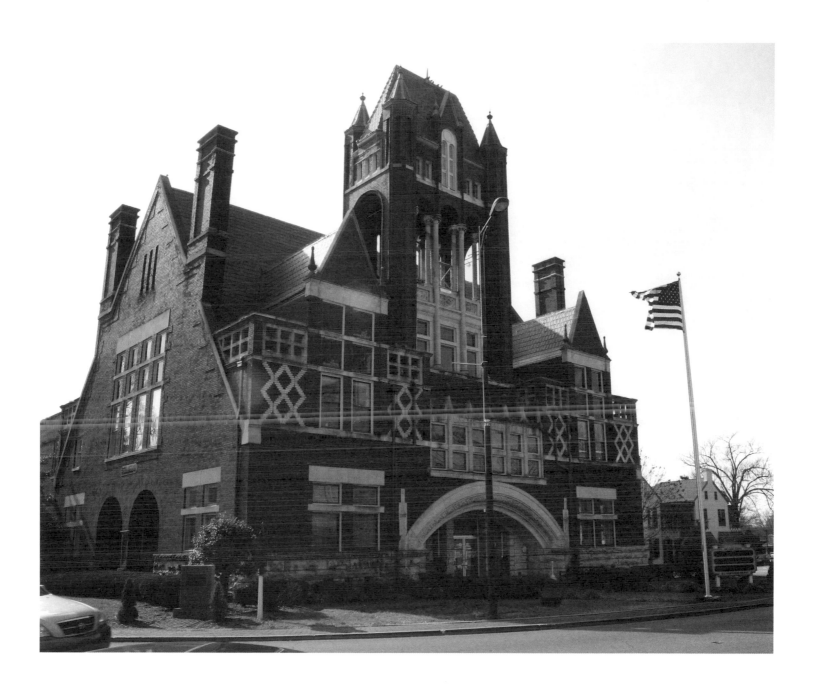

1.2 The original Nelson County Courthouse, facing
north on Third Street (Route 31E).

future as Nelson County's industry develops. "My job is not always easy. We have so many people in Bardstown that care deeply about its history, so there are always people in place to question changes, to make sure that development is in line with our city's historical integrity. We want to make our city comfortable both for our locals and for our tourists. But our history always must be balanced with economic development," which translates into changing forms of the economic base in Bardstown.

Bardstown is tremendously unique in that the local businesses in town have been supported by droves of tourists throughout the presence of the big boxes, so economic challenges downtown have not been as apparent as they have been in most towns in the South and Midwest. The downtown district here is lively, bustling with people buying books from the bookseller, antiques from the myriad of dealers, candlesticks from the design shop, and art from the galleries—but these shoppers are mostly tourists. Local businesses say they have had to change the way they do business in the last three decades, and in part, that has been accomplished by catering more to tourists than to locals. Strict zoning codes in the downtown area have kept the entire district completely free of national corporations, save for one Baskin-Robbins ice cream store, whose pink and blue sign is always up for questioning at city council meetings.

That is not to say that the big boxes have not had an impact. In Bardstown, just as in cities and towns all over the country, the buildings themselves have had a huge influence on the structure of the town itself, sculpting the shape of the city. Bardstown is an example of how big box buildings are like giant elephants swimming through town, carving new "centers" in their path.

Bardstown's first courthouse was constructed in 1785, right in the center of town, a temporary building made of logs. This became the hub of city planning. All roads led to and from the courthouse. In 1790, the log cabin was replaced with the first permanent courthouse, built of limestone carried from Bardstown's Beech Fork River. It faced east, the direction of the Resurrection in Presbyterian tradition. The courthouse was modernized in 1892, using the same limestone base. This updated courthouse faced north on to Third Street, which had become the focal point of the town's activity.[2] The building continued to act as the hub of civic activity, a major draw for circulation throughout the downtown shopping district, and to this day you have to drive around this structure in order to get across town in your car. Quite literally, this courthouse has always been the unquestionable center of town.

In the 1980s, the first Wal-Mart franchise of Bardstown situated itself on the eastern edge of town, about a mile from the courthouse. This was identified as the perfect loca-

tion for a Wal-Mart store—it sat directly across the street from Federal Hill, the state shrine, and just down the road from the historic downtown district. Because all roads led to these tourist attractions, it was easy for the big box to slip right into the traffic flow, practically catching cars as they drove by. In order to get to My Old Kentucky Home or downtown, you would have to pass by the Wal-Mart store. All roads led to this lot. It became the economic center of town.

In 1989, Wal-Mart decided to expand to a larger store and moved from its location on Route 150 into a green field on the north side of Route 245. The new Wal-Mart store was twice the size of Bardstown's first franchise: 80,000 square feet as opposed to 40,000. The new Route 245 location was the same distance from the downtown district as the old Wal-Mart site had been, but the new northern property also offered access to the store from the western and northern ends of Nelson County, drawing in the population from nearby Springfield and Bloomfield.

The first building was left behind, vacant and barren. In its vacancy, it was still sitting in a tremendously accessible location. A stoplight remained in place, and the empty parking lot was still intact. The building itself was falling apart, but drivers still passed by on their way downtown or to My Old Kentucky Home. Bardstown's BINGO center operated out of the structure for a brief time after Wal-Mart vacated the premises. It was also used momentarily as a flea market, until the roof leaked and the windows were broken. The old Wal-Mart site at the Bardstown Plaza fell ghostly and silent in its vacancy.

Meanwhile, the new Wal-Mart building began to attract other businesses, so that it soon became the economic center of town. "Wal-Mart is like a celebrity, everyone wants to be seen with them, to be near them. Businesses literally want to be in the direct line of site with the Wal-Mart store, so that their building will also be seen when customers see the Wal-Mart," says Huston. It is no surprise that most businesses that had surrounded the old Wal-Mart followed the retailer across town, building up Bardstown's new economic hub.

In the late 1990s Kentucky began a statewide initiative to update county courthouses. The state's goal was to upgrade the courthouses technologically, while enlarging their parking lots and general operating size. The state of Kentucky is responsible for 85 per cent of the courthouse renovation costs, and the respective county is responsible for the other 15 percent. Courthouses fifty years and older are deemed eligible. In 2001, there were seventeen courthouses under construction in Kentucky, with fifty-three more on the docket, at a total cost of $558 million.[3]

Through the project, old Kentucky courthouses gain access to the technology necessary for the functioning of a modern courthouse: video surveillance, security checkpoints, digital connectivity, Internet access. Kentucky towns generally agree that certainly these are necessary updates for local governments to function accordingly. However, there is one major complaint about the courthouse replacement program. The government offers no money for the redevelopment of the old courthouse buildings that are left behind in the process.

"The priority for keeping a downtown vibrant is people," according to Huston. "We need people to stay downtown, especially pedestrians, shoppers, and diners." Bardstown is not alone in its courthouse's centrality; towns throughout Kentucky traditionally based development on the placement of the county courthouse as the hub of activity. In effect, all across Kentucky the traditional center is being removed by the courthouse updates, as towns are thrown off balance, teetering, and trying to find new sources of gravity. A courthouse generates regular visits from locals, which has always helped maintain weekday downtown circulation to filter amid the businesses. The shopping districts of historic downtowns are a primary draw for tourists statewide.

Upon the announcement of the courthouse update in Bardstown, questions immediately surfaced about the domino effect of moving this center to a new site. Would the absence of the civic hub lead to failing downtown businesses, lead to a barren downtown, drive tourists away? What happens to a town when its civic center shifts, and how can a town calculate the steps it takes to balance the removal of the traditional nucleus of activity?

The city came up with a plan to reuse the original downtown courthouse as a Bardstown welcome center for tourists, the headquarters for the chamber of commerce, and the local economic development offices. Some city officials maintained their offices in the building as well, so that the Nelson County courthouse would never be abandoned. The town was appeased with the continuation of the city's reuse of the hub, and the implementation of a welcome center for tourists compensated for the loss of daily local traffic at the site. The downtown area shifted most officially from a hub for local activity to a hub for tourism. Local businesses have stayed alive by catering to a new clientele to do so.

Bardstown, Kentucky, began scouting sites for a new courthouse building in 1997. The primary question: In what location will a new courthouse serve as this traditional civic center, continuing its role as the hub of town activity?

The Nelson County courthouse renewal project was initiated under the watchful eye of Mayor Dixie Hibbs—preservationist, town historian, and expert of Bardstown lore. Hibbs says to me, "I am a historian, so I think in 'then and nows.' The actors change, but the play remains the same, even to the words. It is up to us to change the scenery appropriately." The new courthouse would continue to house local court cases, and it would also house the offices of the circuit clerk and the Department of Motor Vehicles office.

The new Nelson County courthouse needed to be centrally located, just as the old courthouse had been. It needed to remain at the civic and geographic heart of the community. Ideally, this new center would also have infrastructure nearby to house supporting businesses and extra governmental agencies, like the police station and the fire station. The town scouted many sites and weighed pros and cons, budgets and costs.

Right at the turn of the millennium, the city of Bardstown decided the most prudent choice for the placement of the new courthouse building was at the site of Bardstown's first Wal-Mart building, a mile east of the old courthouse, and right across the street from My Old Kentucky Home. Bardstown bought the property in 1997, by the hand of Judge Executive Dean Watts. The existing Wal-Mart building was razed in 2002 to make way for a new courthouse, proclaiming that the historic downtown district was no longer the only center in this town.

The curious placement of plans for the new courthouse, in what some would call the "edge" of town, a vacant big box lot, was a peculiar setting for the courthouse, an institution that is so central to small-town life. What was it that deemed the old Wal-Mart lot so central to the city's activity—indeed, the entire county's circulation—after it had been sitting dormant for a decade? How was it that the new Nelson County Justice Center could actually operate more smoothly sitting in the place of the old Wal-Mart building? There are the obvious eyebrow-raising questions about "justice" being served here, on the remains of a building constructed by a corporate empire notorious for anything but justice. Does the impact of that corporation trickle down into the civic reuse of this space?

I began with such questions, but I soon learned that there were more complex questions at hand about the very centrality of this space itself, in conjunction with this use of land: How does this building—and indeed this empty lot itself, even after the building was razed—hold enough gravity for this town of preservationists to consider it sensible to host the new courthouse? This lot had, in its past, generated more car trips in a given day than the downtown courthouse had; it was truly accessible. The lot itself continues to be a strategic location after the corporation has left it behind, and in fact after the structure has been removed. The gravity remains.

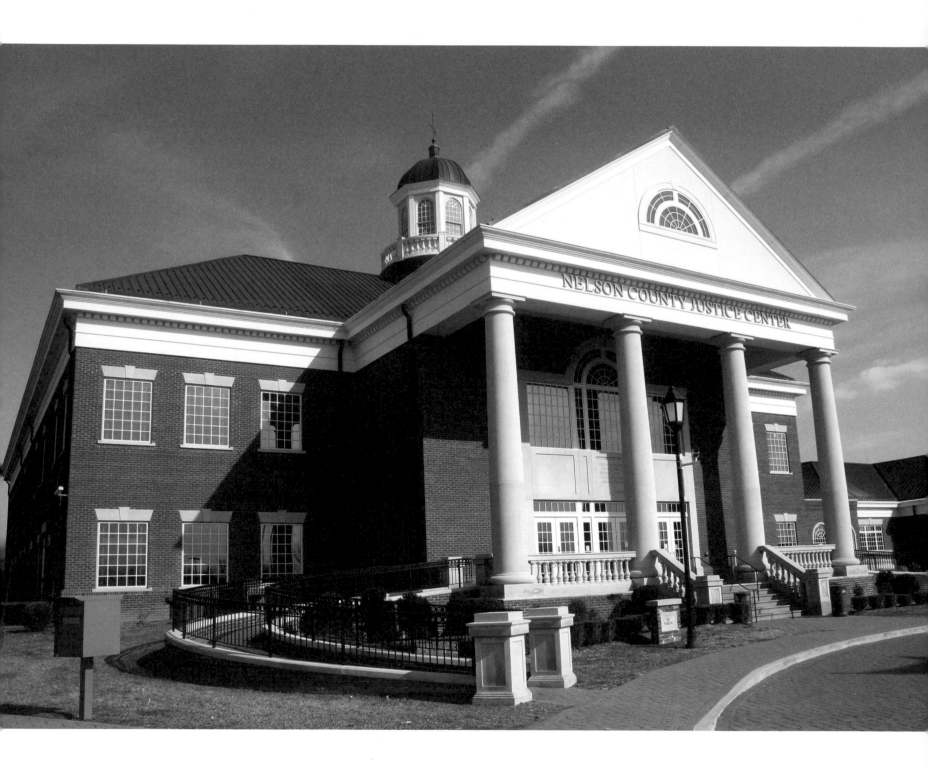

1.3 The Nelson County Justice Center, constructed in 2002 in an abandoned
Wal-Mart lot, in the place of a razed Wal-Mart store.

"The lot was perfect for the new courthouse," says Huston. "The infrastructure for the traffic was there, which was something we were really lacking downtown. It was inexpensive, after years of neglect, and the empty stores surrounding the box offered potential economic development. It was an opportunity for us to enliven a vital part of town that had been dormant for years." Given the state's courthouse replacement funds, the redevelopment of that plaza was very appealing.

Today, the courthouse is no longer called just "the courthouse," but "the Nelson County Justice Center." This title declares its updated centrality and commitment to justice, as it sits in its new civic center—directly across the street from the Federal Hill plantation site—on the real estate that Wal-Mart once deemed most crucial. The courthouse sits behind a three-acre parking lot, next door to a strip mall with a Subway restaurant and a convenience store. It shares the lot with an abandoned movie theater. It is a brand new neo-Georgian structure, surrounded by the old strip malls, which are slowly becoming other governmental services, the sheriff's office, and an emergency medical services station.

On the other side of town, by the year 2000, traffic had increased enormously near the Wal-Mart site at the intersection of Routes 245 and 31E. Roads were widened, turning lanes were implemented, and more stoplights were put into place, so that today twelve streams of traffic are controlled at the intersection. A bypass was implemented that connected Route 245 to Route 150, on the eastern side of town. The expansion of this infrastructure provided a major shortcut between these two parts of Nelson County.

Most fascinating, the bypass also provided a major shortcut between the active Wal-Mart store and the abandoned Wal-Mart site, which had been the town's economic center ten years earlier and today is the Nelson County Justice Center. These building sites were acting as silent poles for circulation and infrastructure in the town's development.

In 2005, Wal-Mart opened up its third store in Bardstown, a 200,000 square foot supercenter. The placement of this site was at a brand-new intersection in town—the corner of the Route 245 bypass and Route 150.

So, in effect, as of 2006 the most powerful location in town, according to Wal-Mart, is directly in between the two properties that it abandoned within the last twenty years, two lots that today are still focal points in the community—both initially carved out by the corporation. The supercenter sits at an intersection that was created primarily to control the traffic generated by Bardstown's first two big boxes. We have no reason to believe that the new supercenter won't also be abandoned in a few years. The city of Bardstown was aware of inevitable abandonment during the design phase for the site, and city

1.4 The old Nelson County Courthouse acts as Bardstown's traditional center of circulation, with a concentric street circling the building. Streets run in cardinal directions from the building throughout the town. The Federal Hill attraction and the original Wal-Mart store are on Route 150, which juts out to the east from the courthouse. Route 150 leads to the Bluegrass Parkway, the major east–west thoroughfare in the state of Kentucky.

1.5 Wal-Mart's expansion to its second store in 1989 shifted operations to the north. The corporation constructed on a green field at the corner of Routes 245 and 31E (Third Street). The original site was left vacant.

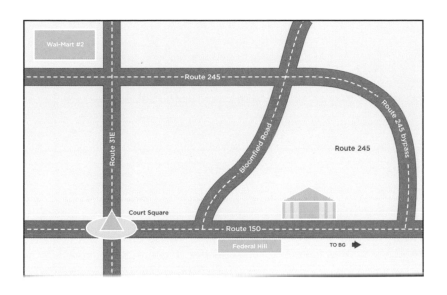

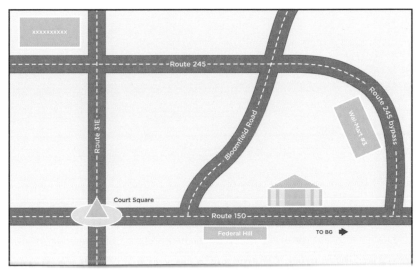

1.6 The city implements the expansion of Route 245 by constructing
a bypass and reuses the original Wal-Mart lot for the new Nelson
County Justice Center.

1.7 Wal-Mart opens its latest incarnation in Bardstown on the newly
accessible Route 245 bypass.

officials successfully placed restrictions on Wal-Mart's plans, in order to make adaptive reuse less problematic in the future. The town forced the company to construct a berm along the edge of the parking lot, so that it was not visible from the road; it requested a façade with multiple entrances, so that the building could eventually be reused more easily by several entities rather than by a single user. And the family that owns the land leased to Wal-Mart has a teardown stipulation in the deed, so that Wal-Mart is responsible for dismantling the structure—lot and all—if the building is not reused within a determined time frame.

The economic hub developed by Wal-Mart's second Bardstown incarnation, abandoned in 2002, remains vital to the town economy even today. The largest grocery in town, Kroger, has its own big box next door to the old Wal-Mart. The rest of the plaza is composed of restaurants, banks, and automotive centers. Bardstown was able to fill that empty Wal-Mart building relatively quickly, with a couple of local and regional businesses, a clothing store, and a sporting goods store.

Today, My Old Kentucky Home and the historic downtown district are still important hubs for tourism, and the general civic goings-on of Bardstown. But the two abandoned Wal-Mart sites in town are now just as important for activity and circulation. The first, of course, is now the town's courthouse, enlivening that plaza with local civic activity. The second is a major economic center for the city's sales base.

And the cycle continues. The new Wal-Mart store has attracted a Lowe's home improvement store, and the town's first national chain "sit-down" restaurant, a Chili's. "We can hardly keep up with the number of businesses that are calling to see about starting a new franchise on that end of town," says Huston. "Come back in five years, and you will not even recognize it; that intersection is about to undergo such massive change." The road has been widened and zoned for business between the new Wal-Mart store and the Nelson County Justice Center, and development is springing up between the first abandoned store and the latest incarnation of Wal-Mart.

Preservationists often tolerate big box buildings because of their economic potential and consumer convenience, as long as they are kept safely on the edge of town. However, there is often such immense investment in the infrastructure and activity surrounding these lots that what we see is these edges actually becoming new town centers, an idea that Joel Garreau examined thoroughly in his seminal work, *Edge City: Life on the New Frontier*.[4] Today, the edge is emerging as a new center even in rural towns that seem too small for suburbs, like Bardstown.

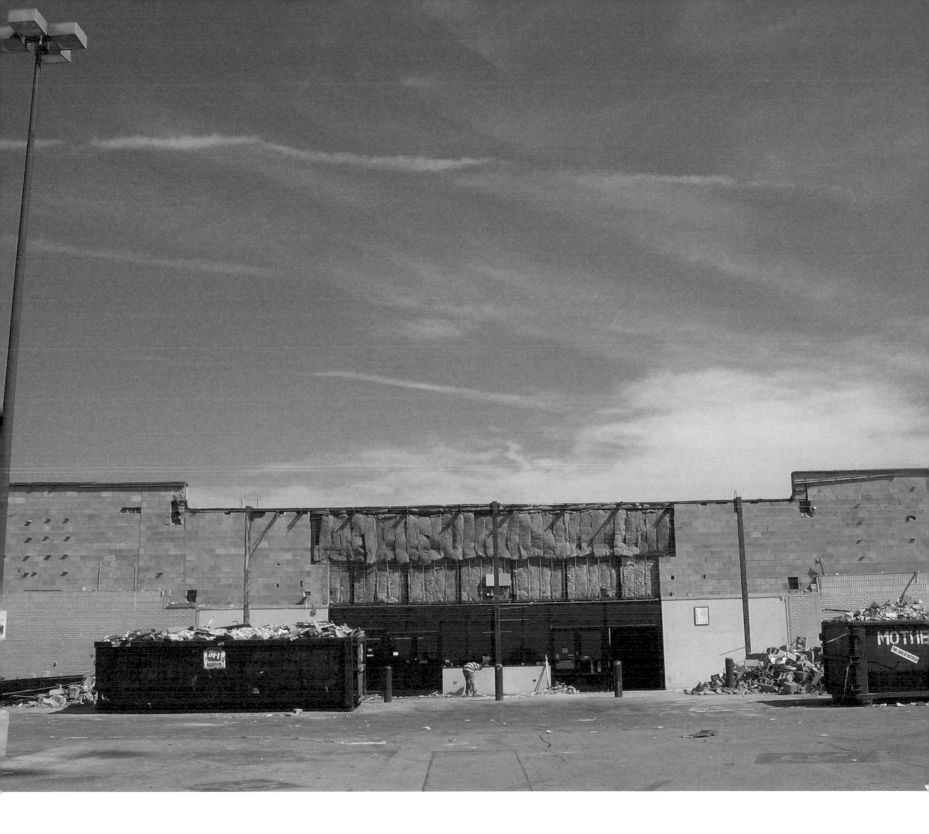

1.8 The second abandoned Wal-Mart store in Bardstown in between uses.
This building is now used by Peebles, a department store chain.

The new justice center was designed so that future generations will come to perceive it as part of the natural continuum of Bardstown's history. The Nelson County Justice Center was carefully designed so that heritage is built right in; the character of the building is connected with the historical integrity of the rest of the town. Meanwhile, its size, placement, and stature are congruent with the very big box landscape on which the building exists, leading to an interesting question about the future: how will local heritage and historical integrity intersect with the reused big box landscape on a larger scale, collectively, across the country?

The lead architect of the new courthouse, Tim Graviss of John Romanowitz Architects of Louisville, worked in Bardstown several times before, once on the old Farmer's Bank and Trust Building, and once on the farmer's market structure, both in the historic downtown district. The city trusts Graviss and his company with the delicate handling of Bardstown's bricks and mortar.

The city council was initially interested in putting the justice center in front of the old Wal-Mart parking lot, in order to hide the sea of asphalt. But the Nelson County Justice Center was actually built behind the parking lot, sitting just as the Wal-Mart sat before it. Graviss considered the Wal-Mart lot in conjunction with the estate across the street, the Federal Hill plantation. Graviss found that the structure of a Wal-Mart big box lot is not unlike the structure of an old plantation: the main house sits behind a huge lawn, and the outlying houses dot the perimeter of this lawn. The Bardstown Plaza was basically set in this same orientation: Wal-Mart acted as the main house, the yard (i.e., the parking lot) sat in front of it, and the strip malls on either side of the main building were situated like the outlying houses at My Old Kentucky Home across the street. Graviss took a conscious look at the similarities between the plantation structure and the structure of the Wal-Mart lot, and tried to connect the two, so that the new county courthouse would formally mirror the tourist attraction on the other side of the street. Both sites had, at one point, acted as primary nodes of business in Bardstown; both were the destination for local and nonlocal traffic; both were—and still are—central, and loaded with political and economic power. The Wal-Mart and the plantation practically mirrored each other already.

The cornerstone of the justice center is a limestone rock that was removed from the base of the original courthouse built downtown in 1787. The interior of the new courthouse building is full of dark cherry wood, a soft wood. This wood is sensitive to the touch and will wear relatively quickly with human contact. The Nelson County Justice

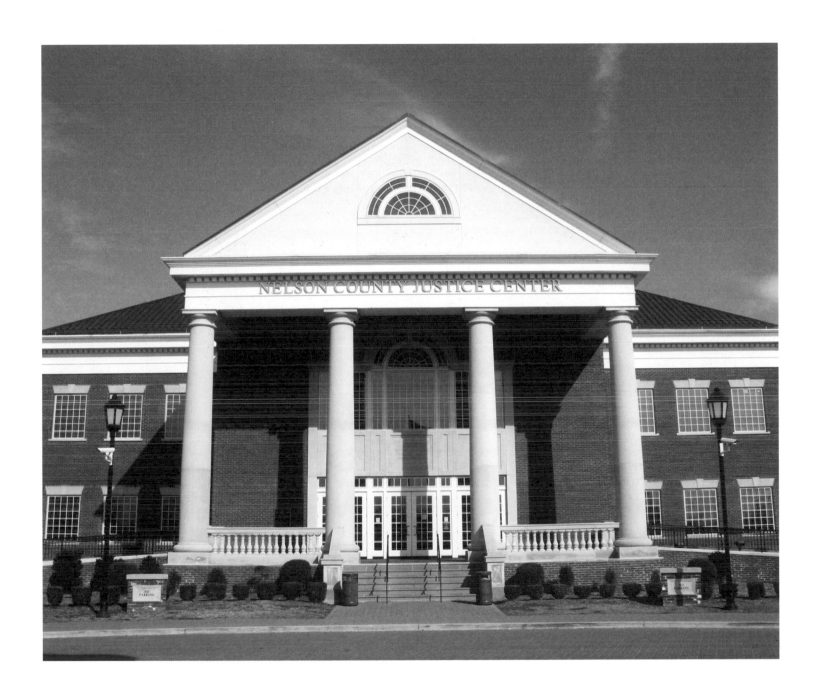

1.9 The Nelson County Justice Center on Route 150,
across the street from Federal Hill.

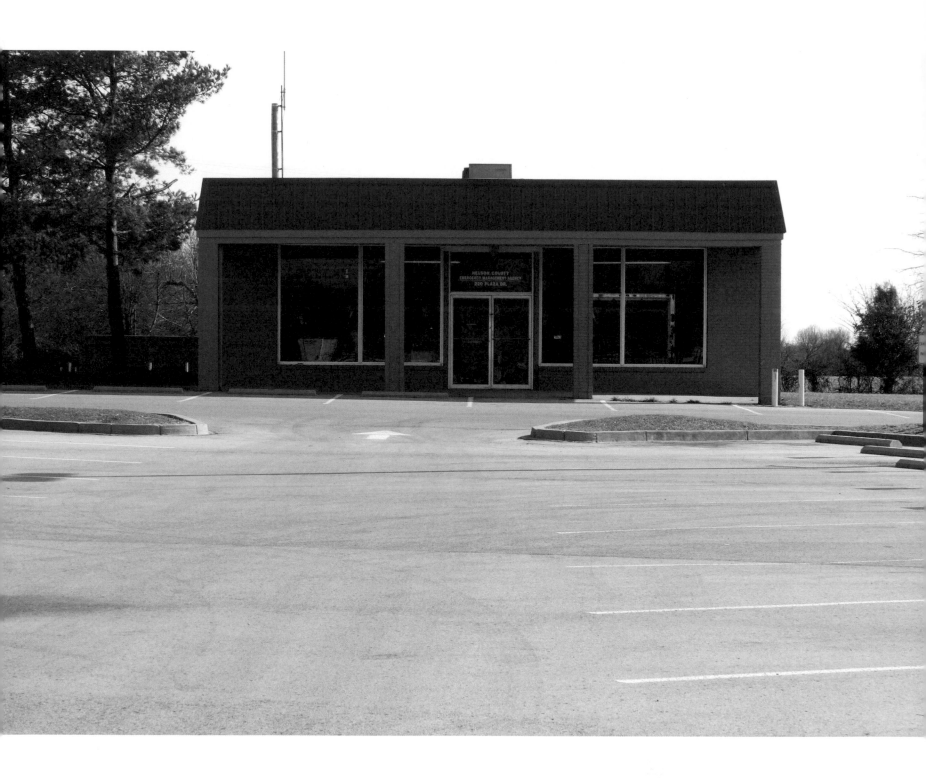

1.10 The Nelson County Emergency Medical Services outpost, in what used to be the Hunan Dynasty restaurant, sharing the parking lot with the Nelson County Justice Center.

Center was constructed so that it would age gracefully—and quickly—giving it the appearance of having existed there, in place of the Wal-Mart, for a long, long time.

The young trees in the lot were chosen because they mature fast. It won't be long before they are large and breezy, perhaps giving the property the appearance that the trees came first. The weathervane on the roof is a manufactured replica of the weathervane on the courthouse downtown, a true sign of heritage. The date of Nelson County's establishment is boldly marked on the metal arrow that spins above the Wal-Mart lot: 1785.

2.1 The RPM Indoor Raceway's signage, on a reused Wal-Mart sign.

THE RPM INDOOR RACEWAY

2

REUSED WAL-MART BUILDING
ROUND ROCK, TEXAS

The asphalt was freshly laid when I first visited the RPM Indoor Raceway. The parking lot was sweating in the dead heat of a Texan July, and the soles of my tennis shoes fused slightly with the tar as I walked across it. Three acres of asphalt loomed in front of the building, reflecting all light and moisture right back up, so that a world of heat was hovering above the ground, right around my ankles.

As we drove into the parking lot on that summer day in 2002, I first encountered the now familiar site of a reused Wal-Mart sign: those three tiers on a post that once announced "WAL-MART," "We Sell For Less," and "ALWAYS." Now this sign read "RPM Indoor Raceway," "Speed Happens," and "Go-Kart Racing," a merging of the building's past life and its current incarnation. Driving down the highway or on a country road today, when I see that multitiered sign, I am clued in to the strip mall's hidden past—Wal-Mart once operated in that building. In some instances I wonder if the reuse of the signage is an adaptive reuse of Wal-Mart's branding, a strain of marketing that carries through from the building's past life, an obvious nod to Wal-Mart's legacy at the lot.

Round Rock, Texas, is a town that was historically a suburb of Austin. By 2002, when I first visited, the suburb had grown so that it was no longer "sub" anything: in 1990, the U.S. Census listed the population at 30,923; as of June 2006, the population was at 86,902; the 2006 Annual Report of the city projects a 2010 population of over 100,000 people. Along with a boom in people came a boom in development, and the town structure stretched and flexed in order to support its new population. Round Rock won a prestigious Comprehensive Planning Award from the Texan chapter of the American Planning Association in 1999, and the city website boasts about its long-term plan for expansion.

Round Rock is characterized by its strip malls, big box stores, and overpasses arching against the sky, which apparently have all been carefully planned.

The old Wal-Mart building is on a road called Hester's Crossing, a name that stands out among the surrounding road names, all of which consist mainly of numbers. "Hester's Crossing," a street name that is surely a relic of some forgotten use of the surrounding land, is now home to several big boxes. The building is directly accessible from Interstate 35, so that the Austinites nearby had easy access to the Wal-Mart store when it was in operation. This big box was first constructed decades ago, and at the time, it sat out on its own, away from all other development. The aerial photographs of the building site at the time of construction, in the early 1980s, show that the building was indeed a cement and steel island in a sea of yellow grass. "The aerial photograph shows no other commercial development in the frame of the picture," says Charlie Gifford, owner of the racetrack. Slowly, stores moved nearby, just as had been the case in Bardstown. The Wal-Mart building attracted other nearby businesses, helping build Round Rock into a commercial center, drawing heavy traffic from the surrounding region.

My first visit to the RPM Indoor Raceway was in the summer of 2002. As my tour guide, Austin resident Jacqueline Saltsman, drove me north from Austin, I noticed a definite break in the continuity of the sprawl. There was a distinction in the roadside landscape between the city of Austin and the city of Round Rock, a break in the commercial development lining the highways. As we drove, we passed a few stray highway exits that led to seemingly residential districts, but there was indeed space lining the highway; the land was not yet entirely consumed by the impending sprawl.

During a second visit to the site in 2006, only four years later, the drive from Austin to Round Rock offered a seamless continuation of development, so that the Round Rock exit signs snuck right up on me on Interstate 35 while I still thought I was in Austin. My second visit to the site occurred when I was summoned to investigate a compelling update: the racetrack had been evicted from said building, and the structure had been broken into a strip mall hosting a Gold's Gym, a smoothie shop, a health food store, a men's hair salon, and a tanning salon. In the words of Gifford, "The evolution of that big box property from vacant land, to Wal-Mart, to the RPM Indoor Raceway, to Gold's Gym, is indicative of the evolution that has taken place in the last decade in the greater Austin and Round Rock area."

It is also indicative of a real estate phenomenon that is becoming increasingly prevalent in the United States: commercial and corporate interests are buying up land across the country at an alarming rate, controlling vast amounts of space and its use with,

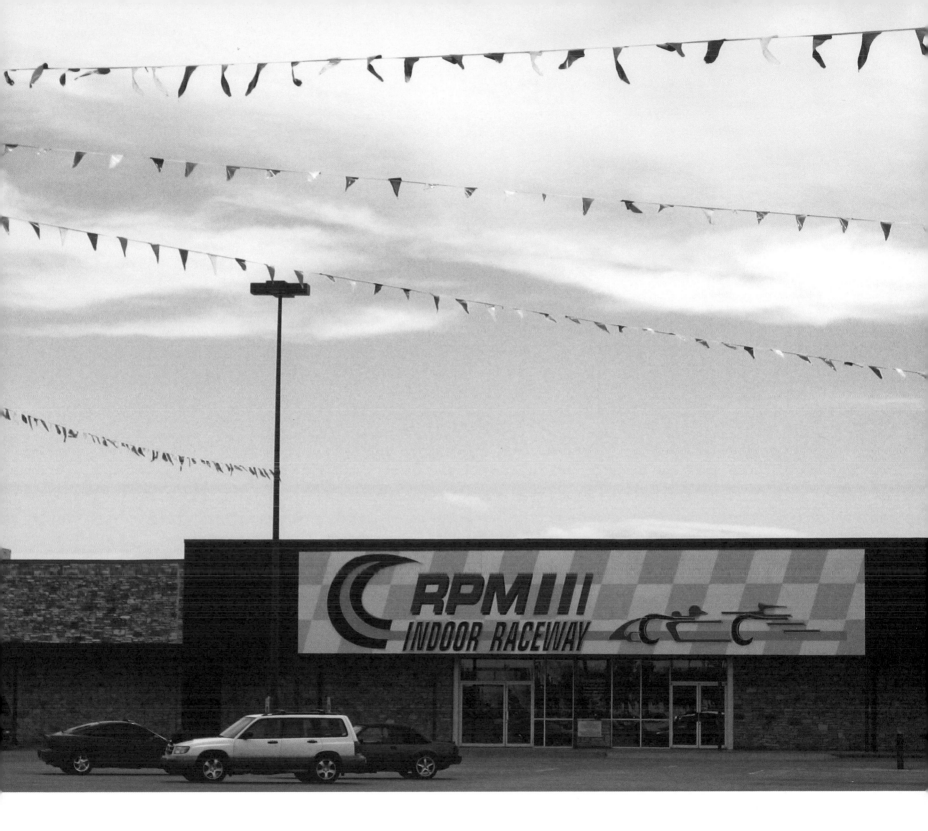

2.2 The RPM Indoor Raceway in a renovated Wal-Mart building on
Hester's Crossing in Round Rock, Texas.

naturally, self-serving economic interests in mind. These commercial real estate developers, including the big box corporations themselves, lay claim to the future of these parcels too through the implementation of noncompetition leases that extend stipulations for land use decades into the future.

How do the forces of globally invested commercial and corporate real estate developers interact with local businesses attempting to navigate big box real estate? How did this business interact with the location to foster community at the go-kart track, turning it into an entertainment center? And what had made the venture unsuccessful enough not to just close up shop, but to actually be evicted from the building altogether?

Let's begin at the beginning.

In 1876, a major event occurred in the course of Round Rock's development, when the International-Great Northern Railroad (IGN) constructed a railway station that connected Round Rock with nearby cities. IGN was given a state bond totaling $500,000, and the state donated a total of 6,389,120 acres of land to the railroad in central Texas. Consequently, IGN sold much of this land through the Texas Land Company at 70¢ an acre, for a total of $4,463,960. The implementation of the train depot at Round Rock caused the town to re-situate its business district for convenience to the train, and the area around the train depot became the center of town. Just as the courthouse had been the civic magnet in Bardstown, the train station was the hub in Round Rock. Incidentally, the train made the trip between Round Rock and nearby Georgetown frequently, and there was no way to turn the train around at Georgetown. Because of this, the train ran backward into Round Rock. From the beginning, Round Rock seemed to be a latecomer, a town in the shadow of nearby Austin; even the train that ran directly to the town was not exactly direct.

In 1984, a most auspicious year in the next century, another major event took place in Round Rock's development when University of Texas student Michael Dell began his new company, Dell Computers. Dell is headquartered today right off Hester's Crossing in Round Rock, Texas, with a local employee base of upward of 30,000 employees. Commercial development in Round Rock has been ceaselessly phenomenal since the inception of Dell, and the headquarters of the corporation has acted as a new hub of activity.

By the late 1990s, Round Rock had grown tremendously, and a new major retail mall broke ground, IKEA built a franchise in the area, and a Super Wal-Mart was constructed. The Wal-Mart Supercenter building was constructed in the corporation's new "Main Street design": several small pseudofaçades mask the entire big box. The original Wal-Mart lot was the 8.4-acre parcel of land right across the road from the new supercenter, the building on Hester's Crossing. The original Wal-Mart location was in such a superb

location amid the sprawl. It was really as if the corporation had intuited the development that would come if it put its store there first, before its move directly across the street a decade later. By doing so, the corporation had easily doubled the amount of land it owned within the quickly developing retail hotbed of Round Rock.

The DuPont Group is a commercial real estate company based in Austin, directed and owned by Rick DuPont. The company had set its sights on the purchase of the vacant Wal-Mart building for a few years. But Wal-Mart had continually turned away the Dupont Group, in part because the real estate company did not have a guarantee regarding its plans for the building's future. It was clear that Wal-Mart would rather pay the lease on the empty space than sell the building. It was hot property, and the corporation was in no rush to let go of it, especially without a guarantee of what the lot would be used for in the future. The lease on the Wal-Mart building had a list of companies that could never, as Charlie Gifford tells me, "sell so much as a bag of potato chips out of the structure." DuPont himself explains that the restrictions on the deed varied depending on the level of direct competition, for up to fifty years in the future.

Gifford and his brother had been interested in starting a newfangled racecar track in Austin since 2001. Indoor racing is a sport for car enthusiasts, consisting of small RPM cars that drive at around 45 miles per hour, a tremendous speed in a confined area indoors. The sport had caught on steadily in Europe, and about seventy raceways existed in the United States when the Giffords first hatched their plan. Charlie knew that the area's unique population offered the right demographic to support the first Texan RPM raceway. Round Rock was a city of displaced techies from cities nationwide, and adventurous Texans and college students lived nearby in Austin.

In 2001, the Giffords met Randy Beaman of the DuPont Group. Beaman and DuPont were quickly sold on their go-cart idea. When the realtors asked the Gifford brothers what sort of property they were looking for, they explained that they had recently seen the abandoned big box building on Hester's Crossing, and they contended that a large open structure like the empty Wal-Mart would be perfect.

It was at this point that the DuPont Group was finally able to buy the building, and the company drew up papers guaranteeing the RPM Indoor Raceway lease. "It was a great idea, and it was the perfect business for us to put in that building," says DuPont. Although it was never involved financially, the DuPont Group was instrumental in the opening of the raceway. DuPont told me that the guarantee of the RPM lease was not the most significant factor in the purchase of the building, but Gifford says that their agreement provided the noncompetitive business plan for the structure that allowed Wal-Mart to sign

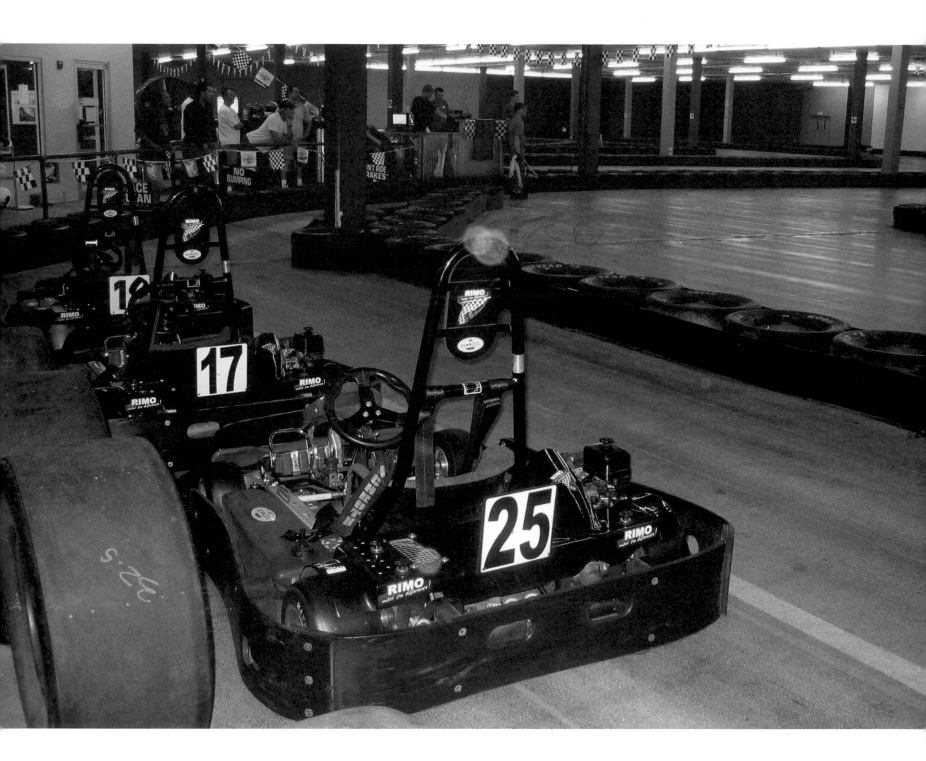

2.3 Track interior.

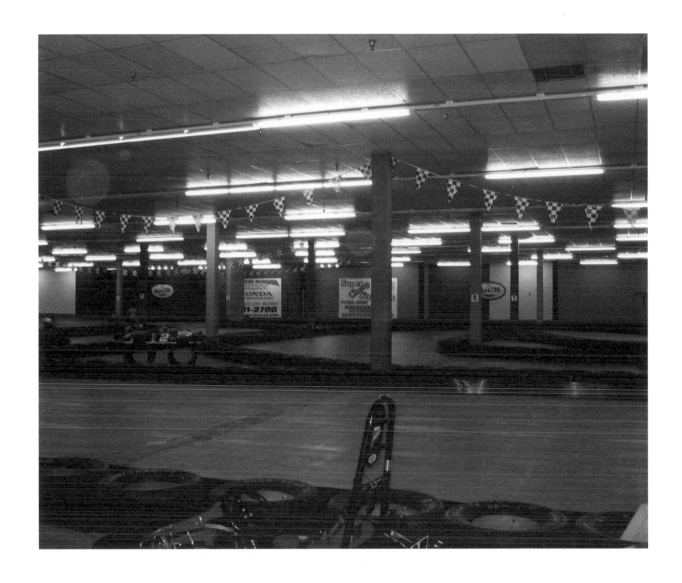

2.4 Track interior.

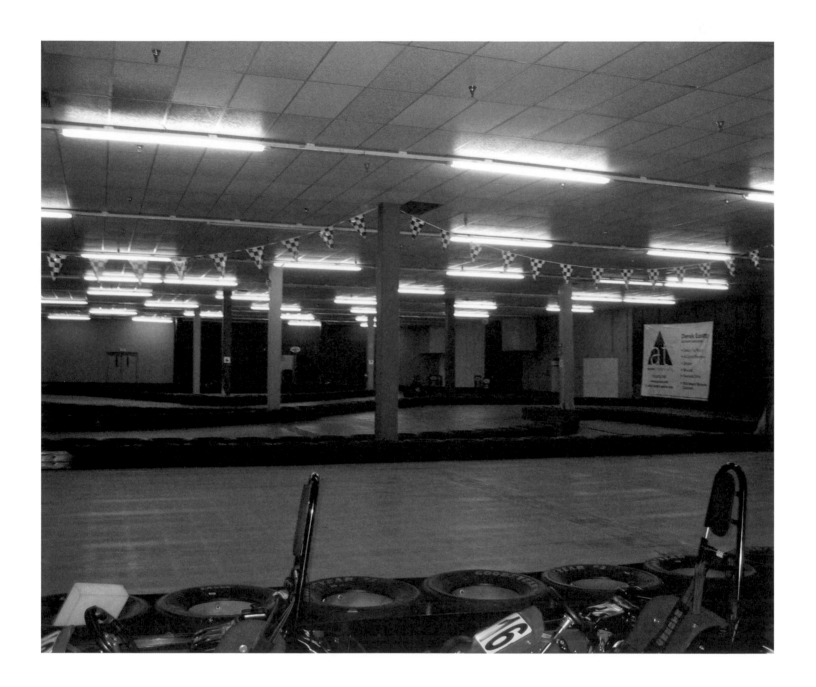

2.5 Track interior.

off on the sale—the RPM Indoor Raceway did not offer a competitive business plan that would potentially detract from the corporation's business across the street.

The DuPont Group bought the building from Wal-Mart in 2002 for $3.2 million, with the intent to lease the building to the RPM Indoor Raceway for $42,000 a month.

The placement of the property on Hester's Crossing is indeed perfect, in the eyes of the commercial real estate shark. It is right off the highway, facing Dell's headquarters, and now, after twenty years of ongoing commercial development, this building—which was once sitting all alone in a field—is within a square mile of every big box retailer under the sun.

The layout of the old Wal-Mart building started with 92,000 square feet of raw open space; the raceway used 70,000 square feet of the space. The centerpiece of their reuse was the track itself, a 40,000-square-foot room with two 1/3-mile courses weaving through the space. Up to ten cars could whir around each track at once. The RPM Indoor Raceway owned a total of forty cars, which were corralled along the front of the track. Track atten-dants doubled as engineers, working on cars in the RPM Shop, a 2,500-square-foot room at the back of the building, strewn with tools and wheels and parts. Wal-Mart had constructed a storage space on a second level along the back of the building, a concrete split-level that made the back few feet of the building unusable, because of the overhanging obstruction. The pillars in this part of the building were placed every fifteen feet, as opposed to the pil-lars in the rest of the building, spaced at a more manageable thirty-three feet. The front lobby stretched the length of the track. Four conference rooms were at the front of the building as well, supporting an agenda of the enterprise's program: to offer a community-building source of entertainment for corporate employees (primarily those at Dell).

The total cost of renovation for the RPM Indoor Raceway was $412,000, a cost funded completely by the raceway itself. The lease stated that all improvements were to be ac-complished and paid for by the tenant. In hindsight, Gifford tells me, "The Achilles' heel of our business model was that we did not own the building." The Giffords had to spend the money to renovate the building without the promise of a long-term life within the structure.

The $412,000 sum included all the major renovations at this site necessary for the op-eration of the raceway within the big box: the installation of the new heating, ventilat-ing, and air-conditioning (HVAC) system, track preparation, and the general construction. A major ventilation system was installed in the building, and it completely replaced the air within the entire structure every ten minutes, which was necessary in order for the

cars to all rev around the track simultaneously. The bathrooms had to be moved from the back of the store to the front, which entailed the digging of a trench through the building so that a "grinder," essentially a powerful pump, could be placed between the main pump and the new bathrooms.

The renovation cost also included the process of turning a Wal-Mart sales floor into a racecar track, which was ultimately the greatest challenge of this renovation. The original Wal-Mart floor was in fact used for the raceway floor, but the RPM Indoor Raceway shot-blasted the surface of the cement, a process that gave the surface texture. A huge machine basically shoots pellets at the cement at an incredibly high speed, causing a texture to develop on its surface, which allows for the traction necessary for cars to speed safely on the cement.

The use of the space was obviously very connected to the building itself, since the racetrack filled the better part of the building. The building itself was not interchangeable—the racetrack for cars was built into the big box; the activity merged with the structure. This connection to the building is actually fairly unique in terms of the big box reuses that I have seen; usually the location trumps the structure as the most attractive characteristic of the site. Here, the location was indeed a huge factor in the purchase of the site, but the reuse itself was most connected to the building, the big box.

Human circulation within the building was clearly much different as a racetrack than it had been during the days of retail. Building the conference rooms was a wise investment. Departments from Dell often rented out the raceway, just as the Giffords hoped, bringing company employees to the track for "corporate entertainment." Dell, like many large companies, budgets a certain amount of money each year for employee entertainment. The Dell business structure has the company broken up into "Small Business Units" (SBUs), and each unit performs a different role within the larger structure of the company. The raceway was in an ideal location for Dell. Because it was so easy to get an entire SBU across the street for the afternoon, the raceway became a home for Dell's "Corporate Entertainment" endeavors. Sometimes Dell would rent out the entire business for larger events; the raceway once hosted approximately four hundred Dell employees at once. This segment of the raceway's clientele is relative to the larger circulation pattern that Wal-Mart had set in motion when it was at the location, since Dell employees had shopped at Wal-Mart prior to its conversion to the racetrack. The building also continued to feed, obviously, off its proximity to the interstate, which brought people to the track from Austin, just a couple miles away. The RPM Indoor Raceway had wi-fi in the lobby long before wi-fi was everywhere, a marketing tool that got

those techies from across the street to come back to the track. Community began to form within the building.

The RPM Indoor Raceway leagues took place on Monday and Tuesday nights, which created the primary revenue source for the track. The league nights were frequented by local enthusiasts, and like a true entrepreneur, Gifford knows his statistics by heart: "About half of them were living within ten miles of the raceway, usually aged between twenty-eight and forty-four, and making over $50,000 a year." The leagues would last for eight to twelve weeks, and each league had about thirty members. On league nights there would be anywhere from two to four leagues meeting. The cost of one night of racing was $33.00 if you were a part of the league, as opposed to the $80.00 for a nonleague member. The leagues were competitive; everyone raced three times in a night, and the field was varied from one race to the next so everybody raced against everybody. The top ten racers went to the finals each night. Competition kept the evenings lively and kept customers returning for more.

Spectators would watch the races from the fence surrounding the noisy track, or from the café in the lobby. Dell used the conference rooms when it had meetings before or after the racing. The staff at the raceway numbered twenty altogether, and twelve people were usually on hand to run the operation at any given time. The building bustled with human activity: people used laptops in the lobby, viewers stood around chatting, engineers worked on cars, while the space roared with drivers racing around the track. All of this human activity in a space that once housed merchandise and humans with one agenda: to shop.

The RPM Indoor Raceway repaved the parking lot. Updating the parking lot was not necessary to attain the occupancy license; it was already in fair condition. Rather, it was an aesthetic and functional investment. The ever-entrepreneurial Gifford brothers saw this parking lot as a marketing tool, an outdoor space that could actually enhance their motto "Home for all things racing!" Indeed, the parking lot began to play host to a myriad of events.

A motorcycle safety school operated in the lot two to four days a week year-round, conducting defensive driving courses for motorcyclists. The raceway also ran "pocket bike" races on hot summer weekends, and twenty to forty people would race around on very small motorcycles in the parking lot. The summer and fall brought remote control car races to the lot a couple of weekends a month, as a part of a statewide racing series. Raceway staff erected an elevated platform for the remote drivers to stand on, and out in the parking lot, they set up an elaborate road course. "It was tragically funny when one

2.6 The parking lot, a town commons for Round Rock.

of these remote control cars would crash," Gifford tells me. Over three hundred people would show up at these races, setting up trailers and mobile homes in the parking lot, as a community of traveling remote control car enthusiasts emerged in the parking lot.

An antique car club used the parking lot frequently on Saturday nights for car shows. Anywhere from twenty to two hundred cars would turn up to show off their stuff, low-riders, antiques that had been restored, sports cars, and more. In the words of Gifford, "They would pop the hood, turn up the booming stereos, pull out the lawn chairs. Then they would talk about their cars, look at their cars, and lie about their cars." There were even two organized weekend-long car shows, complete with judges, bouncing contests, stereo contests, and burnout contests. Hundreds of people were drawn to these events. Once or twice a year a roving carnival came to town and rented out the parking lot for a week or two. The carnival would set up a Ferris wheel, a tilt-a-whirl, game booths, and so forth, and would pay the Raceway $5,000 up front for the use of the lot. The RPM Indoor Raceway would also receive a percentage of the money made during the carnival, when thousands of people would visit the parking lot throughout the course of a weekend. There was once a huge three-on-three basketball tournament on the lot, pre-arranged by a national organization. The group set up thirty half-court-sized courts on the parking lot, and ran five hundred people through the competition. A local theater and pub set up a huge inflatable screen from time to time and hosted a drive-in theater. It showed such films as *Le Mans* and *Death Race 2000*. "Home for all things racing" indeed.

The RPM Indoor Raceway soon became "the place where you could go if you needed to use a big open space," which meant the parking lot. This lot began to serve as a new town common for Round Rock, pointing to the expansion and multiplicity of what could conceptually be called the "town center." Urban planners traditionally assume that the parking lot is the edge of the action, the border between the spaces in which interaction actually occurs. But in the urban fabric of Round Rock—and places like it all over America—the parking lot is the most accessible wide-open space in the landscape, leading to parking lot use, or "reuse." These three acres of asphalt saw a tremendous amount of human activity in a space meant for parking cars.

Although it never really directly brought in much money, the parking lot did its job as an effective marketing tool. The various groups that used the parking lot marketed their events throughout the area. Meanwhile, the RPM Indoor Raceway marketed heavily to the hundreds of folks who attended each of these parking lot events, and raceway statistics show that most of these people came back to race indoors. Within the fabric of the edge-town-turned-center, the parking lot apparently can play a crucial role in socializa-

tion. The site was home to a celebration of the automobile. In a way, this had been true when Wal-Mart used the building as well, as it harnessed the auto-centricity of the surrounding community.

At this point we are well aware of the economic impact big box retail has had on the fabric of local business, and in Austin, the community has made a compelling effort at making its residents aware of the importance of their home-grown businesses. The RPM Indoor Raceway was a part of an organization of local businesses called Choose Austin First. The group is comprised of locally owned and run businesses that band together to make the presence of local business clear in the city of Austin. The group's emblem is a cartoon of a little dog with the motto "Do Your Business Here." The members of the organization are collegial and help one another whenever possible. For instance, all of the RPM Indoor Raceway's catering was done by Po-Kee-Joe's BBQ, an Austin institution. Meanwhile, the restaurant was able to promote the raceway through the relationship as well. The theater that rented out the parking lot for outdoor screenings was also a local business. The fellowship among the businesses is thought to develop town identity, deflecting the homogenous forces of globalization.

Austin's city motto, "Keep Austin Weird," was originally the slogan of another cohesive group of locally owned businesses, the Austin Independent Business Alliance. This group produced a study on money that is spent at locally owned businesses as opposed to nationally owned businesses, which produced the following results:

FACT 1 Modest changes in consumer spending habits can generate substantial local economic impact. For every $100 in customer spending at Borders, the total local economic impact is only $13. The same amount spent with a local merchant yields $45, more than three times the local economic impact.

FACT 2 Development of urban sites with directly competitive chain merchants will reduce the overall vigor of the local economy and ultimately the purchasing choices you, the customer, have. New and different local merchants bring a complementary (instead of competing) line of goods to the market, leading to increased choices among merchants with similar but unique lines of goods.

FACT 3 If each household in Travis County simply redirected just $100 of planned holiday spending from chain stores to locally owned merchants, the local economic impact would reach approximately $10 million.[1]

The Austin Independent Business Alliance motto and mission, to keep Austin "weird," has actually been adopted by cities across the country. In my road trips over the past few years, I have seen bumper stickers urging me to "Keep Louisville Weird" or "Keep Oklahoma City Weird." Businesses band together to organize and publicize, which immediately produces positive public relations for the collective companies. This is an interesting concept, in that it ties local character to shopping. In tourist leaflets and brochures from around the country, there is always a list of local shops to visit. Identity in the United States at the city level can often be characterized, in part, by where we shop.

The raceway's commitment to this initiative is an interesting juxtaposition considering the commercial real estate that it attempted to absorb. The RPM Indoor Raceway was a wonderful reuse of space, inside and outside, building and infrastructure. The business became a part of Austin's local business initiative—and it merged seamlessly with the big box landscape of Round Rock.

The greater Austin community received the raceway enthusiastically. This success continued until September 29, 2004, when Gifford was on his first vacation in years with his family on the south Texas coast. He was flying kites with the kids when his cell phone rang. He picked it up. The DuPont Group was on the end of the line and told him he had thirty days to get out of the building.

Thus began the unraveling of a real estate nightmare, a catastrophic business event for Gifford and his family, and a devastating loss of a creative new business in Round Rock, Texas. The RPM Indoor Raceway, to the shock and dismay of the Giffords and their patrons, closed its doors on October 31, 2004.

Gifford had immediately sensed that not owning the building made it risky for him to build a business that was so dependent on the building itself. The DuPont Group's initial interest in the startup was not just a matter of "helping the little guy begin an entrepreneurial venture," in the words of Gifford. They were businessmen, and as helpful as they were at first and friendly throughout the raceway's time in the building, when all was said and done, the DuPont Group executives just wanted that property. "We thought it was a great business, and I was a good landlord for the Giffords, but the time in the market was just not right for them," says DuPont.

In 2004, when stipulations on the property's far-reaching rules began to recede, the DuPont Group found lessees that would pay much more money than the RPM Indoor Raceway ever did. The raceway was being used as a "land bank," a user of the space that was able to keep the property afloat, to some extent. The idea of a land bank very often

2.7 Redeveloped Hester's Crossing Plaza, anchored by Gold's Gym.

2.8 New signage for the seasoned strip mall.

applies to businesses commercial real estate dealers may "use" to fill a rental contract for a period of time in order to maintain business, and to keep the parcel of land vibrant within the larger circulation of a region. Keeping traffic flowing into the site keeps the building vital amid the fabric. Often, the concept of the land bank is applied directly to vacant buildings, as commercial real estate owners will maintain vacancy in an empty building at a parcel that might be rising in value, despite its lack of use. If they wait six more months or a year, they might be able to make double the profit on that empty building, so they sit on it and wait. There are thousands of empty big box buildings all over the United States right this minute, rising in property value, like giant savings accounts asleep on the asphalt.

It is true that the raceway had gotten a little behind on rent and taxes, a dangerous place for the business to be while their landlords were ready to evict them in the first place. The rent every month was $42,000, and Gifford claims the raceway broke even at $88,000 a month. The RPM Indoor Raceway always paid its employees first, along with its bills, and it was never late on either of those payments. But at the end of the line, the company got to be about $80,000 behind on rent, accruing a total of $556,000 in late fees.

Gifford scrambled to come up with business models that would keep his own business afloat and convince his landlords to let them stay in the structure. Perhaps his business model needed to diversify. The implementation of a big box building removes certain multitextured factors from surrounding urban development, as the monolithic big box consumes the land. Often, I have observed that in the act of big box reuse, people attempt to reinsert a multitextured program back into the space. Maybe this is because of the vast amount of space available at the site, lending the building to a multiuse plan. Or perhaps our car culture leads to a tendency to attempt to form "centers," so that like-minded businesses should be near each other for the sake of parking. Gifford simply thought that inserting other like-minded businesses into the program of the space would create a synergy that would attract customers—and therefore, profit.

He was using 70,000 square feet for the track very liberally, and figured that if the raceway were to shrink to 55,000 feet, then he could offer two other businesses almost 20,000 feet each, expanding the programming within the building. He landed a deal with two companies, Austin-based Blazer Laser Tag, and the Austin Rock Climbing Gym, which had been in business for five years and had two active locations. The three businesses would form an incredible synergy there together on Hester's Crossing: indoor fast-paced go-kart racing, laser tag, and indoor rock climbing. And what's more, the development would create a multiuse facility of locally owned businesses within the big box fabric, an

interesting shift amid the large blocs of ownership and control that usually occur on the edges of town.

In January 2004, Gifford gathered letters of intent from the laser tag and rock climbing companies and presented them to the DuPont Group. Then he waited patiently, until three months later when the DuPont Group called him up and turned him down. In May 2004, Gifford's plan attracted investors from the Austin-based Axiom real estate company, who were interested in actually buying the lot themselves so that Gifford's company could implement the expansion with the rock climbing gym and the laser tag operation. They offered the DuPont Group $3.5 million for the purchase of the building, which had been bought for $3.2 million just over two years before. In June, this offer was also turned down. Gifford reworked the business model again, so that the DuPont Group would also receive a percentage of the profits of the newly formed business alliance, giving the commercial real estate company even more incentive to allow the business to flourish. Then, the Axiom Group offered a whopping $4.5 million for the building, which would have given the DuPont Group an instant $1.3 million profit on the building.

But again the DuPont Group turned down this offer. Even an easy profit of $1.3 million was negligible compared to the money that could be made in the future simply by holding on to the property. When the $4.5 million offer was rejected, Gifford knew that his business was about to see its final days. Soon after, the DuPont Group signed a letter of intent with Gold's Gym, made the phone call to Gifford at the beach, and then signed the full lease with the gym.

Gifford claimed a personal Chapter 7 as a result of the demise of the raceway. Gifford maintains good relations with the real estate company; he says DuPont investors are friends and wise businessmen, and they may just do business together again in the future. The real estate surrounding the building in Round Rock continues to sit at the center of activity. DuPont tells me in 2007 that his company recently sold the building for "north of ten million dollars."

My second trip to the site, in 2006, takes me to the new health-centered strip mall, with its gym, hair salon, tanning salon, and smoothie shop. The RPM Indoor Raceway is gone without a trace, but when I look out at the Gold's Gym interior, a sea of treadmills and elliptical machines, I can still imagine the go-karts racing among the pillars, and I can still hear the roar of ten engines.

The traffic infrastructure in Round Rock has changed so dramatically since my last visit that initially I am not even sure I am in the right place. But yes, this is Hester's Crossing. Bypasses still run mazes around the parking lots, overpasses streak through the sky,

scaffolding and orange construction cones litter the scene. I remember the aerial photographs of this lone building, back when Wal-Mart constructed it, out on a field, away from any other buildings. Standing on the sweltering parking lot in 2006, I realize that this power center, initially anchored by Wal-Mart's first Round Rock store, has prompted much of the overwhelming commercial activity that is here today. As I stood there in the parking lot, snapping photos of that reused Wal-Mart sign, I look around and observe an endless ribbon of strip malls, full of buildings just like this.

I think to myself, they have stories too. All of these faceless, nameless, corporate big box buildings—which turn over so quickly for the sake of "business"—actually have stories behind them, stories well hidden behind their stoic façades. These buildings have an impact on the lives of people. And the narrative of each building affects the trajectory of urban development, as the city grows.

3.1 Signage for the Centralia Senior Resource Center, in a renovated Wal-Mart building in Wisconsin Rapids, Wisconsin.

THE CENTRALIA SENIOR RESOURCE CENTER

3

REUSED WAL-MART BUILDING
WISCONSIN RAPIDS, WISCONSIN

Rivers are the original highways, interstates borne of water and dirt, movers humanity and of industry. The rivers of the United States are lined with old brick factories and mills, relics of America's industrial age past. These vacant factories are the origins of many prosperities, the starting point of mass production. They are the docks that sent American-made goods out in to the muddy network connecting the innards of the United States to the seashores and beyond.

The abandoned brick factories on these riverbeds embody challenges facing industrial towns throughout the country in the twenty-first century. Within the global marketplace, small towns strive to maintain active and diverse economies. A paper mill town in Wisconsin might not always be a paper mill town. In towns where the river has never failed to provide, the sudden decline of manufacturing and displacement of jobs overseas is often very abrupt compared to the long challenge of diversifying the local economy that lies ahead. The economic boon of being situated on a river grows more and more obsolete.

Wisconsin Rapids, Wisconsin, is historically a mill town, and from the mid-1800s to the turn of the twenty-first century, the town was consistently one of the world's largest producers of paper. Wisconsin Rapids, like so many old industrial river towns, is steeped in paradox: boom and bust, past and future, collapse and progress. The town's two major paper mills were run by local families: one was owned by the Alexander family, the other by the Mead family. In 2000, a Finnish company, Stora-Enso, bought the Mead paper mill, which had been Wisconsin Rapids' Fortune 500 company. Roughly 5,400 jobs were lost. In 2000, the Nekoosa paper mill, owned by the Alexander family, was bought by the the Canadian paper company Domtar, who shut down three

of the Nekoosa paper machines, eliminating 160 more jobs. This in a town where the employment base is just at 12,000.

The community has met this economic challenge with great resourcefulness and has capitalized on its booming dairy and cranberry economies to stay afloat. There are still some papermaking jobs available, and the town has benefited greatly from its newest factory, Renaissance Learning, a company that makes software for schools. This is indeed a poetic progression from the days of milling paper.

The Mead and Alexander families continue to act as strong philanthropic forces in Wisconsin Rapids, as they have since the beginning of the paper empire. Philanthropy is such a driving force in Wisconsin Rapids that in 1995 the Community Foundation of South Wood County was developed, a nonprofit that solely manages the community-based endowments donated to the people of Wisconsin Rapids. The Community Foundation is one of 750 community foundations nationwide, each facilitating grants to community-based initiatives within a specific geographic range. As a result of this philanthropy, along with a benevolent local government bent on community-based initiatives, a remarkable quality of life developed in Wisconsin Rapids throughout the last century. The town boasts a great education system, it makes affordable and accessible health care available, and the cost of living has remained low.

Meanwhile, the glorious natural environment of the region makes it a hot spot for owners of second homes from throughout Wisconsin and from the state's southern neighbor, Illinois. Many people summer in Wood County, home to Wisconsin Rapids—especially senior citizens. According to the 2000 U.S. Census, Wood County and the next county north, Marathon County, are home to 34,631 people over sixty years old. This accounts for 22–28 percent of the greater Wisconsin Rapids area. This number increases drastically each summer, when seniors flock to the lakes and the woods of the county to enjoy their second homes.

As Wisconsin Rapids worked to diversify its economy after the decline of the paper mills, capitalizing on senior care seemed to be a natural decision. Quite naturally, the care of senior citizens has become a driving force in the economy of Wisconsin Rapids, along with the dairy and cranberry farming. "We provide a good education for our children here, and good health care for all ages. We believe that we need to pay just as much attention to the other end of life, to offer resources specifically for people in their golden years," says Mayor Mary Jo Carson.

The Centralia Senior Resource Center of Wisconsin Rapids, Wisconsin, is located in a renovated Wal-Mart store, right in the center of downtown. I enter the front doors

of the Centralia Center, and a group of twenty senior citizens quickly walk past me. They are exercising, doing laps around the long hallways that run the perimeter of the building. These halls offer a warm place to walk during the freezing dark months of winter, in a part of the country where interiors are a crucial component in the urban fabric. Throughout the 1980s, the Wal-Mart store had anchored the Rapids Mall downtown before supersizing on the outskirts of town. Today, the Centralia Center is in Wal-Mart's building on the east end of the mall. Fifty full-time employees work at the center amid the three agencies that operate under the big roof: the Lowell Center, the Aging Resource Center of Wood County, and the Park Place Adult Day Service program.

"This center is eighteen years in the making," says Rosemary Felice, director of the Aging Resource Center of Wood County. "We went through so much together to make this place come to life, and were dedicated because we knew the power that this place would have to change the quality of life in Wisconsin Rapids, now, and in the future," Carson adds, "We know that this place will still be here when we reach our own golden years, and we joke that we'll all be here together in this building forever."

Prior to the renovation of the Wal-Mart building, the senior center already had a history several decades long. In 1982, the Lowell Center for Senior Resources first opened in a vacant school building in Wisconsin Rapids. The Lowell school structure underwent three years of intense renovation in order to house the town's first senior care center. Meanwhile, the South Wood County Department of Aging, a separate agency, was located in a small section of the town courthouse downtown. The Wood County Adult Day Care, a third agency, was in another location altogether. The dispersed location of the three primary senior agencies in town proved to be problematic for a number of reasons. Communication between the three agencies was minimal, although their resources were closely connected and their clientele list was practically identical. This also meant lots of driving between the institutions, as clients and their caregivers traveled frequently from agency to agency. The continuous loop of cars moving between agencies meant there needed to be continuously open parking spaces, which was impossible with the dispersed downtown locations of the three facilities.

In the early 1990s, the Consolidated Paper Foundation, a philanthropic group formed by local paper companies, teamed up with the United Way of South Wood County to begin examining the possibilities of instituting a comprehensive multipurpose senior resource center in Wisconsin Rapids.[1] The Consolidated Paper Foundation spearheaded

the senior resource center project with a $15,000 grant, which was to be used to begin the examination of various sites around the county.

A project committee was formed. In 1994, Vierbicher Associates, a firm based in nearby Madison, was hired by the city to act as the designer, architect, and manager for the senior center project. Vierbicher Associates had a track record of community and downtown redevelopment throughout the upper Midwest.[2] Kelly Lucas, president and CEO of the Community Foundation of South Wood County, became involved in the project. Wisconsin Rapids resident Mary Jo Carson acted as the primary organizer and fundraiser for the project, and in 2002 she was hired by the Community Foundation to work full-time on the project—a job that she fulfilled so successfully that she was later voted town mayor. Funds were soon raised for the purchase of a new lot to be used as a senior center, where all of these agencies could be consolidated into one location.

Several sites were considered, but they each had at least one negative characteristic that deemed them unsuitable: unsafe power lines underground, railroad tracks on the property, too much industry nearby, too many residences nearby. Eventually they settled on five acres of land on 25th Avenue downtown, and plans were made for the new center to be constructed. The design would cost a total of $3.85 million.[3]

Carson and Vierbicher Associates applied for a Community Development Block Grant (CDBG) for the construction of the new senior resource center on 25th Avenue. This CDBG is provided by a federal fund for urban redevelopment, and the money is funneled through states. The CDBG program maintains several initiatives that drive its criteria for economic development, including producing new jobs, curbing blight, and helping people of low to moderate income.

The initial senior center proposal did not receive this funding. "We simply did not score enough points on the CDBG criteria, primarily because we were building on green space," says Carson. "The grant was an important piece for our fund drive. It was money that we really needed, since this was such an important step in our town's community development." When the CDBG money was declined, the committee knew that it had to go back to the drawing board.

The Wal-Mart lot had initially been considered for the project, but one major obstacle existed regarding the use of this site: great resistance from the community. It was an 85,000-square-foot building, abandoned in the mid-1990s, and it had been vacant ever since. Everyone knew that roof leaked. Everyone knew that its vacancy had caused the mall to lose business, which in turn caused the downtown to lose business. It was simply culturally stigmatic to move the senior care facility into that dilapidated Wal-Mart build-

ing. People were envisioning a brand-new, high-tech senior center. The community did not expect this vision to be met in the abandoned Wal-Mart structure at the Rapids Mall.

But Vierbicher Associates studied the building. The firm tested it, drew pictures of it, and researched it. And they quickly found that its reuse was not only feasible but actually very promising. There was no asbestos in the structure at all, the struts were strong, and the space was vast. The only structural issue was that roof did indeed need to be replaced. Renovating this structure had an economic incentive, since their decision to do so would surely meet the CDBG criteria—it was demonstrating downtown redevelopment while providing jobs and care for a minority demographic, the elderly. Gary Becker, head project manager, said in the local newspaper, the *Wisconsin Rapids Daily Tribune,* "There are a lot of attributes to this site which are very attractive for redevelopment . . . It is like making a silk purse out of a sow's ear."[4]

However, the biggest obstacle remained: getting the community behind the idea. The people needed to see that this would not look like a Wal-Mart building with a new sign on its façade. To educate the community about the building's potential future, the Community Foundation began hosting public presentations on the possible redevelopment of the site. Veirbicher Associates made drawings of the architectural plans, showing skylights and dramatic entranceways, benches and green space surrounding the site. "When we finally got the seniors on board, that is when things really took off. Once they bought on, there was a lot of passion," says Carson.

"Yes, once they bought on," adds Becker, with a half-smile, indicating that the public needed some convincing. The presentations went a long way in getting feedback from the community, while exhibiting to them the care and expertise that would go into the renovation of such a seemingly inappropriate building site. Meanwhile the *Wisconsin Rapids Daily Tribune* played a tremendous role in educating the public about the entire process. Several reporters for the paper, most notably Antoinette Rahn, realized the local media's role in creating a public document of the proceedings of this community-related issue. A tremendous archive of articles about the struggle to reuse the abandoned Wal-Mart lot emerged, which created awareness of the community's need for the senior center and the challenges (and triumphs) of reusing the big box. This journalistic accomplishment brought statewide attention to the Wisconsin Rapids project, eventually drawing fund-raising and support from beyond the city limits. The backlog of articles from the entire timeline offers a wonderful example of the power of local media.

The renovation project at the Wal-Mart site was estimated at $7–9 million, as opposed to the $3.85 million plan for the 25th Avenue site, which included the purchase of the land

and construction upon the premises. Although this site was going to cost more than the initial building plans for 25th Avenue, choosing to use the Wal-Mart site resulted in a revitalization of the dwindling downtown and opened up more space for other institutions to piggyback on the gravity of the anticipated senior center. This meant that steady rent could be pulled in from likeminded institutions, and similar services would further the goal of centralizing senior resources. Furthermore, Carson and the designers knew that the redevelopment of the Wal-Mart site would make the project eligible for the CDBG money, and that they would also be able to explore potential grants from the town's Redevelopment Authority. Both of these funds would ultimately even out the costs.[5]

When Wisconsin Rapids was wooing Wal-Mart to town in the early 1980s, the city had been given an economic development loan of $450,000 from the Wisconsin Department of Commerce to make the town's infrastructure more suitable for the retailer. The city, in turn, loaned this money to Wal-Mart, who used it to expand the existing Rapids Mall parking lot, which in turn created a slight jog in the road in front of the structure. "The grant was based directly on job production," said Carson. "That money was received specifically because of the number of jobs that would be offered by Wal-Mart."

When Wal-Mart left the downtown location to build a larger supercenter on the outskirts of town, Wal-Mart Realty put the building on the market at $1.1–1.2 million for the first three years of its vacancy. In the fourth year, Wal-Mart unexpectedly came down on the price, to roughly $750,000, for reasons that are still unknown—but meanwhile, Wal-Mart still owed the town of Wisconsin Rapids $350,000 on the development loan from years before, a cost that would be assumed by the buyer. (You'll notice that $350,000 plus $750,000 is $1.1 million.)

The hopeful senior resource committee initially attempted to convince Wal-Mart to donate the building to the city. The corporation was clearly not going to consider that as an option, so the thought faded quickly. When the price dropped on the building, the committee became excited again, until it realized that the city would also be forced adopt back the very loan it had given to the Wal-Mart Corporation when it came to town, which it had used to expand the surrounding infrastructure as it saw fit. The city's next hope was that the Department of Commerce would forgive that remaining balance on the state loan. But that was not going to happen either.

The building remained empty, even though the city had made a great case for its use and the local media had publicized the situation throughout Wisconsin. Community members of Wisconsin Rapids were vocal and united in their goal of making this senior center happen, and they wanted it downtown. They made Wal-Mart aware of all of this,

and eventually, the senior committee talked Wal-Mart down to a purchase price of $400,000. Wal-Mart accepted this offer, on the grounds that the city would indeed take on the remainder of the debt that Wal-Mart owed it. "We did not exactly get a deal on the property," says Becker. The grand total of the property, including the loan price, was around $750,000.

Fortunately, the city was able to approve bonds that would cover the loans generated by Wal-Mart. And in 2002, the senior resource project was awarded a $750,000 CDBG from the state of Wisconsin. The initiatives of the CDBG program were being fulfilled to the utmost: the care for seniors gave the project high marks for helping a low- to moderate-income demographic; the resource center would offer new jobs to the community; the project would fill a gigantic hole in the center of downtown. Along with the mall, the downtown had been failing since the Wal-Mart's departure. As the group imagined it would, this grant was the financial catalyst that ultimately moved the project forward.

Local fund-raising was strong and ongoing. Even workers at the currently operating Wal-Mart store on the outskirts of town signed up for Wal-Mart's "Volunteerism Always Pays" program. Through this program, Wal-Mart donates $100 to a local cause when an employee volunteers fifteen hours to the cause within a three-month period of time. The staff at the local Wal-Mart donated enough time to raise $2,700 for the senior resource center.[6] In effect, Wal-Mart workers were volunteering so that the corporation would donate money for the purchase of its own abandoned building.

Another important piece of the fund-raising came in 2002, when the Paul family, who owns the software company Renaissance Learning, gave a $250,000 matching fund to the project. In the end, the breakdown of the fund drive was extensive and inspiring:

- The estimated amount that came from local fund-raising was over $800,000.
- The grants that were awarded to the project also equaled $800,000.
- The CDBG was for $750,000, one of the largest grants given in recent years.[7]
- The seniors themselves raised over $200,000.
- The city was offering anticipated loans in one taxable bond totaling $1.6 million, and one principal-exempt bond that totaled $1.8 million.
- The Common Council of the town vowed a donation of $2 million to the project.
- The Lowell Center for Senior Resources donated $30,000.
- Wood County's Centralia Center Adult Day Care donated $30,000.
- The sale of the old Lowell Center for Senior Resources brought in $125,000.[8]

3.2 Main entrance.

On May 23, 2002, the city signed the papers. Wisconsin Rapids owned the abandoned Wal-Mart structure that had once anchored the Rapids Mall on 3rd Avenue.

The structure's size was 85,000 feet. The senior center itself really only needed 35,000 square feet to operate. When the Redevelopment Authority invested in the endeavor, it voiced concern over the vacancy of any space, asserting that the entire volume of space must always to be in use in order to fulfill its mission of redevelopment. It was definitely feasible, and part of the plan, for the center to rent out space. But 50,000 square feet was identified as too much space for the center to realistically rent out to other agencies.

Vierbicher Associates came up with the radical solution of actually knocking part of the building down altogether, right at the start of the adaptation process. The firm proposed demolishing 18,000 square feet of the building, and working with only 67,000 square feet of space, rather than all 85,000. This was at first met with resistance; the town had bought the building after a decade-long process of fund-raising, research, and commitment. It seemed ludicrous to knock down part of the building at this point, before renovation had even began. But Vierbicher Associates continued to talk about the value of decreasing the building size: it would allow the city to continually maintain occupants in all of the rental spaces, which would keep the center vibrant and alive, while fulfilling the Redevelopment Authority's mandate. Having too much space in the building could ostensibly put the project back at square one, with a half-empty abandoned Wal-Mart structure now owned by the city. The portion of the building that would be demolished was right on the river, and the ground beneath that part of the building could actually be turned into a park, used as green space. Vierbicher Associates eventually got its case across, and an 18,000-square-foot section of the east end of the building was torn down. This was the primary structural change made to the space.

Today, as you approach the Centralia Center, you stroll into a park full of planters and benches, on the Earth that was once covered by 18,000 square feet of the Wal-Mart structure. The seniors have a community garden here. During my summertime visit, I was offered green beans by a senior citizen, wearing gardening gloves and a floppy sunhat. The demolition set the big box back from the road, creating a buffer of greenery between the traffic and the resource center. Dramatic entryways have been added on the eastern and southern façades of the building, with awnings and large doorways. These aesthetic decisions attempt to mask the fact that this was once a corporate Wal-Mart building. Despite remaining characteristics, such as the massive parking lot and the building's direct attachment to a mall, in the eyes of the locals the building has been transformed.

3.3 Transition from the Centralia Senior Resource Center to the Rapids
Mall, which was previously anchored by Wal-Mart.

3.4 Reception area in the senior center. The design includes wide halls and skylights.

Inside the building, high ceilings feature skylights. The three agencies in the senior center, the Aging Resource Center of Wood County, the Lowell Center, and the Park Place Adult Day Service program, all have their own office areas: 4,500 square feet, 13,600 square feet, and 2,300 square feet, respectively. The shared common space takes up 11,700 square feet, including a 950-square-foot conference room, and a state-of-the-art kitchen and dining room. The kitchen and cafeteria are located in what was once the craft section of Wal-Mart. Meals are prepared here that are sent out all over the county, to elderly people who receive assistance from the senior center. "Hot meals are served here everyday, and holiday meals have become huge events that pack the dining room," says Carson. "The place is filled to the max on holidays, and our patrons have a really great time."

What was once the Wal-Mart's main entrance now leads to an 11,700- square-foot foyer, a space that segues to the building's rental property, since 25,950 square feet of the building is now rented to other agencies. The rental money provides a constant income, keeping the costs of the building use manageable. The rental agencies are all community-oriented, nonretail entities, making this center a true community endeavor. The Rapids City Community Access cable station rents a 2,200-square-foot space. After a twenty-two-year stint in a 600-square-foot space in the basement of the MacMillan Library, the cable station is operating to an extent it never imagined. The Wisconsin Rapids Montessori School rents another space, and the Rapids City Community Theater rents another. Together with the Centralia Senior Resource Center, these operations have created a powerhouse of civic activity, enlivening the downtown area.

Consolidating the three senior care agencies under one roof was key in the success of this site, "especially in terms of the fund-raising," says Carson. "Providing a one-stop resource for all three agencies was the piece that made the project appealing. It got the seniors and their families behind the project, since they would no longer have to drive all over town to get to the three separate resources. The site was so accessible, and offered so much space, that we knew we could harness it for the good of the resources we were offering through the redevelopment," adds Becker. The one-stop customs generated by this building in its life as a Wal-Mart were remanifested in its life as a senior center.

"There are names of 950 people on that wall," a senior citizen says to me as I examine a plaque in the foyer covered with the names of local donors to the project's success. I visited on a Monday, which is ladies' day in the billiards room. The room was packed with elderly women shooting pool, and the radio was on. These women have obviously played

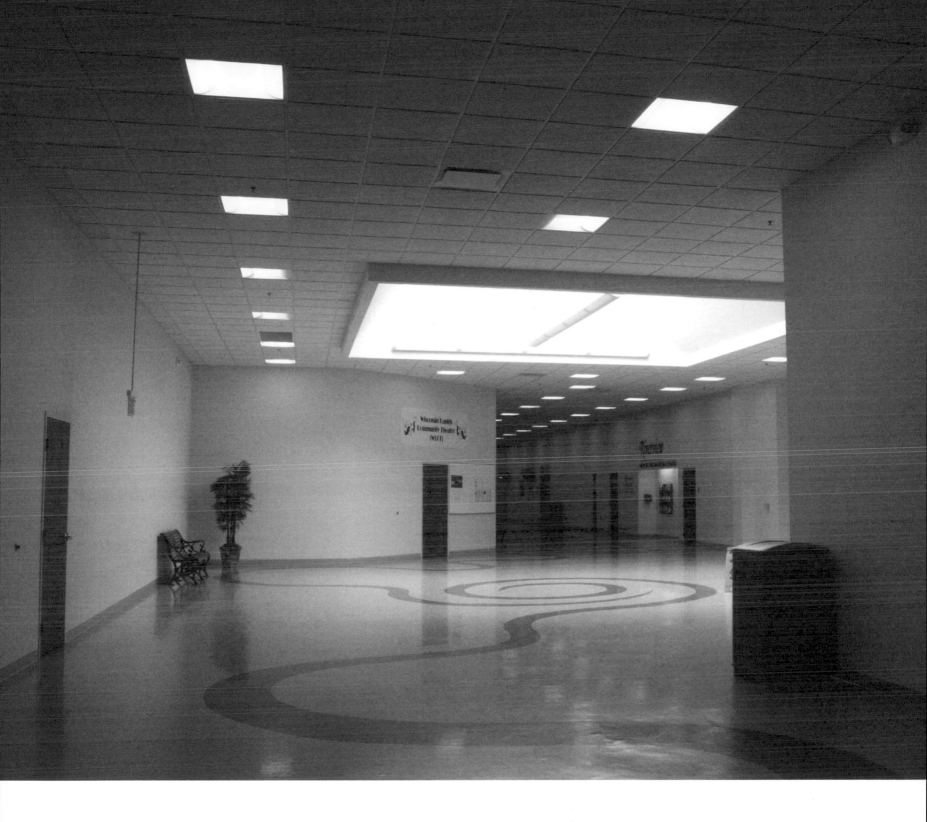

3.5 Public area shared by the rental portions of the building. This hallway segues
into the Rapids Mall from the Centralia Senior Resource Center.

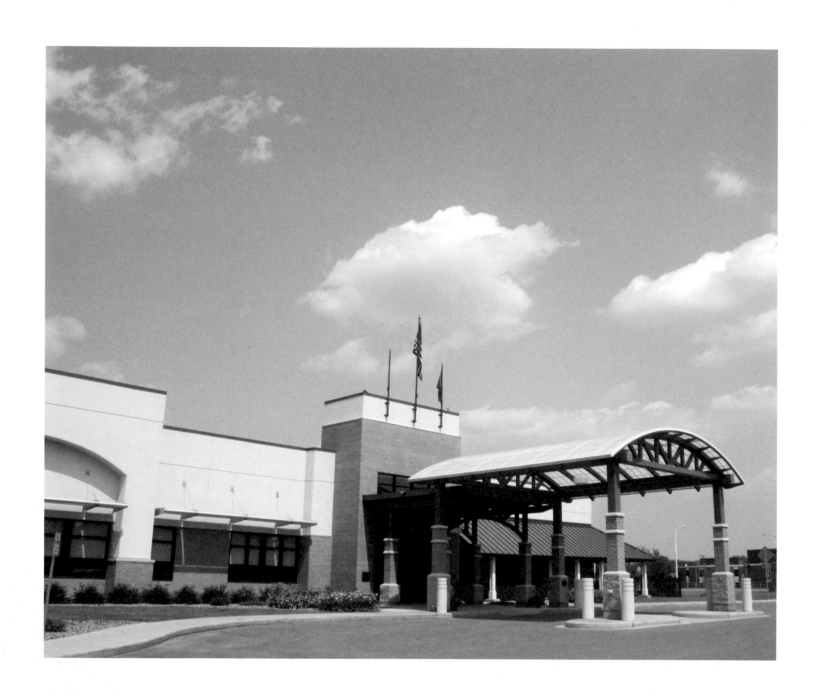

3.6 Resurfacing of the Wal-Mart: a new façade for the
Centralia Senior Resource Center.

pool together before. In fact, as one of the ladies informs me, they have played together "for decades." She continues: "We have played pool together for many years, in many places. This is our poolroom these days, and we love it. You have to sign up early to get in here on Mondays." Apparently, you also have to sign up early for bridge games, for bridge lessons, or for a seat in the card room in general. The activity in this place is tremendous, and hundreds of people seek services here everyday.

Reuse of the big box in Wisconsin Rapids has reintroduced an updated version of yesteryear's multi-textured downtown fabric, injecting a new affected version back into the landscape—within the walls of a building that was constructed by the corporation who assumedly removed much of that fabric in the first place. Kelly Lucas tells me, "We are striving to create an experiential downtown environment in Wisconsin Rapids, a place where people walk to shop, mill around for socialization, and visit civic resources without having to drive all over town. In that regard," she says, "it is a good thing that Wal-Mart left our downtown area, simply because they do not support the kind of pedestrian-friendly atmosphere we are hoping to achieve here." Restaurants and coffee shops are beginning to pop up along the road leading to the senior center. The mall has seen improved business, with the new foot traffic produced by the Centralia Center. I was told that the mall in this town does not only provide a place to shop, it also serves as an interior space for the harsh winters, a walking space, a meeting space.

"The Centralia Center serves as the new anchor for downtown," says Lucas. This anchor is acting as the hub of circulation in town, drawing people to the downtown district, and the effect is spilling over to the surrounding streets and businesses. "The Vierbecher team had great expertise in community development, and all of us locals had the passion. Together we built a very strong team." During our conversation, she flips through the scrapbook filled with years of newspaper clippings about the project, and on some pages she stops and looks over at Becker, and points to a headline or a picture, fading on the newsprint. They remember each moment of the process that they went through. "There was a clear vision for the potential community development at stake here, we could really see that we could absolutely make a positive, permanent change in our community. I really believe that our story is an example for others of what can really be accomplished at a site like this.

PART II

NETWORK

People and geography have become increasingly networked, globally and digitally. Updated modes of travel and communication emphasize the global community produced by these networks. We communicate more, and in an instant, with people around the globe; travel between continents is also (theoretically) relatively simple. Meanwhile, humanity simultaneously may experience less actual interaction, as society learns to interact digitally with a dispersed community, and the experience of place may be increasingly virtual.

When we consider geography, we think about the meaning of specific places within the larger context of space. We define a site as a specific point, with quadrants and characteristics that are unique to any other point in the world. A community of people who live at that site are unique to that place, and historically their relationship to other people or communities is primarily influenced by geographic proximity. In our networked society, however, this paradigm of community is not as relevant, since people are constantly forming digital communities despite proximity, sometimes without even knowing where their cohorts reside. Meanwhile, the virtual experience of place can be delivered through technologies like Google Earth, virtual reality, or live webcams. As communities utilize the ability to become more geographically dispersed, and as space is experienced virtually, the uniqueness of place is brought into question.

Big box buildings also create a network, a series of nodes that react to one another. No big box building may operate without its system, which is made up of a thick web of highways, trucks, shoppers, factories, ships, distribution centers, and other big box buildings. The buildings themselves grow out of the asphalt at apexes of transport, humanity, and consumerism, and each is a part of a larger network of stores developed around one mighty distribution center. So, each of these buildings is dependent on the existence of the next building. They collectively need the goods that originate at their hub, their sun: the distribution center. In their essay "Wal-Mart and the Logistics Revolution," Edna Bonacich and Khaleelah Hardie note that the company opens a distribution center first, which then allows them to open and close the stores surrounding the distribution center at very little cost.[1] Once the power source is in place, stores can be switched on and off like light bulbs stemming from a single outlet.

How can the network of these buildings induce cultural change, and how do people absorb that network into civic life? When we consider big box reuse, we must think not only about the structure itself but also about the infrastructure: how do the parking lot, the surface streets, the highway system, and the global marketplace relate to culture's shift to embrace the big box?

Meanwhile, how does the experience and preservation of the "local" play into this scenario? The big box building is not specific to any one place in the way a historic courthouse or music hall might have been; rather, each big box is part of an encompassing, corporation-specific, multisited experience. An identical experience can be expected at each node, as in the familiarity of going to a McDonald's restaurant to order the globally synonymous Big Mac while traveling in a foreign country. As we have seen in the case studies so far, when the big box retailer leaves the building behind, the community takes a chance on absorbing the building and making it local, reprocessing the space into a place congruous with the activities of the lives of the community. In the networked sense, the building maintains a sense of anonymity; it is still "one of many" in a giant system. There is nothing unique about a big box building; tens of thousands of practically identical big boxes like it exist all over the country.

The big box network of buildings has been developed as a part of the economic strategy known as the "just-in-time" principle, the heart of big box retail. This strategy contends that companies operate most efficiently when they are only holding as much stock as is needed for operation in the very near future. Legend has it that, fittingly, Henry Ford was the first to maintain the just-in-time principle, a method that simply could not operate without the use of a fleet of transport. As such, big box stores do not use much room for storage. In effect, most of the nation's big box storage is actually happening all around us, moving about in the massive fleets of trucks owned by big box retailers. Stock is cruising on the highways connecting the buildings right now, storage on wheels. Each item sold at a big box store takes a long trip to get to the shelves: Materials are shipped from all over the world to a factory, usually in Mexico or China, where the product is assembled. This product then travels on a ship from a factory overseas, lands at one of several docks in the United States, where it is loaded on to a truck, and is driven to a distribution warehouse, where it is funneled to another truck that is headed on to the appropriate highway. Finally, the product is driven to the store, unloaded, and sold at a remarkably cheap price considering the journey it has made. Sometimes the step of stocking the shelves is even skipped, as retailers load entire palettes on to the center of the floor, without any pretense, a simplistic gesture of abundance.[2]

The strength of a network, be it electronic, architectural, or humanistic, can often be determined by its flexibility, the diversity of its parts, and the varied tasks that its separate nodes are able to handle. At the same time, as Keller Easterling points out in her essay "Differential Highways," the strength of a network may also be determined by the abundance of redundancy.[3] A network with redundant nodes, all performing the

same task, offers more flexibility in terms of trial and error, and, importantly, wider channels of transport for the movement of goods—in other words, more "bandwidth," per connection.

Apply that notion to the roads and buildings that make up the big box network. We are looking at thousands of redundant nodes, with clearly carved pathways between them—infrastructure that has been widened by local governments for corporate accessibility, connected to the endlessly burgeoning highway system of the United States.

As a larger community, can we brainstorm about how to intervene in this existing big box network for environmentally positive applications? What if we accessed those nodes for a new alternative energy source and infrastructure, for instance? The nodes are in place, giant parcels of land complete with giant roofs ready for solar panels or some yet-to-be-determined energy source, right at the juncture of the highways.

Part II turns to two examples of educational facilities that have adopted and adapted the networked nature of the big box stores. The first is a new form of American public education, the charter school. This institution questions the boundaries of what is considered "public" and what is considered "private" in American civic life, and changes the way we think about school districts in the United States. The second case study shows how the big box network extends beyond the borders of the United States, and how this global network affects life even in rural areas such as central Nebraska. It is about a Head Start preschool, a publicly funded institution created in 1965 to provide education and health care to low-income children in the United States.

What makes the anonymous big box building unique when a school moves in? Is it perception alone? How is the anonymity useful for educational purposes? How is education shifting to align with the big boxed landscape that has emerged?

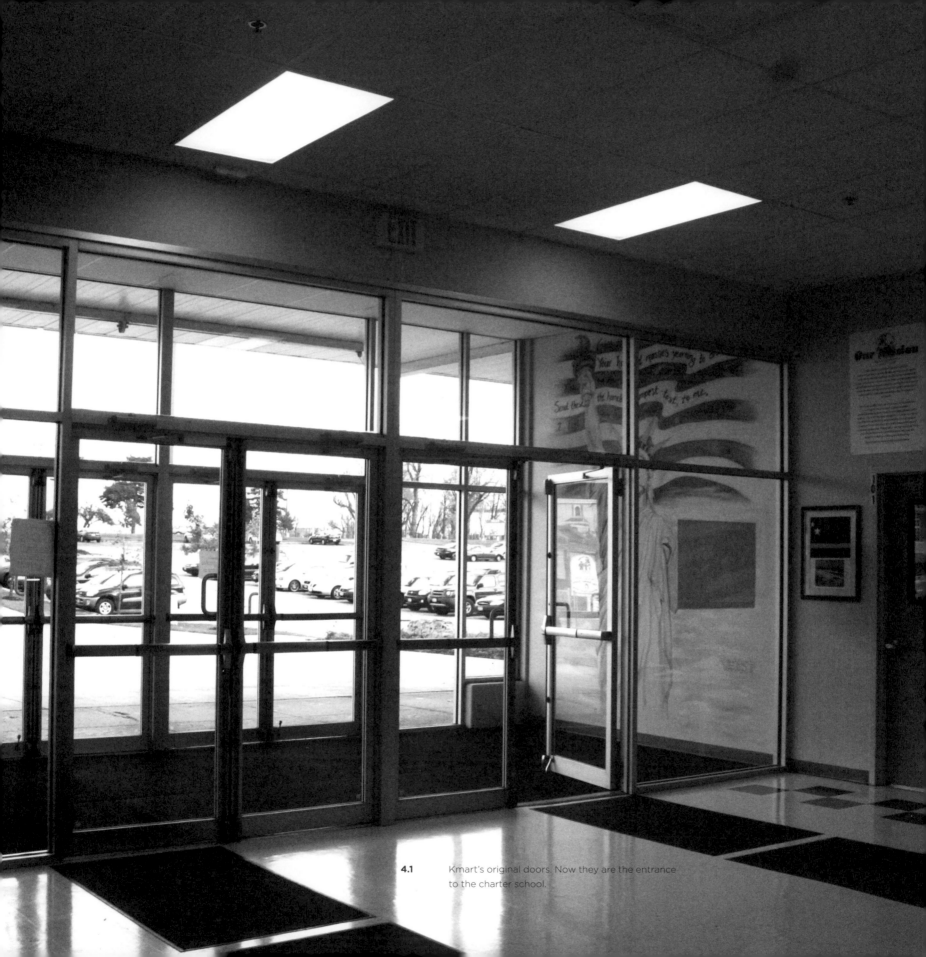

4.1 Kmart's original doors. Now they are the entrance to the charter school.

THE CHARTER SCHOOL

**REUSED WAL-MART AND KMART BUILDINGS
BUFFALO, NEW YORK;
CHARLOTTE, NORTH CAROLINA;
LARAMIE, WYOMING**

I am driving amid a sea of parking lots when I realize that my computer-generated directions have become entirely irrelevant. The highway is to the left of me, I can see it, and somehow I have entangled myself in a mass of tiny roads that connect a string of parking lots. Following Internet-generated directions to a reused big box store is always problematic. Google Maps or MapQuest guide me through unmarked access roads and unnamed highways with strange codes that allegedly define my navigation to these new locations here on Earth. These highways and access roads have grown on top of one another like cement weeds, and still our tendency is to refer to traditional directions: "Turn Left at Access Road #17STX West," or "Turn Right at Highway 19LXSOUTH." At this point, construction has grown over itself so continually that following basic coordinates might be the only answer: "Stop at Latitude 30, Longitude –90."

Nonetheless, I am basically left to intuit which way to the abandoned Wal-Mart building. I am left to guess which of these parking lots is also named Route NE19S13, and which direction is "left" at a six-way intersection.

What a compelling place to put an elementary school.

These were the thoughts on my mind as I navigated to my first charter school in a renovated big box building. I have seen more charter schools in big boxes than I have seen any other single type of institution. The charter school phenomenon is a new wave in American education—a "public" school that receives money directly from the local traditional public school district's fund, with the potential of legally receiving additional funds from private sources. Charter school laws are a clear example of how in America, "public" and "private" institutions are rarely dichotomous anymore, as private

(or corporate) money may freely uphold many a public venture, from parks to governmental decisions to the implementation of new public schools. This is not to say that all charter schools are corporate, or that all charter schools receive money from private sources. But the laws have been created in this country so that they may do so, and the laws vary from state to state about how far this public-private merging may go.

Many states allow public charter schools to operate as for-profit entities. Edison Schools Incorporated, for instance, is a private company that manages public charter schools in the United States in such states as California and Michigan, and in the United Kingdom as well. A charter school corporation creates a network of school buildings and, in effect, develops a distributed public school district. This school district is based not on geographical proximity, but rather on a shared charter. Money is funneled to the corporation from these distributed nodes (i.e., the local school districts that host the myriad of new schools under the single corporate charter), and then this money is filtered back to the distributed nodes. This is a nationwide school district controlled by a single corporation.

But not all charter schools are developed or maintained by corporations. A charter school is started when a group of individuals write a "charter" for a form of public education they feel is missing from the community, oftentimes to serve underprivileged students or some other specific demographic. The school does not have many of the curricular regulations the nearby public school has, but the charter school is mandated to maintain the same testing procedures as the public school. If standardized testing shows that the students are not achieving at the rate of the public school, the school's charter will be revoked. Charter schools are under intense scrutiny at all times, and the charter may be revoked for a wide variety of policy infractions, meaning that these schools are very fragile businesses. If the charter is revoked, the school is disbanded, all money that has been invested is lost, and all students will be forced to find other means of education. So charter schools like to stay out of the spotlight, out from under the microscope. In fact, every charter school that has taken part in this research has asked that the name of the schools and its associated employees remain anonymous in print, perhaps for these reasons. As such, in this chapter, the names of those associated with the schools are pseudonyms, and the locations are purposefully left vague.

In most states, although the charter school may receive public funding, it is responsible for finding and funding its own school building. Furthermore, it is generally looking for flexible, existing buildings that allow for growth and change. Bill Lake, financial advisor at the State University of New York Charter Schools Institute, says that charter

schools are often built piece by piece, in existing buildings, rather than on green space. "Our schools are changing all the time, and are often started up in an existing space that was available in the community, rather than building from the ground up," Lake tells me. Many of these schools are basically start-up businesses looking for a lease rather than a property to buy, a space that they can occupy while they are strategizing and experiencing their initial growth. Ultimately, charter schools are speculative businesses that might just fail if they are not able to prove to the state that the school is worth public school funds. Leasing a property does not give them the same pressure that buying land would.

Enter the big box.

The first charter school I visited was in the suburbs of Buffalo, New York. The school building is a 68,000-square-foot abandoned Kmart building, on an eleven-acre lot that was abandoned in the late 1990s. The school opened in 2002. "This building is suited to us because we can renovate as we go, we can expand as we move along. This building is much more malleable than a traditional school building, so we are not tied to renovating the entire structure at once," says Principal Blue. This school was first interested in moving into a traditional building in the same town, a vacant school that had been abandoned years before. They ran into various issues in renovating that space, and now, the principal could not be happier about the current arrangement in the big box. "I used to work in a traditional school building, and the curriculum there was often hindered by the structure. Since we are a new school, we don't have any set guidelines about how our school is supposed to look. We are not bound to the traditional school building," says Blue. He goes on to tell me that they are experiencing a rapid rate of expansion, requiring constant renovation of the space. "We are always adding new grades that we teach here; we are currently at K–6, and we are in the midst of applying for the license to teach K–8. By starting with an empty shell that we can build into, we are able to grow as we go."

The gigantic parking lot in front of the building is a sea of yellow school buses. Students are bused from all over the city both in the traditional school district's buses and in the buses owned by the charter school. For instance, if a student lives in the district of Public School 15, a school bus operated by Public School 15 will bring the student to the charter school on its way to the traditional public school. Although charter schools are "autonomous islands trying to stay above water," in the words of the principal of this particular charter school, the schools rely heavily on a network that is already in place—the busing network of the American public school system, which has been in place since the 1960s. Coincidentally, this is same decade that gave birth to the big box network.

4.2 Hallway painted with murals of places around the world. This charter school has an emphasis on the concept of the "global village." The hallway pictured here is dedicated to the continent of Asia.

It is beneficial that the building is all on one level, so the entire structure was accessible to people with disabilities from the start. Renovating a seventy-year-old school building may not have offered the same accessibility. This is also useful for year-round construction projects. Working on only one floor makes it easy for crews to move in and out. And so far, the work has all been conducted on the interior of the building, so renovation can take place year-round. "A great benefit for a construction team in the upstate New York winter," confirms Blue.

A local development company from Buffalo owns the site, and the school has been renting the lease from the company since it opened its doors in 2002. Initially, the school came up with a price package with the intent to buy the property, which included all necessary renovations—a "turnkey operation," meaning when the school turned the keys in the front door, it would be ready for use. But as they started calculating the incidentals, the price wound up being much more than expected. Ultimately, they approached the development company to see about working out a brokerage scenario.

"We bought the building and completed the initial renovations," the head of the development team, whom we will call Mr. Green, tells me. The price of the structure was $1.6 million for the land and the building, and the school spent roughly $750,000 for the initial renovation. The school has completed continuing renovations on its own, out of pocket, Green tells me. "Our company has looked into the development of other charter schools. This is the only one that we have decided to actualize, simply because we were sure that building would not offer any surprises. We knew exactly what we were getting—a big box." Green continues to tell me that the cost of renovating a vacant old school building is basically incalculable. "Buying an old building to renovate for a school is like opening a Pandora's box. We have no idea what we are going to run into, in terms of plumbing and electricity and other upgrades." He says that state codes for educational buildings have changed drastically in the last fifty years; classrooms must be larger, and sprinkler systems and wheelchair accessibility are necessary. These new regulations make all of the vacant school buildings in their town basically obsolete. "The big box building was open and clear. Everything that was there in the structure was there, out in the open, for us to see," he concludes.

The flexibility of the open space in the box offers a broad range of possibilities for development. Principal Blue says, "We can do anything we want in this building, as long we do not touch the original support structures." These pillars are hidden well in walls throughout the entire building. The twenty-five classrooms are situated around the perimeter of the structure. Light is an issue in any big box renovation, since the interior of the building

4.3 Cafeteria.

4.4 Wide hallways. The principal cites the wide hallways as a curb to behavioral issues among students.

4.5 Interior of the gym, which was once the auto center for the Kmart. Because Kmart had implemented a sloping floor here for the easy cleanup of oil and debris, there is a six-inch difference between the floor of this gym and the ground outside. The school had to level the auto center's floor before building the gym.

4.6 Classroom with painted murals, a popular decoration technique in reused big boxes.

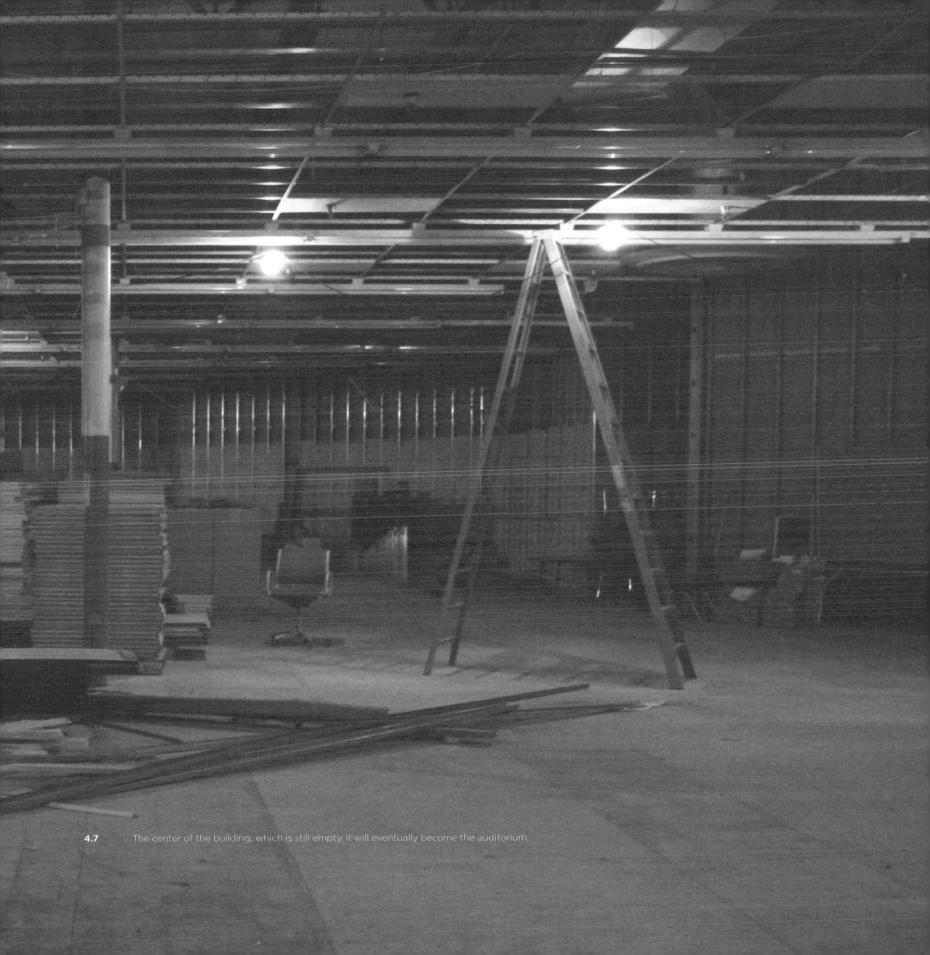

4.7 The center of the building, which is still empty. It will eventually become the auditorium.

4.8 Kmart's cargo bay, sometimes used for construction purposes at the school.

has no access to windows. Placing the classrooms around the perimeter allows for light, which streams through the large windows the school had cut into the exterior walls.

The classrooms and hallways are large, with tall ceilings. "We believe that the more space you have, the fewer issues you will have with disciplinary problems. In my experience, children are better behaved when they are not cramped," Blue tells me. Hallways here are roughly twelve feet wide, and the ceilings are all at least nine feet tall. The building is also very quiet. Insulation doubles as soundproofing, while it protects the structure from the upstate New York elements. This aspect of the building also has a positive effect on discipline, according to Blue. "A quiet, spacious school leads to good behavior."

The school's gym is in the old auto center of the Kmart. The major issues in this portion of the building were, as they are in the reuse of every Kmart auto center, the sloping floor and the hoists embedded underground. The hoists were dug up, and the floor was leveled, so the gym could fill the entire auto center. As I visit, I could make out the outlines of what were once garage doors on the wall of the gym. "These doors were once used by the cars being serviced," Blue tells me. The original cargo doors are still accessible from the rear, but the principal assures me that they will soon be forgotten: "When we reach critical mass, we will expand the structure back there. Our plans are to double the size of this building within the next five years of renovation."

Charter schools often choose a specialty for their curriculum that might not be a priority at the nearby public school. This school has an educational focus on technology and the emergence of the global village. The school has a particularly diverse student body, and the school hosts three powerful servers for its Web activity. The wiring for this technology is all above the drop ceiling, making it easily accessible for technicians. When you look above the drop ceiling, you see the entire expanse of the building, teeming with a mass of electronic cables wired for communication.

The center of the building will be the last portion of the space to be renovated. Eventually, the 30,000 square feet in the center of the building will turn into an auditorium. For now, it is the bare inner workings of a big box building, completely exposed. This section of the property is a vast, empty, raw big box, with struts and steel beams and wires and naked light bulbs. You can see clear to the roof in this future auditorium, about twenty-five feet overhead. The original ductwork has been replaced, but red trusses that have been there since the construction of the building still hang from the ceiling. Green tells me they did have to revamp the HVAC and electrical systems: "The building had electric heat and air. We had to bring in natural gas. We basically gutted the structure, and put new heating and cooling units on the top of the building." The exposed ceiling

in the future auditorium shows the workings of the extensive fire protection water system that came with the property, which Blue also cites as a positive aspect of the structure. There are shopping carts scattered throughout this room, which are still used by the school for carrying items around the building.

The plumbing is underground, buried under deep concrete, which initially posed a problem for the addition of bathrooms throughout the building. But ever since a trench was created, the addition of bathrooms has gone smoothly. Again, the school has been able to add the bathrooms one at a time, as they have become necessary, rather than all at once.

The exterior of the property has remained largely the same as it was during its life as a Kmart building. There is an ample parking lot in front, and the cargo doors in back are helpful for construction. But they will be closed for good eventually, as the school continues to renovate and develop. The parent development company has portioned off an area of the parking lot for the use of two other businesses, a daycare center and an occupational therapy center.

The school received its next five-year charter in the beginning of 2007, and it is poised to finally buy its building. What was once a rather speculative real estate investment for the development company has turned out to be worthwhile. "It was speculative in that buying a building for a start-up always has a bit of a risk involved," said Green. The school has survived the toughest part, and it now has a strong track record in the eyes of the education system. This is due primarily, he says, to the dynamic people who have built this school from scratch: "There has been some changeover in the people who are running the school, but the group that is there now has really taken the place to new heights." Green is glad to have been instrumental in the implementation of what has become a new public school in a downtrodden town in upstate New York. He tells me that 99 percent of the charter school's payments come from the public school district, and they have never been late on a payment.

Naturally, for him, the whole charter school project is really just all about the real estate. "Looks like they will take the real estate off our hands pretty soon. Would have been more lucrative for us if they'd leased it for another five years before buying the property. But as we always say with properties, easy come, easy go."

My next charter school was in Charlotte, North Carolina, in a renovated Kmart structure. Previously there had been no education facility in this neighborhood, a historically underprivileged district in the city of Charlotte. "When we began searching for a building in which to house our school, we were at a loss. We had little money and we were not

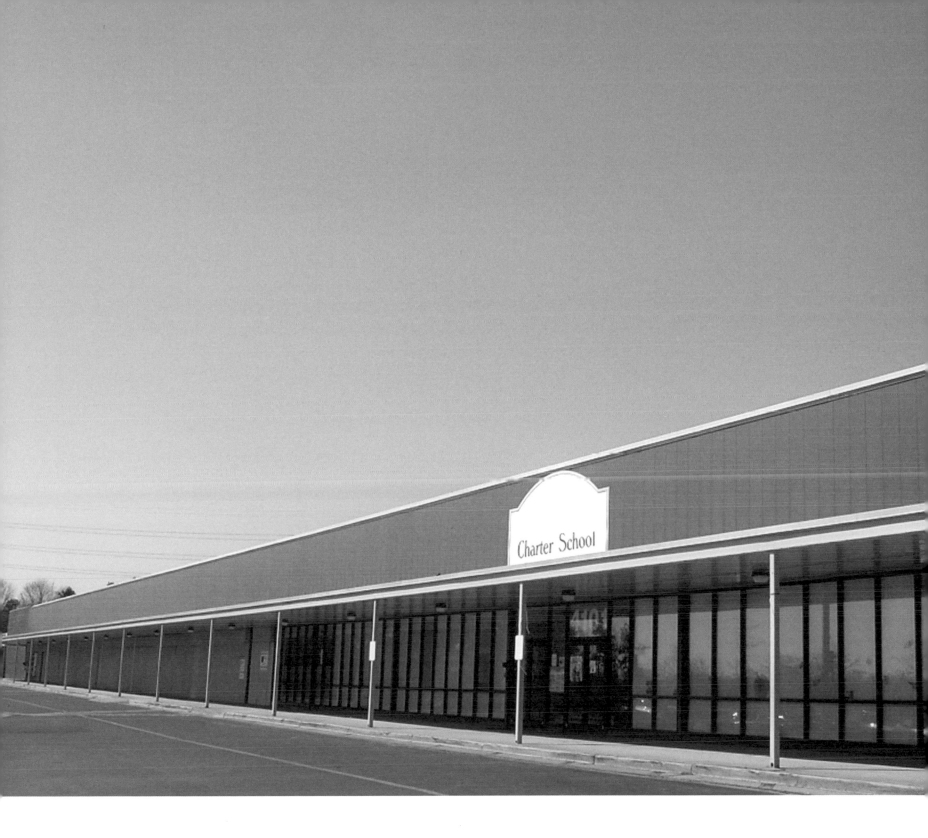

4.9 Charter school in renovated Kmart building.

sure where the endeavor was leading us, but we had strong support from the community and our school board was dedicated. We operated for a time out of the local recreation center before we were able to secure the lease on this big box. This building was the final piece that we needed in order to make our charter a reality," says Principal Red at the charter school in Charlotte. The building definitely looks like an abandoned Kmart building from the exterior, and upon my visit, the façade still featured a bright blue awning, a cement porch stretched the length of the structure, and a gigantic parking lot flanked the building.

The lot is chock full of cars, and in the morning when the students arrive, a stream of cars moves slowly around the lot for up to an hour, dropping off students one by one. "Our student body comes now from all over the city, so this parking lot serves the purpose of parking the cars and moving the children," explains Principal Red.

Therein lies a major networked aspect of the charter school phenomenon, which translates so directly to the use of big boxes for their implementation. The student body at a charter school is not based on geographic proximity, meaning that students may travel from a completely unrestricted geographic range in order to attend the public school. Traditional public school districts, conversely, draw their student populations from a specific geographic area, in order for the student body to align with its corresponding tax-paying district. As a result, the traditional public school system is made up of "neighborhood" schools, where students live within relatively close proximity to each other, and theoretically, their families do too. In this historical construct of the so-called nuclear family, neighborly relations could develop within the context of the local school. The construct of the family has shifted at this point in the United States, so it can no longer be assumed that the family has geographic cohesiveness. It is not surprising that in the twenty-first century, relations emerge from new networks, and educational facilities are also changing form.

The student body at a charter school is, by its very nature, a dispersed community. It is as if the dispersed nature of our electronic culture, our automobile culture, our suburban culture, has been transferred to a new typology of education where the student body no longer needs to live next door to one another. The range of the effects of this scenario is far-reaching and encompassing, affecting social issues beyond the realm of education. It is a change in the way children form social networks, with student bodies based on common bond that has nothing to do with a shared neighborhood, a shared basketball hoop, or a shared cul de sac. Do students see each other less, and do parents have less interaction with each other? Red says, "Since we have students who travel here from

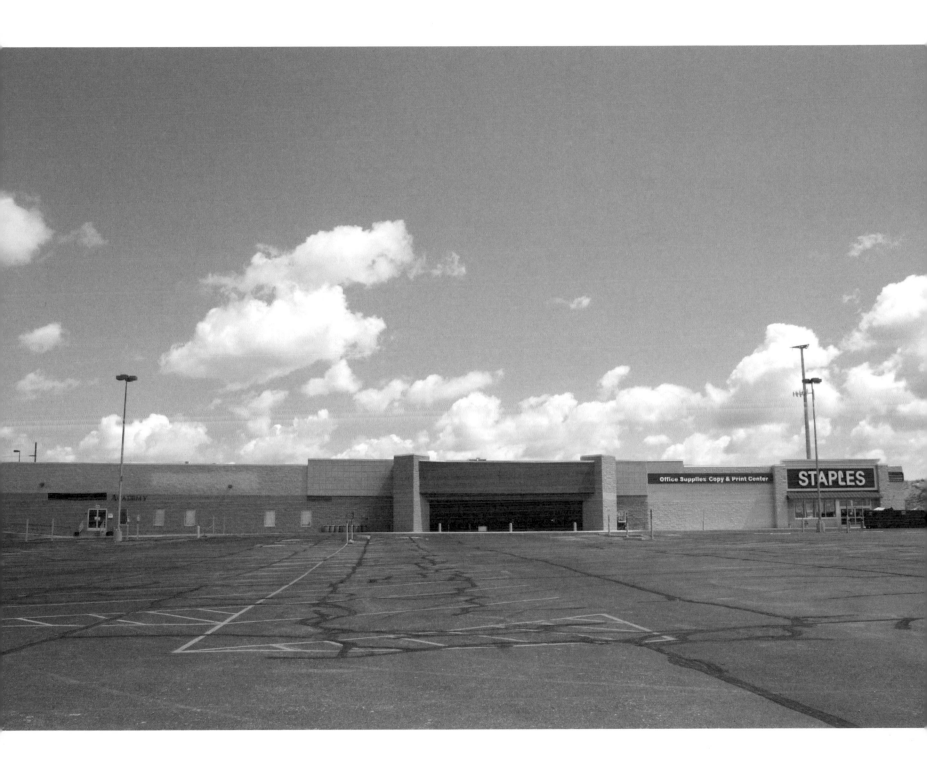

4.10 The charter school and a Staples store sharing a renovated Wal-Mart building.

such varied distances, we offer extensive before- and after-school activities. Our school necessitates many volunteers too, so parents are here a lot before and after school as well. Because of the building's location, it has become very central to our community." This building is the hub of the network, the server for the broadband of automobiles that stream into the lot day in and day out.

The wide hallways in the school building run clear from the front of the building to the back, reminding me of the aisles that existed here before they were halls for a school building. The electrical structure of the building is the same as it was in its time as a Kmart store, so the electrical structure of the hallways runs right along the previous aisles. Two major hallways run along either side, and the block in the middle is used for classroom space. On either side, running along the perimeter of the building, is more space for classrooms and a library. Skylights line the hallways.

When I visited this charter school in Charlotte in 2002, however, it was using only about a third of the space within the walls of the Kmart building. On the eastern side of the building, the long hallway had alcoves with two doors built into the side that lined the inside of building, which led to the school's library. On the other side of the hallway were matching alcoves, but they had no doors inside them. The principal leads me to the area behind this wall, and there, 30,000 square feet of empty space stared back at me. This space is filled with storage, lit by two flood lamps with boxes and basketball hoops casting a million shadows over the walls. And then the reality of the scenario strikes, as Principal Red said to me, "Look at all the hope in this room. This is a cafeteria, this is a school gym." In this actuality a group of people had created a school from scratch, in a part of town that had never hosted its own school before. This building was the manifestation of hope, and the principal clearly cherished this progress.

I have visited a third charter school three times, but I have never talked to anyone on the premises. They have never answered an email or a phone call, and each of my trips there has been during the summer, when summer vacation was in full swing, so nobody was present. But each summer I would drive right by it on my cross-country research excursions, so I would swing by. It sits just outside of Laramie, Wyoming. I have seen its exterior evolution over the years, noting the updates with each visit.

The school is clearly in an abandoned Wal-Mart building, the stripe around the rim at the top of the building is still in place, although it is pink now, rather than the original Wal-Mart blue. I have seen this pink stripe on abandoned Wal-Mart stores in other locations too. Perhaps when you look down at the Earth from above, you can tell the difference between the functioning blue-striped buildings and the nonfunctioning pink-

striped buildings, a code for extraterrestrials or hovering surveillance cameras. My first visit to the building showed new signage in front, as if the school had just moved in to the structure. My second visit back showed the addition of a playground, and more signage in the lot. The third visit showed the most remarkable update: the school building was now being shared with a Staples store, the national office supply chain. It is so disappointing that I have never been able to ask what the relationship is between the school and the store.

But it makes sense for a retailer to use space in the store alongside the school; after all, the network of big boxes is meant for retail. In a location this rural, the accessibility of the structure for retail is clear, especially considering the obvious investment in infrastructure that surrounds the building—two highway exits, a surprising expansion of the highway in this rural region, a wash of hotels and gas stations lining the highway.

And of course a new, huge Super Wal-Mart sits just across the street, glowing in the dry, hot dusk of the Wyoming evening. Standing on the side of the highway, having a distinctly Wyoming moment, with hot gravel sneaking into my sandals and the dusty dry wind blowing my hair into my eyes, I think to myself: this same glow is emanating from Wal-Mart buildings all over the country, in suburbs and in cities and in little towns, probably even from the same brand of light bulb. Here I am, experiencing the summer wind and cool heat of Wyoming, witnessing a node in this system of homogenous buildings, simultaneously glowing from coast to coast. And behind me, on the other side of the highway, sits a school that has adapted a node from this same network into a brand new framework.

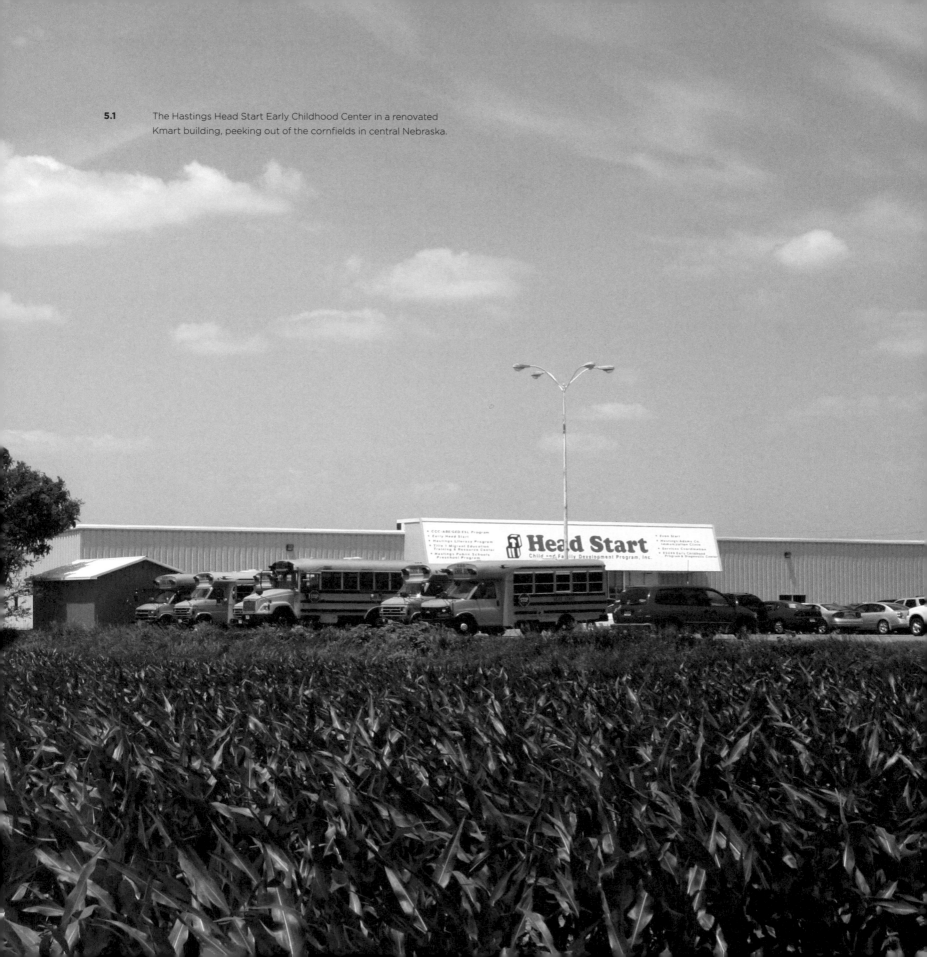

5.1 The Hastings Head Start Early Childhood Center in a renovated Kmart building, peeking out of the cornfields in central Nebraska.

THE HEAD START EARLY CHILDHOOD CENTER

REUSED KMART BUILDING
HASTINGS, NEBRASKA

The horizon in central Nebraska is a stark straight line that stretches tightly east to west, north to south. Sky and land as vast as these on the prairies of Nebraska vibrate with the static of endurance. I am struck by the fixedness of the floor and ceiling of this prairie; the land appears to be sitting as it has been for centuries, and the sky really has no place to go. The stability of the sky and the land magnifies the temporality of the primary forces between them: weather and transport.

The plains of Nebraska deflect weather right back up to the sky, causing just the right wind and humidity to activate Nebraska's annual plethora of tornadoes. Two of the top ten most economically disastrous tornadoes in United States history have happened in Nebraska: number eight—$260 million—in Grand Island, thirty miles north of Hastings, and number one—$1.1 billion—in Omaha, just two hundred miles to the east. According to the University of Nebraska at Lincoln's High Plains Regional Climate Center, in 1999 the plains of Nebraska were home to over one hundred tornadoes. This was the first year in history that the tornado count broke one hundred in Nebraska. Since then, the count has continued to dance around the one hundred mark, with one hundred ten tornadoes touching ground in 2004. In 1950, six tornadoes were reported in the state of Nebraska.

I have driven twice to Hastings, in south central Nebraska (population 24,064 in the 2000 census), to visit the Head Start Early Childhood Center. Head Start is a program of United States Department of Health and Human Services that provides education, nutrition, and health care to millions of low-income children in America. The Head Start in Hastings is one of 1,600 program locations in the United States and serves 1,200 children who live in central Nebraska. In Hastings, I met with teachers from this publicly funded

institution that provides care and education for young children, and learned how the operation has changed locally in recent years.

The U.S. Census 2000 showed that between 1990 and 2000, Hastings had a 401 percent increase in its Hispanic population, and the wave of immigration has not slowed down since then.[1] My visits to Hastings have been a striking reminder of how globalization affects even the deepest corners of rural America. In the global marketplace, ultimately, not only products but also humans cross borders, entering new lands for livelihood. The lines between countries blur amid movement, transport. Ships and cars rub out boundaries like pencils erasing pencil lines, as governments dig for means to redraw an invisible line. The conceptual definition of a border reemerges as a reality.

The Head Start in Hastings currently operates out of a vacated Kmart building. The Kmart building was once the local big box destination for hundreds of thousands of those products that had made that networked trip around the world to land on the shelves. Today, those shelves have been replaced with classrooms. Hundreds of the students have recently relocated with their families to Hastings, from Mexico.

The Hastings branch of the operation was previously housed in a renovated hardware store on the east end of town. The roof of that building was ripped off with one breath of a Nebraskan wind on August 18, 1998. Hastings, Nebraska (latitude: 40.586N, longitude 98.388W) is 117 percent more likely than the national average to have a tornado hit. As the Head Start's roof set sail, thrashing out over the asphalt, sprinklers were set off, filling the building with eight inches of water. The structure was unsalvageable. School started on September 1.

The Head Start scrambled to find locations throughout the city in which to set up satellite classrooms, so it could ready itself for the school's anticipated start date in two weeks. The center formed makeshift classrooms in church basements, unused portions of existing school buildings, and gymnasiums in the town recreation center. This is the way it continued to operate for several years, scattered across the city, with no centrality, no home. The community in Hastings adjusted itself to accommodate the Head Start. Space was offered to meet the institution's needs.

At the same time, Hastings was beginning to see what would grow to be a drastic change in its local population. In 2007, Deb Ross, executive director of the Head Start Child and Family Development Program in Hastings, told me that since the 1990s the increase in the operation's services to Hispanic children has grown by almost 1,000 percent. Central Nebraska's ever-expanding meatpacking industry attracts Hispanic migrants to Hastings.

This is not the first time there has been a mass migration to central Nebraska. Although this part of the country does not border another country, or even a body of water that borders another country, Nebraska is at the center of the United States, and the central plains are a location of endless movement. Nebraska's agriculture has attracted migrants for centuries, since seasonal work is always available here. Bison-hunting Native Americans traversed these plains for centuries, following herds and escaping weather; in the 1700s and 1800s Euro-American pioneers and explorers blazed through this land, some claiming territories laid out by the Homestead Act, signed into law in 1862; in the early 1900s, waves of German immigrants came to central Nebraska, initially drawn by the agricultural and beer-brewing industries, and eventually making up a substantial percentage of the Nebraskan population.

The land of the former Blaine Naval Ammunition Depot begins just two miles east of Hastings. Blaine NAD, established on July 11, 1942, consisted of approximately 48,753 acres, and was used for the storage of ammunition during wartime. Today, the Hastings Training Site, Nebraska's primary armor and range training site, uses 3,211 acres of this land. Approximately 35,000 acres of this land are now controlled by the United States Department of Agriculture. In 1964, this land was designated as the Roman L. Hruska Meat Animal Research Center (MARC), where, according to the MARC website, research regarding "Animal Health," "Environmental Management," and "Genetics and Breeding" takes place.[2]

Nebraska ranks second among the United States in cattle production, and Hastings is home to several of the nation's largest food processing and packing plants. This includes ConAgra Foods, located in nearby Omaha, which produces forty-one major brands of food (including Chef Boyardee, Healthy Choice, Reddi-Wip, Slim Jim, Swiss Miss, Parkay, PAM cooking spray, Libby's, and La Choy). According to the Head Start Child and Family Development Program (HSCFDP) Community Assessment of 2005, migrant workers are largely responsible for the cultivation of fruits, vegetables, and animal food products that are produced in the state of Nebraska.

Globalization is not only contributing to the movement and transport of new populations to coastal American cities but also driving immigrants to areas where population is sparse. Nebraska had the second-highest increase of Hispanic immigrants from prekindergarten to eighth grade in the 1990s.[3] After a year of operating out of church basements and recreation centers, the Head Start reached a critical mass. The Early Childhood Center in Hastings had to flex its services and expand its operation to properly serve its new student body, the town's changing demographic. And in doing so, the first matter of business was buying a larger building out of which to operate.

Since 1992, the Kmart building on the corner of 2nd Avenue and Marion had been vacant. There was one person in town who maintained a keen interest in the lot: Deb Ross, who also acts as principal of the Head Start school. Ross contacted Kmart in 1992 to inquire about the possibility of renting the space, long before the Hastings Head Start had been rendered homeless by the storm. The Kmart Corporation quoted her a rate of $117,000 a month. At the time, people in Hastings were renting storefronts for a few hundred dollars a month and buying single-family homes for $30,000. $117,000 a month was extraordinary, even for the 40,000 square feet of space. The price was an insurmountable obstacle for the Head Start, and the idea soon left Ross's mind. Years went by, and the building remained empty for an entire decade.

As Ross learned more about the technicalities of the Head Start program in the United States, she explored the variety of services that it was actually designed to fulfill. Head Start is a multifunctioning 501c3, so although it is generally thought of simply as a public preschool institution, it is actually able to apply for funding to cover a variety of community needs, including immunization, English-as-a-second-language training and implementation, and basic support for naturalization processes. By providing these services, the Head Start in Hastings could potentially become a powerful tool in the safe, legal, and swift immigration of families interested in relocating to the Hastings area.

Ross and her staff see this resettlement in a historical continuum, meaning that they are interested in the positive cultural impact this wave of immigration will have on their locality in the future. Many people in Hastings have family members who came from abroad in the last three generations, mostly people of European descent. Ross tells me stories of her own grandmother's arrival in Hastings from Germany when she was a girl, and how she was picked on for being different. The hope is, Ross says, that in the twenty-first century the population in Hastings—or at least the students at her school—will welcome people of varying backgrounds as a part of a more diverse community in the greater Hastings area. "In the future," she says, "Hastings will be home to populations of not only Germanic and Native American heritage but populations of Hispanic heritage as well." For this reason, the Hastings Head Start continued to expand the services it provides, initiating health and support programs for immigrants.

By 2000 governmental funding had been secured for a variety of services, and the student body began to surpass the capacity of church basements and empty rooms at the recreation center. The Head Start still owned the lot on the south side of town, the site of its first incarnation in the renovated hardware store prior to the storm. The lot was a prime piece of real estate on that side of town, a financial asset to the Head Start agency.

Meanwhile, the Kmart was still empty on the north end of town, and Ross decided to pursue her interest in the structure once again.

The lot that was home to the Kmart building was tied up in a real estate package too complicated for most interested layman buyers. The situation is typical of commercial real estate, but to Ross and most other Hastings residents it was nearly indecipherable. Three major contractual stipulations on the property existed:

1. A commercial real estate company in California owned the building, along with several other big box buildings in the Midwest.
2. Kmart owned the lease on the building.
3. The land was owned by a local man in Hastings, who had purchased the five acres using an educational trust fund left to him by his parents.

Right this minute, thousands of big box buildings sit empty across the United States, their vacancy perpetuated by nonlocal entities exchanging money, as rent flies from state to state. Ultimately, localities are faced with an abandoned building that the owner has never seen. In the Hastings scenario, checks went from Kmart to the real estate company in California; checks came from California to the landowner in Nebraska. The local man was not financially unhappy with this situation, nor was the investment group thousands of miles away in Los Angeles. Kmart was the entity with the power to break the chain, but its investment in the empty space kept competition from moving on to the lot.

Johnson Imperial Homes is a Hastings real estate company established in the 1930s. The company expanded into new offices in 2000, building a high-class strip mall filled with office space on 2nd Avenue, directly across the street from the empty Kmart building. The company was attracted to the corner for the same reasons that Kmart had been in the early 1990s: its central location and its accessibility from the highway and from the rural routes countywide. Sitting in their offices and looking out their north-facing windows, the real estate agents faced an empty big box. These real estate agents pondered the box, they questioned the box, and, together, they feared the box.

One fear was that it would remain empty forever. Another fear was that the building would be purchased by a company that cared even less about its use than the current owner(s) did. Johnson Imperial Homes eventually realized, though, that it had the capacity to deal with the property. The company knew the local owner of the land, and it obviously had real estate experience. Johnson Imperial Homes had the expertise to deal with all aspects of purchasing the entire property. Because of its geographic proximity to

the building, Johnson Imperial Homes felt a benevolent responsibility to the community of Hastings to make sure that something positive happened to that building. The property value of its own office space was at stake, and for its own sake—and the sake of the town, who had been facing that empty building for a decade—the company wanted to attract a user who would stay in the building for a long time.

In late 2000, when Johnson Imperial Homes decided to buy the building, the company put thirty-five-year real estate veteran Bob Finningsmier on the case. Finningsmier began the purchasing process with the local man involved in the real estate quagmire, the man who owned the land as part of an educational trust. He agreed to sell the land to Johnson Imperial Homes. Next Finningsmier made the necessary arrangements to have the lease of the building transferred from Kmart. The final step was for Johnson Imperial Homes to buy the building from the real estate company in California.

The company never intended to use the building itself but to sell the building to a new user—in essence, "flipping" a big box. Johnson Imperial Homes hoped for a community-based agency, something that would not cause heavy traffic, and something that would not go out of business anytime soon—which would signify a return to the vacant big box scenario. When Ross contacted Finningsmier about the property, things began to fall into place. Ross knew her numbers. She had calculated exactly what the Head Start could spend to obtain the building and told Finningsmier exactly what the Head Start wanted— a building in "turn-key" condition, meaning that Johnson Imperial Homes would include all renovations of the lot in the selling price. The Head Start offered $1.4 million, in addition to the land on the east side of town that housed the original hardware-store-turned-Head Start building.

A deal was drawn up within three months. Ross signed the contract in March 2001. The Kmart building officially became the new home of the Head Start in Hastings, Nebraska, and the first day of school in the old Kmart building was in September of that year.

The Head Start building now sits at the very intersection that Kmart had deemed most lucrative two decades before. As an education center, the placement of the building is crucial, because the Hastings Head Start serves a population from five counties. In every big box reuse that I have visited, the location is always cited as the most attractive factor of these buildings, right at the center of transport.

Because of the reuse at this site, "the [Hastings] Head Start," in the words of Ross, "is able to function as it is supposed to."

"The receptionist is sitting right where we used to purchase our shoes," jokes an employee at the Head Start. The hallways run the length of the aisles, from the front of the

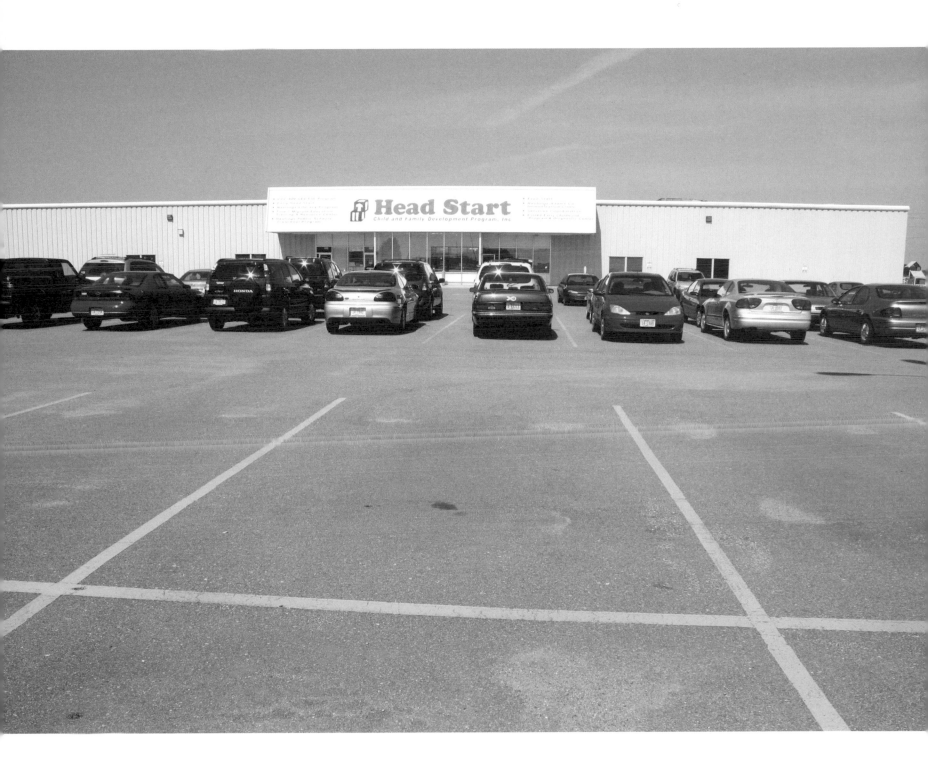

5.2 The exterior of the Hastings Head Start Early Childhood Center, in a renovated Kmart building.

5.3 Classroom decorated for learning about the cultures represented
by the student body and faculty.

building to the back. "My classroom is in the jewelry section," one teacher tells me. Everyone used to shop here, and they remember the building in its first life. There is joy in the eyes of these employees, as they explain to me their creative process, reimagining this space. There is a connection between the building's past life and its current life. Certain zones of the big box store are homogenous—shared across sites, from building to building. The jewelry section has no variance from place to place, so it becomes a collective zone, a jewelry section distributed across the nation. "Teaching in the jewelry section" connects that teacher and that classroom to the thousands of big box jewelry sections just like it. How do the students relate to this zone, especially the students who have recently moved to the United States? Does the presence of the old store play into their thoughts, or the origin of the absent jewelry that made a trip across the border to get to this room?

Shopping carts are scattered throughout the building, leftovers from the building's past life; they are used to cart paperwork and toys from room to room. Staff members joke about meeting for lunch in the dressing rooms, as they eat in a cafeteria that was once where they tried on clothes at Kmart. There used to be a blue light—left over from of Kmart's "blue light special" marketing campaign—in the school's storage room. It was never used, then it was misplaced, and eventually it disappeared without a trace.

Students walk past unused cargo docks on the playground, once used to unload consumer goods that traveled from across borders, right past the cornfield that surrounds the building, and into the building where this diverse student body attends classes. This local product of Hastings, corn, surrounds the old Kmart building, and the Head Start has developed a curriculum that involves this cornfield. The students draw pictures of the corn at different points in the season, studying its growth and the methods of the farmers whose corn borders the Head Start property. The Head Start is immersing students in the local produce, corn, which will probably be processed and shipped out around the world, from these cornfields on the Great Plains.

The physical renovation of the building involved navigating International Building Codes, the electrical, plumbing, and fire protection specifications for the educational repurposing of a structure in Hastings. No architects were involved in the renovation. Instead, Johnson Imperial Homes' internal engineers drew up plans for the space, with the direct assistance of Ross. She made the design sketches herself and presented them to Finningsmier. Johnson Imperial Homes implemented her designs.

The building began with 40,000 square feet of space, all open except for the garage and auto area. The auto center had a sloped floor, as is generally true of the auto centers

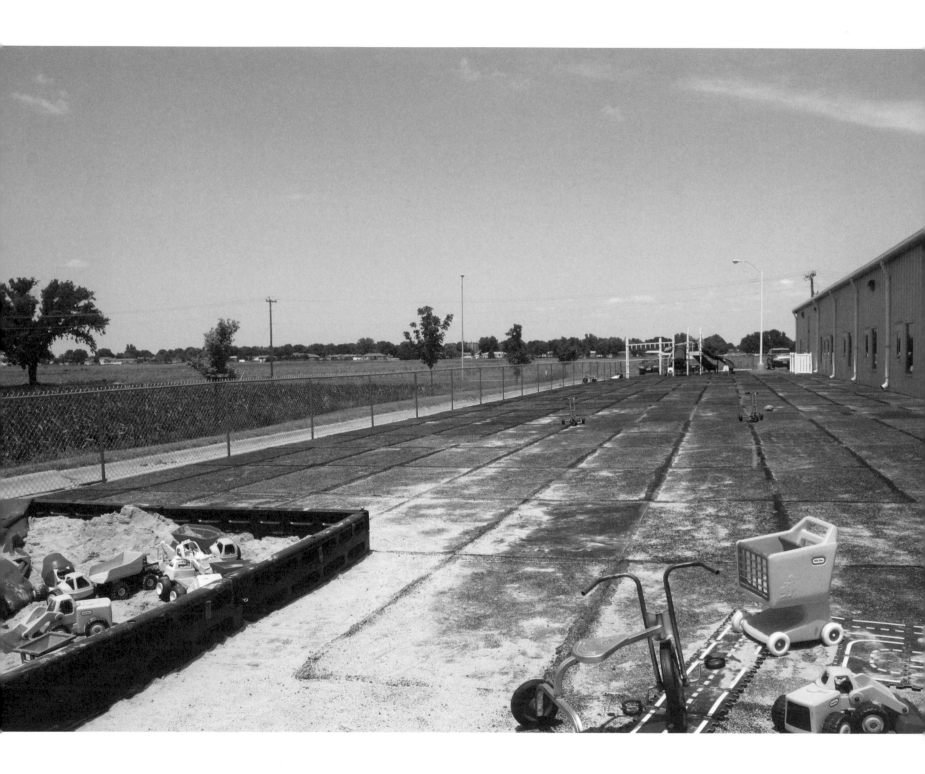

5.4 Rear of the exterior near Kmart's cargo bay, used as a playground. The use of this space allows students to interact with the cornfield.

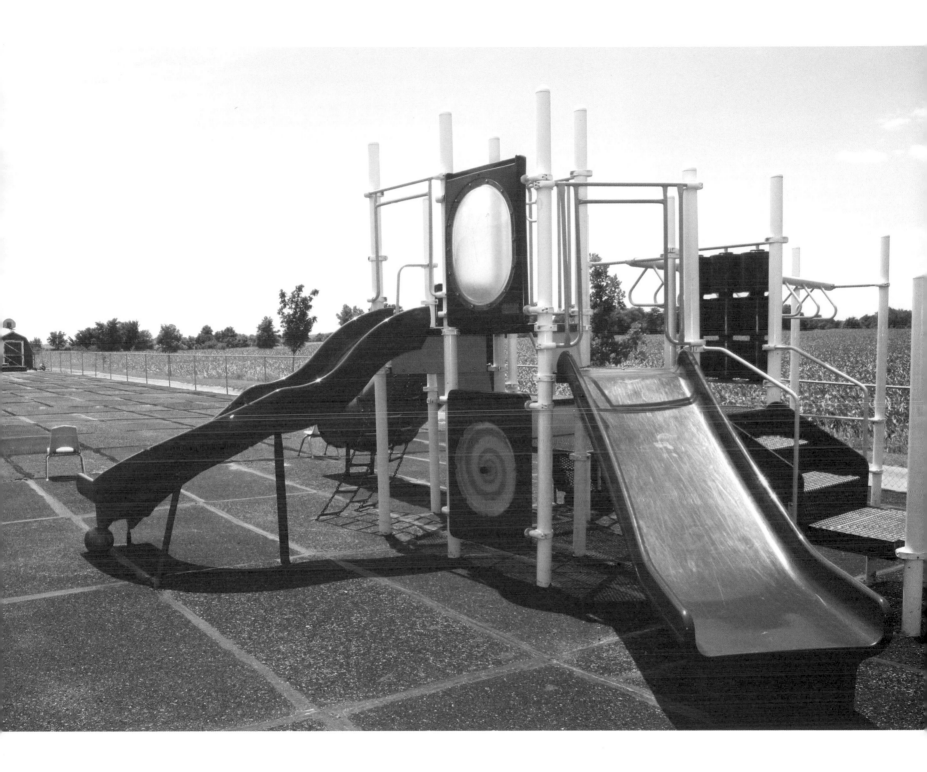

5.5 Playground on what was once Kmart's cargo dock.

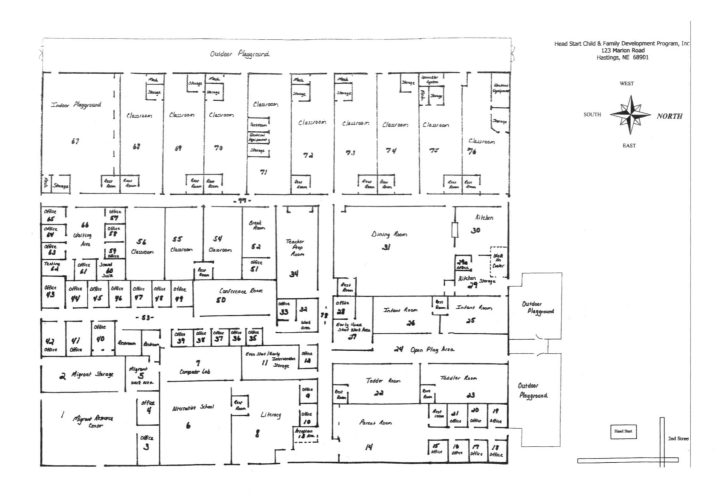

5.6 The building plan, as drawn by Executive Director Deb Ross. Courtesy of the Head Start Early Childhood Center, Hastings.

in all Kmart structures. The sloped floor allowed for easy cleanup of the oil and debris from the auto center when it was active. Contractors had to dig up the six hoists embedded in the ground before the floor could be leveled out to match the level of the rest of the building.

The original electrical structure of the building was left in place. Sprinkler systems were updated throughout the building. The renovation included the addition of nineteen bathrooms, so it is not surprising that plumbing was cited as the biggest challenge in this reuse. The original plumbing was embedded beneath the structure, and the system had to be expanded to provide the number of bathrooms the school needed. The school has about twenty classrooms and four meeting rooms, as well as office and storage space.

Additional spaces in the structure are rented out to agencies that blend well with the Head Start program. The Head Start rents extra space in the structure to the Hastings Public Schools and Educational Services for a cost of $3.50 a square foot. This price includes the use of the receptionist at the front desk plus all utilities. The geographic consolidation of these school-related entities has allowed the educational facilities of Hastings to gain new levels of interdepartmental communication, since they are all now under one roof. This building was once used to house the monolithic franchise of a Kmart. Now the building is home to a multilayered conglomeration of agencies that blend well together, reinforcing the word "center" in the institution's title.

The Hastings Head Start has not felt the need to invest deeply in the exterior of the building, so renovation of the façade has been minimal. The parking lot continues to function appropriately, to store parked cars. The streetlights throughout the parking lot were a considerable benefit for the Head Start and were taken into account when Ross inquired about the building and its going price. Streetlights are mandatory in the parking lots of public schools in Nebraska and can add a hefty cost to the repurposing of large buildings.

The Head Start makes monthly mortgage payments of $35,000. "We can easily use the building for another thirty or forty years," says Ross. Expansion will probably take place by 2010. Ross contends the parking lot offers room for expansion, a bank of more space for when it is needed. The three or four rows for parking furthest from the building are rarely used. Patrons usually park closest to the structure, and the entire parking lot is simply not needed for Head Start's purposes. Roughly 27,000 square feet can be added right off the front of the building and on to the first few rows of parking, with adequate parking space remaining intact.

As of 2006, the Head Start Center at Marian and 2nd Street in Hastings, Nebraska, serves a total of 1,200 children from Adams, Clay, Franklin, Hall, Nuckolls, and Webster counties. The Hastings Head Start has over two hundred full-time employees and offers twenty-three programs, including Even Start English as a Second Language classes, Head Start Early Childhood Education, Hastings Literacy Program, Hastings Public Pre-School, Hispanic Mother's Support Group, Infant Toddler Initiative, Johnson & Johnson/UCLA/Head Start Health and Dental Initiative, Migrant Education Training and Resource Center, State Migrant Tracking Program, Region 9 Preschool Interagency Council and Training Initiative, and Title One Migrant Education. To be eligible for Title One, the student must have crossed the border of a country within the last year, and their parents must be working, or looking for work, in the realm of agriculture, fishing, or meat processing.

According to the Head Start's 2005 Community Assessment, the Title One Migrant Program facilitated by the Head Start in Hastings serves five hundred migrant students. The numbers have not stopped growing since then.

This is clearly not just an early childhood center as its title suggests. It is also a center for immigration, for socialization, for childcare, for education, and for health care, serving people from an extensive geographic range. It is remarkable that this center has found its point of gravity in this rural location, in what was once considered the "outskirts of town." This center relies heavily on the network that Kmart had identified years before, the network of roads and highways that so easily lead to this spot. Perhaps because the Head Start clientele is a dispersed community, with people driving in from all over, big box centrality allows the building to remain accessible from all points surrounding it. This new civic center has been located within the network of rural roads that lead to the highway—the highway that leads to the border of this country.

The disastrous weather event that forced Head Start out of its original home has led the institution to reinvent itself as bigger and better. "Only something as powerful as a storm can bring about this kind of change," Ross tells me.

5.7 Hallway.

PART III

DESIGN

In 1972, Robert Venturi, Denise Scott Brown, and Steven Izenour introduced the idea of the "duck" and the "decorated shed" in the seminal work *Learning from Las Vegas*.[1] The duck is a building whose use is directly related to its form (the typology is named after a building on Long Island that is shaped like a duck, out of which a poultry store sells meat). The decorated shed is a building whose form does not directly relate to its use, without the help of contextualizing factors like a sign, or a decoration.

The introduction of the big box to the urban landscape turns this dichotomy on its head. It seems that the big box store is the classic decorated shed, both literally and figuratively, since it is in fact a shed with interchangeable signs that could very well host most any activity, as we have seen throughout the course of this book. However, at this point, a big box is also a duck. The decorated-big-box-shed has collected a context, the building itself now stands for an activity—shopping. The big box is a cultural symbol; it is a duck. Although it is entirely possible, moving a church, say, into a big box store is almost as surprising as moving a church into a building shaped like a duck.

The big box is a corporate, plain, cheaply made "duck" of a shed, decorated momentarily with its retailer's sign. Big box structures are ephemeral in their usage, and their aesthetic is designed to convey temporality. Big box buildings exist in our attention's blind spot and also in the blind spot of memory. "When was this building constructed?" and "How long has this building been here empty in the middle of your town?" are questions I must have asked three hundred times in the last few years. And usually the reply is, "I don't know. I can't remember when it was built. I can't remember when it was vacated." Despite its sheer hulk and centrality, people apparently do not notice big box buildings in their direct line of attention or memory. Perhaps the designers of big box buildings hope that the featureless structures will just fade into the landscape, so that communities will not express concern over their appearance or their vacancy. These buildings seem to go unnoticed possibly because people are so enamored with the actual activity that takes place in the building—shopping—that the structure itself becomes irrelevant. Or maybe the primary concern of the building's visitor is actually the travel that it takes to get inside—in other words, the user is more concerned with driving to and parking at the store than actually interacting with the building, deeming the *infrastructure* more important at this point than the human connection with the *building* itself. As communities adapt this infrastructure into their civic lives, we must not forget that this is an infrastructure designed for retail, and our future navigations upon the land will be in circuits developed for shopping. This adoption of corporate infrastructure seems also to be happening on a level beyond our frame of critical awareness.

The big box retailer takes great care to impart the notion that no money was spent on the construction of their store in the area of design. The lack of accoutrements, which leads to a misconception of a lack of design, is indeed a very conscious decision, meant to advertise the point of the big box's existence: a place to shop. This is a decorated duck-shed with a mission.

How do we begin to consider the design issues presented by reusing an empty big box building? People I've met throughout my research have expressed a myriad of cultural problems with deciding to renovate a big box building. The primary objection is that the site is culturally toxic; it was probably imposed upon the town with such corporate voracity that they question whether the building should even be there in the first place, causing them to ask: why should the public spend time and energy thinking about its reuse? I have even met architects who have renovated a big box building, made it into a successful community center or museum or library, perhaps even won an award for their feat. And even then they admitted feeling conflicted about what they had done. They would talk to me with great pride and fervor about the reuse process, and then ask me not to reveal their name in the book. They would ask themselves whether it was acceptable to have moved a community center into the structure. The building looks great, the community has embraced the new use of the structure and is proud of the renovation, and the town has rid itself of a hole that was left in their urban fabric. But still they would question the process, question the effectiveness of transferring the big box's power to their own design—is that a power they want incorporated into their civic life?

Regardless of these social and cultural constraints, the reuse of big box buildings is happening. It is happening all over the country, and even if we close our eyes and sing loudly to drown out the noise, when we open our eyes we will see it: schools, hospitals, churches, museums, all in big boxes, all across the country. It is happening without documentation or collective, systematic thought. By opening up dialogue about this massive transition, we gain the potential of directing land use codes, zoning commissions, and municipalities to make informed decisions about the future design of our built landscape.

Currently, the only way we can learn about how people reuse big box buildings is to go right to the site and gather stories from the renovators. As the authors of *Learning from Las Vegas* put it, "Learning from the landscape is a way of being revolutionary for an architect."[2] It is also a way of being revolutionary for an artist, or a city council member, or a government official. To learn about the phenomenon of big box reuse, we literally need to look to the ground and ask questions about what we see, in order to garner how it is

playing out. Sometimes the scientific verb "ground-truth" is the most accurate word to describe this process, as in, "This is a situation where we are just going to have to go and ground-truth." The compound word reminds us that sometimes the "truth" is actually specific to the very "ground" upon which it is manifested, so there is no way to find it but to go there and explore for ourselves. Within our increasingly networked existence, ground-truthing becomes more imperative, so that we may confirm that what we've read online, for instance, is in fact "true."

And the truth on the ground is illuminating. In part III we look at how three entities—a museum, a library, and a church—have considered design issues within the big box building. What about the interiors, what about the insides? Reprogramming a space as loaded as a big box makes every move seem monumental. Each design move is like observing someone taking a step on the horizon of the desert, a movement so small, and yet it appears glacial to the observer in such a vast, sparse space. Each decision is deliberate, and each decision is crucial.

And yet each of these critical decisions is juxtaposed with the freedom and empowerment of renovating a "low-brow" building. It is interesting to see what people have done with the place. As Stuart Brand asks in his discussion about the "low-road" in *How Buildings Learn,* "What do people do to buildings when they can do almost anything they want?"[3] We have established the perpetual feedback loop between design and community: design informs activity, activity informs design, redesign further informs community, and so forth. It is clear that the big box retailers have designed their own built environment for the specific function of delivering the bargain, in highly accessible locations for automobile-wielding shoppers. When a community reuses a big box building, the people remain connected to the building they once knew as shoppers, but the connection takes on a new form. The community's culture has been affected by the big box—while it was in operation—so how does this affected community reconnect to the structure? How do people alter the building through their design decisions, after their community has been altered by the big box corporation's initial design decisions?

All three of the reuse case studies in part III exhibit strains of the past, present, and future. A museum, a library, and a church, are all significant American vessels that are meant to conceptually archive the past, display it for the present, and preserve it for the future. The stories that follow speak to the resourcefulness of humankind, and they show that when given an empty big box and a mission that they care about, people will find ways to use the space. These reuses are all seen as creative and resourceful in the

towns in which they took place, and the renovators and townspeople claim that they changed the towns for the better.

The question lingers regarding our identity as a larger community. Is this the building typology that we want our future museums, churches, and libraries to operate out of? The power of the successful renovations that follow is that they offer us a glimpse into the future, as we are faced with what we want our future landscape to look like. Despite the effective intervention into their existing built landscapes completed by these renovators, the real question is perhaps about how to alter the mass construction of big box buildings and their infrastructure now, so that we are not faced with the mass challenge of big box reuse in the future—resulting in a creative and resourceful landscape of renovated Wal-Mart and Kmart stores.

The next three chapters focus on design issues. This does not mean, however, that the former chapters didn't deal with design issues as well, and by all means, you can reread those stories too with thoughts of design in mind. The talented designers of the Centralia Senior Resource Center in Wisconsin Rapids thought deeply about the design of their structure. The schools visited in part II of the book have used and absorbed design to shape the education of children. I hope such thoughts will accompany you through the rest of the book.

Ultimately, of course, the hope is that you will think about these imperative design issues when you are not reading at all.

In fact, put the book down.

Go outside, and consider the ground that surrounds you.

Consider your ground's truth.

And then, proceed.

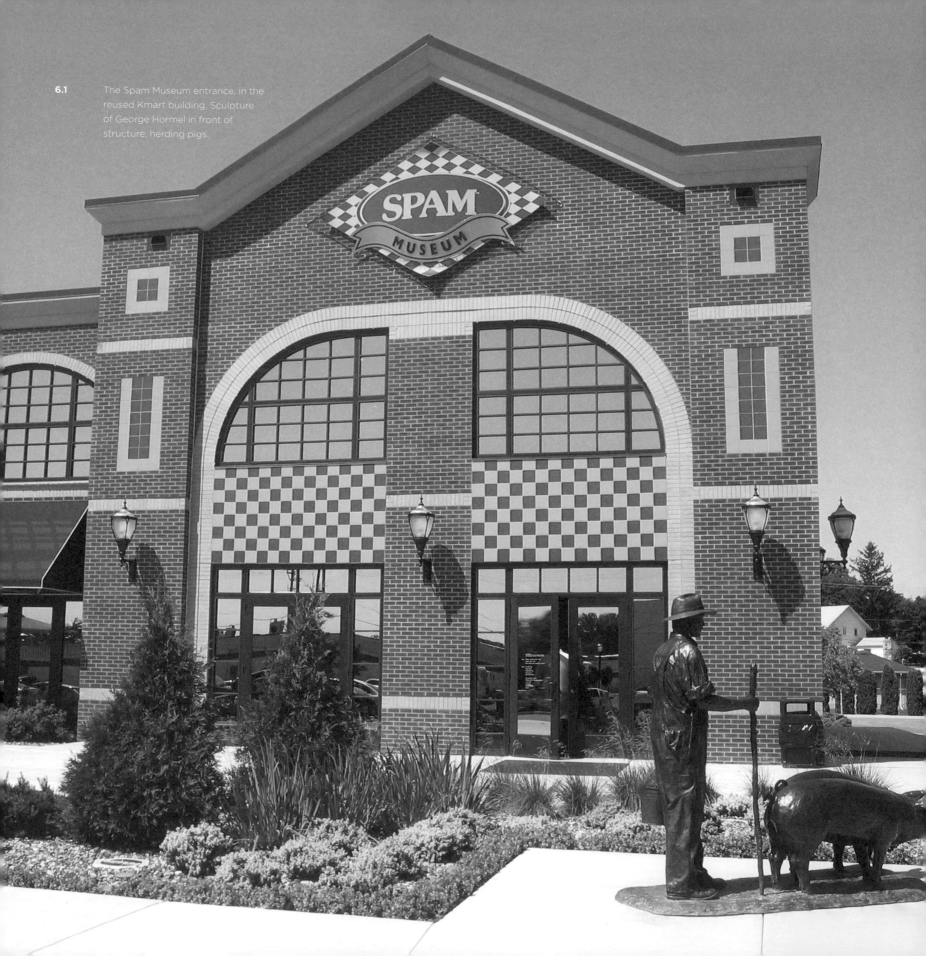

THE SPAM MUSEUM

6

REUSED KMART BUILDING
AUSTIN, MINNESOTA

The Hormel Foods Corporation announced a compelling design competition, and Paulsen Architects of Mankato, Minnesota, was thrilled when the firm was asked to submit a proposal. The Hormel Foods Corporation, maker of meat products—most notably Spam—had purchased a Kmart structure that had been built in the early 1970s in downtown Austin, Minnesota, home of the company's enterprise. Kmart had moved out of the building in 1990 and relocated to the outskirts of town, where the retailer expanded their patronage, drawing more customers from surrounding areas. When Kmart moved, so did the surrounding businesses. A grocery store across the street vacated the area, as did supporting businesses nearby. The vacancy left a footprint two blocks long ghostly and barren for over a decade.

The design competition challenged four Minnesota architecture and design firms to create proposals for a museum and offices to be hosted at the barren site, with the winning design to be carried out at Hormel's expense. The existing Spam Museum was terribly outdated, since it sat largely unnoticed in an 800-square-foot retail space in a dwindling shopping mall. Hormel was expanding its market and business, and the addition of more office space had become crucial. In the design competition, half of the Kmart building would be used as a new corporate headquarters, and the other half would be used as a new and improved Spam Museum.

Hormel did not specify many instructions for the solicited proposals. It trusted the instincts of the four companies who were invited to take part in the competition, and it did not want to impose restrictions that would negatively affect the quality of the proposals. The form and format of the designs were not specified, nor was the programming

criteria for the space, therby leaving it up to the architecture firms to fully envision the site's activity and traffic. "Hormel knew they were taking a leap renovating that building, and they wanted to give creative freedom to the designers so that they could be sure to do it right," says Bryan Paulsen, principal architect at Paulsen Architects.

The new corporate headquarters would provide office space for two hundred employees, with room for expansion built into the space. The Spam Museum would be just what the name implies: an entire museum dedicated to the history of America's favorite mystery meat. Hormel's hope was that implementing a corporate history museum about the town's most famous manufactured product would draw tourists into the downtown area, which had the potential of enlivening the central business district (CBD). The location of the Kmart building offered easy access from the highway, as big box buildings generally do, making it an ideal site for a museum. All available green space in Austin for the construction of a new office building would have been much further out of town, miles from the existing campus. The Kmart site was within one mile of the existing Hormel campus, which was composed of the Hormel factory and the original offices. The large space of the Kmart building offered the opportunity for the addition of the museum at the site, so that the third arm of the Hormel presence would be within geographic proximity of the other two Hormel sites. By consolidating the offices, the factory, and the museum to all operate within a mile of each other, Hormel could make its presence even more visible, beyond the fact that it employed such a huge percentage of the town of Austin.

Paulsen Architects is a Leadership in Energy and Environmental Design (LEED) Accredited Professional firm. According to the United States Green Building Council, LEED certification is the "nationally accepted benchmark for the design, construction, and operation of high performance green buildings."[1] Paulsen's design for the competition naturally included environmental considerations, a compelling paradox to the existence of the building. The firm asked, how does one "green up" a big box? It also considered local heritage in terms of building design, and the firm was interested in retrofitting history into the building. Not only did Paulsen's proposal consider pedestrian-friendly planning, it actually integrated exercise and movement into the workplace. Paulsen Architects won this competition, and the firm's design for the Hormel Headquarters and Spam Museum stands today at 1937 Spam Boulevard, in Austin, Minnesota.

Pulling up to the site in my car, I am stunned by the thoroughness of the renovation. The resurfacing of the exterior is extensive. The parking lot has been softened by the addition of greenery and a wrought-iron fence surrounding the entire complex, and a guide

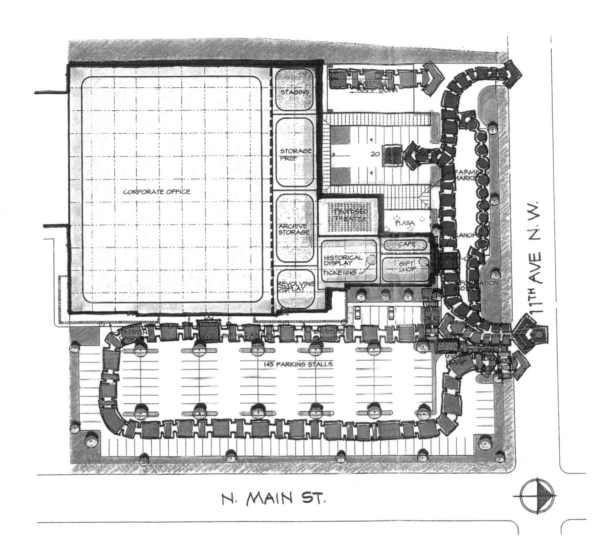

6.2 Preliminary circulation design plans for the Hormel Corporate South site. Courtesy of Paulsen Architects.

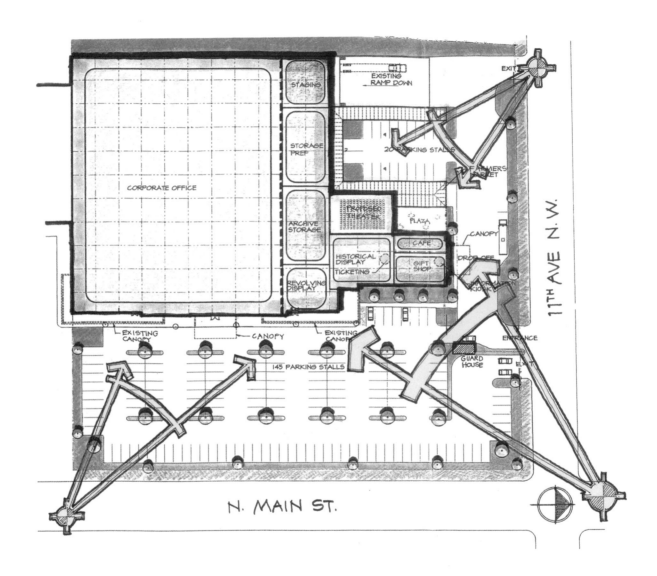

6.3 Preliminary circulation design plans for the Hormel Corporate South site.
Courtesy of Paulsen Architects.

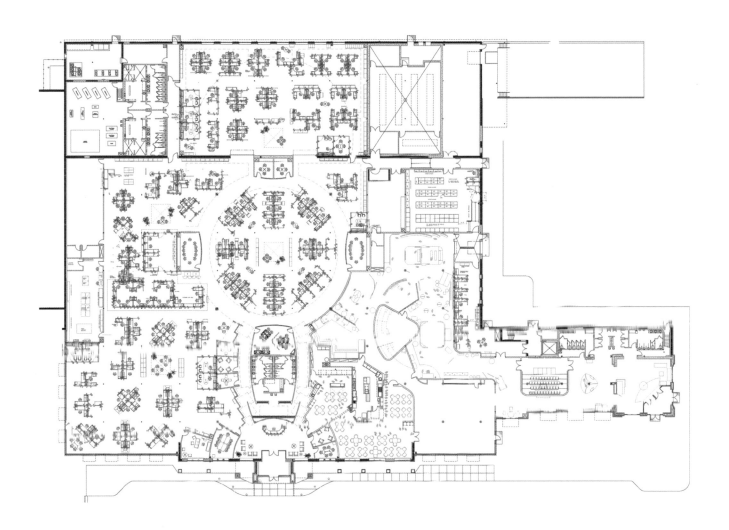

6.4 Paulson's building plan implemented on the site. Courtesy of Paulsen Architects.

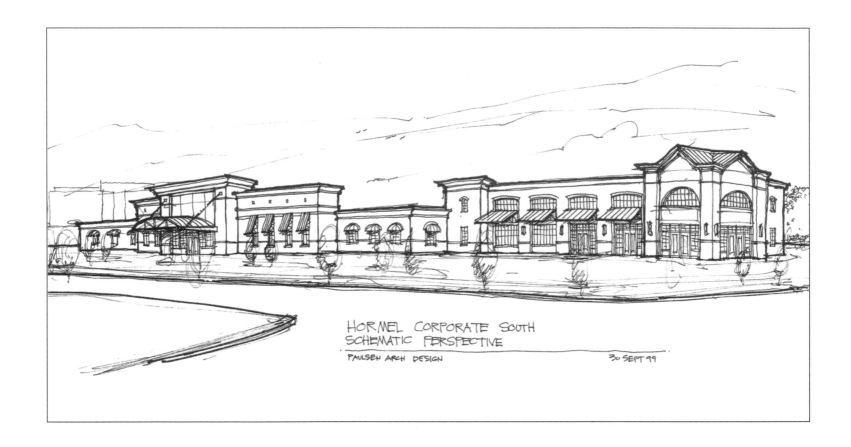

HORMEL CORPORATE SOUTH
SCHEMATIC PERSPECTIVE

PAULSEN ARCH DESIGN 30 SEPT 99

6.5 Hormel Corporate South Schematic Perspective, by Paulsen Architects of
Mankato, Minnesota. This preliminary design was part of the Paulsen entry for
the design competition hosted by Hormel, for the redevelopment of vacant
Kmart store in Austin, Minnesota. Courtesy of Paulsen Architects.

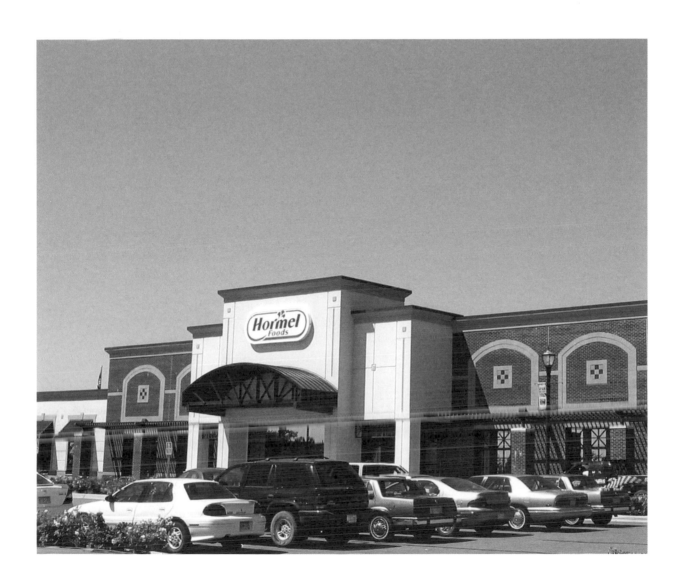

6.6 Hormel Corporate South campus offices.

sits in a booth, greeting patrons as they enter the lot. Bricks cover the structure, and a tall slanted roof sits atop the building. Grass, shrubs, and trees surround the area, and picnic tables line the walkways. Right in front of the main entrance to the museum is a bronze statue of George Hormel himself, with two fated pigs trailing behind him.

Paulsen's primary message to me when I interviewed him about the project was about the latent potential in abandoned big box stores. "These buildings should not be overlooked. From an economic development standpoint, from a design standpoint, and from a sustainability standpoint, these sites have great latent potential," he says.

From an economic development standpoint, reusing this site was less expensive than building a new space from the ground up, according to Hormel engineers. "And there is great excitement in making a vacant building like this come alive," says Shawn Radford, curator and archivist at the Spam Museum, who was very involved in the redevelopment process. "This had been such a hole in our community for so long, and the activity it has brought to the area has been so great." The economic development aspect at this site is clearly not confined to the financial savings of renewing the building itself. For Paulsen, enlivening the surrounding context at the site was a major consideration, and the firm attempted to activate the declining CBD through the installation of the Hormel offices and Spam Museum at the abandoned Kmart site. As Paulsen puts it, "When we think about downtown revitalization, the main question is: how do you get the people to come downtown? That is the trick, to get people moving around downtown, interacting, and ultimately, spending money."

A museum is a great chance for a city to bring people from out of town into the city limits, and the Spam Museum spares no expense in making this a reality for Austin. As I drove east on highway 90 on my way to Austin, I began to see road signs about thirty miles from my destination. Black signs with large white block letters read: "THE SPAM MUSEUM: YES, WE DO ANSWER THE INGREDIENTS QUESTION" and "THE SPAM MUSEUM: EVEN WE DON'T REALLY KNOW WHAT TO THINK OF IT."

These road signs are a part of a humorous highway marketing scheme for the Spam Museum using the same highway network that Kmart had deemed crucial years before. Its goal is to pull people directly from the interstate to downtown Austin, as museum visitors follow the path carved out by the Kmart trucks before them. The museum is in an ideal spot, directly off a major American east–west highway, Interstate 90. Hormel saw the potential economic development in marketing the compelling cultural connotation that Spam holds within the annals of American history, and, thus, the funny road signs. Spam is a corporate icon that stands for Americana, a packaged mystery meat vaguely

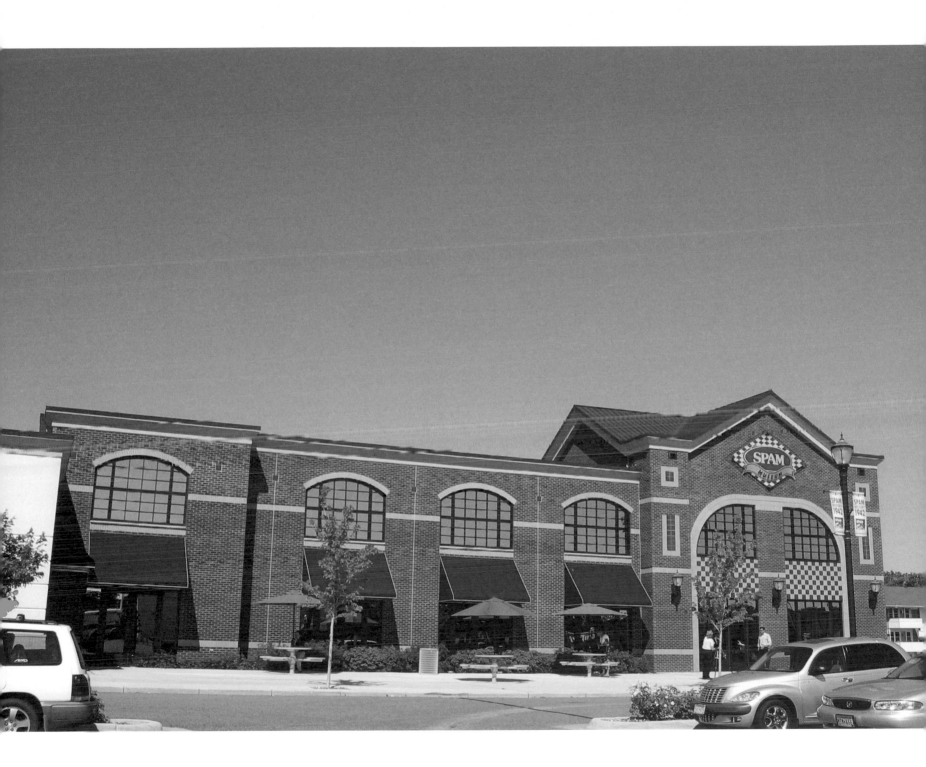

6.7 The Spam Museum.

6.8 Interior of the office space.

specific to wartime (from the 1940s and 1950s), to Formica table tops, and to television dinners. Spam is a canned ode to the American fascination with convenience food. The product is still produced, bought, and assumedly eaten in large quantities even today, but the mystique of Spam is definitely associated with an age gone by.

The marketing scheme for the museum plays on this. It also plays on an even deeper layer of mid-twentieth-century nostalgia, hawking the museum along the highway as another "roadside attraction." The billboards leading up to the museum are reminiscent of the signs leading to roadside attractions of the 1950s, beckoning the traveler to visit, say, the world's largest ball of rubber bands in fifty miles . . . and again in forty miles . . . and again in thirty miles . . . building suspense in screaming children and leading to a much-needed break for driving adults. The Spam Museum holds similar roadside mystique: the signs start early, and by the time you actually get to the exit everyone in the RV has told a story about what Spam dish their mother had forced upon them as a child, or said they have not had Spam in twentysomething years, or else they have asked the question, "What could they possibly say about Spam that fills up an entire museum?"

Reflective humor is perhaps necessary in recognizing that "mystery meat" holds such prominence in the timeline of the United States and in the lives of museum visitors as well. This light humor carries through the design of the entire site. Although Paulsen Architects acted as the designers on the site, Paulsen told me that the development of the site was really a strong collaborative effort among the Hormel engineers and employees, the exhibit design team (from Design Craftsman of Midland, Michigan, headed by designer John Metcalf), and the Paulsen staff. The synergy of this group is quite present in the effortless humor of the site: self-deprecating in a lovable way, not too much, never too little.

The Spam Museum averages over ten thousand visitors a year, according to Radford, who was very active in the development team at the site. Visitors come from every state, every province in Canada, and to their count, from over fifty-three countries since the museum's opening in 2001. "The location is just perfect, easy to get to from the highway and spills people right into the downtown," says Radford. The museum has made a tremendous impact on the CBD, which had been dwindling since the 1990s.

The impact of the renewal was great. "When it was empty, this building began to just fade away; nobody even noticed it after a few years. Sure, people drove by it all the time, but it seemed worthless. It was a mess, and the area had become crime-ridden due to the blight," Radford tells me. Hormel realized that this was actually a hub in the flow of the CBD that had been deadweight for so long, and renewal would unlock this part of

6.9 Skylights add natural lighting to the big box in this flexible office space. Someone has moved a plant into the sunlight.

town from its years of silence. Empty buildings that lined the streets surrounding the empty Kmart could surely benefit from the circulation overflow of a nearby museum.

The Spam Museum and Hormel Corporate Headquarters currently employ a total of over 250 people, who all come downtown every day to work. It is assumed that the ten thousand yearly visitors will also eat and shop. The businesses surrounding the museum have followed suit, and they now offer Spam menus that include Spam burgers, Spam casseroles, and Spam Eggs Benedict. Stores and coffee houses are popping up along the downtown streets as the museum becomes more popular, and Spam Town USA, as Austin calls itself, has made its mark on the United States roadmap.

From a design standpoint, Paulsen tells me, "It was a great big open empty space, which offers some challenges, but there are plenty of advantages too." The open space of the layout is always cited as an accommodating building plan to start with, because it is often easier to add to a building than it is to remove components from the structure.

This is a small big box, a mere 32,000 square feet. Half of the space is used for the museum, and the other half is used for the offices. Employees on both sides of the structure share a cafeteria and fitness club in the back of the building. Physical exercise was considered part of the design concept for the space, and Hormel wanted to be sure that the building made exercise accessible to its employees.

Movement and flow throughout the space was the first thing the designers programmed when creating the drawings for their proposal, and they wanted to plan for extending the circulation beyond the walls of the building and the parking lot. They created walkways that led right out of the parking lot toward the CBD, to encourage walking trips downtown. One of Minnesota's ten thousand lakes sits directly across the street from the museum, and walking paths circling the lake are accessible from the museum's own walkways. From the lake, too, all paths lead downtown. "The city has done a pretty good job of keeping up with the revitalization efforts instigated by the Hormel Corporation, including the updated infrastructure at the pond," Paulsen says. The corporation and the government share in these revitalization efforts.

There are no windows in a big box building. Big box retailers choose to include no windows in their design, shutting out the rest of the world, separating the envelope of retail from the locality outside. Recontextualizing the space for people to use often means inviting the locality inside by creating windows, offering the people on the interior a connection with what lies on the exterior. The techniques that big box renovators use to get light into the building are always inventive. Because of the challenge of adding ambient light to the building for the first time, lighting designs are carefully tailored to the use at

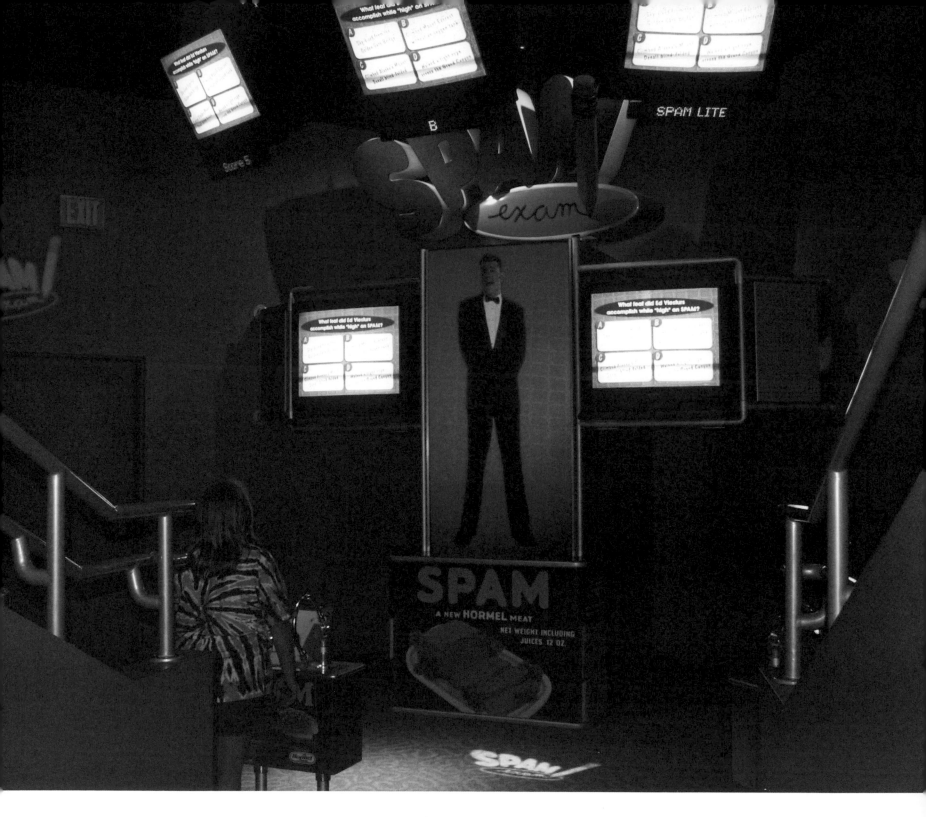

6.10 Spam Museum exhibit.

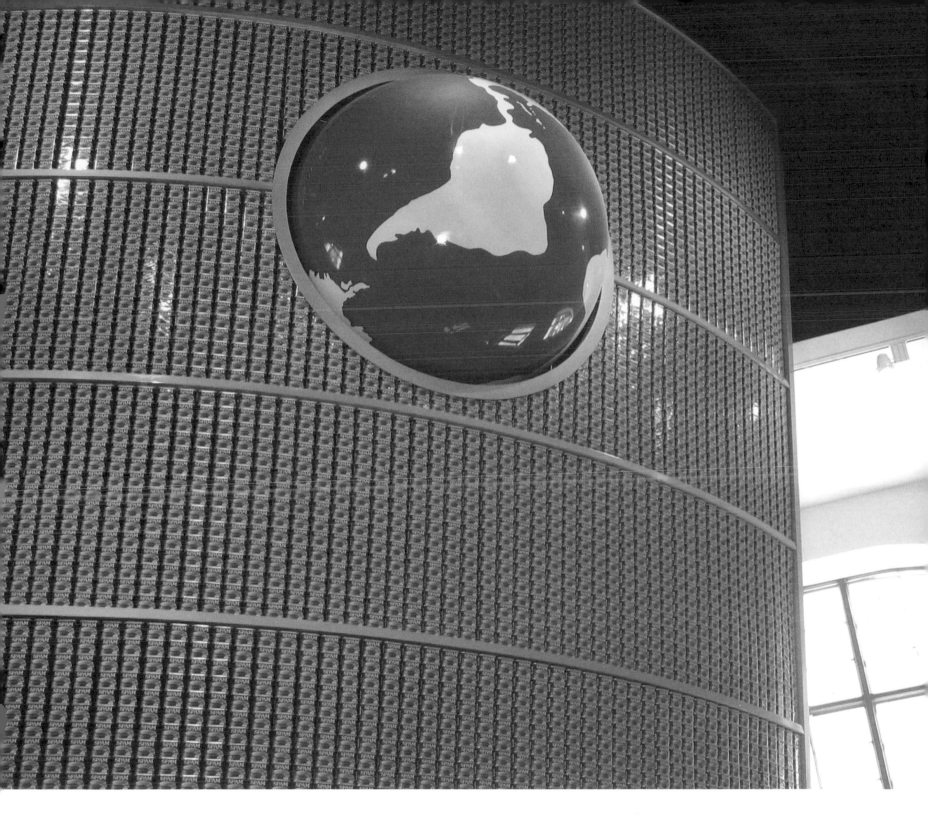

6.11 The Wall of Spam, the dramatic centerpiece of the entrance foyer.

hand. In this scenario, it was actually a great boon that there was no light on the museum side, so exhibit designers could maintain complete control over their lighting designs. Windows and skylights on the museum side are mostly contained in the lobby, hallways, and gift shop.

Interior lighting in the office, however, was an important consideration in the design process. The lighting fixtures throughout the space are unobtrusive, small lights embedded on top of a hanging truss overhead. The light bulbs themselves are not visible so that the user only perceives the light generated by the sources, creating an atmosphere of electronic ambient light cascading from the ceiling. Natural ambient light comes through large windows cut into the front of the building, and skylights are scattered throughout the office space. Larry Pfeil, an engineer at Hormel who has his office in the renovated Kmart site, tells me, "The skylights tend to be to be meeting places, focal points for interaction. People often drag their chairs under the skylights for meetings."

This is one indicator of the flexible working space within the offices. Employees work among small movable walls situated at angles, so that light funnels through the space. No furniture or walls are fixed to the floor; rather, everything can be moved as need be. Because the movable walls are only about five feet high, the huge room is very open, light, and airy. The walls are just tall enough to absorb sound, so the space is actually really quiet, despite the presence of two hundred people working with no complete walls. "It is so quiet in here," says Pfeil, who was himself involved in the design process. "When they first started announcing who would be moving over to the new offices in the Kmart building, we all cringed and hoped that we were not on that list. It seemed like a miserable fate. But now that we are here, we feel like we got the lucky end of the deal."

Design on the museum side is driven by the presence of exhibits, which makes for a wildly different use of the same raw big box space. "We worked closely with the exhibit design team," recalls Paulsen. "Often, they would design an exhibit, and then we would engineer their drawings into the actual structure. Or we would be faced with an architectural element that needed to be worked into their exhibit design. So our teams had a lot of back-and-forth of information."

The most extensive renovation of the museum half is in the area where the Kmart auto shop once existed. First, the deep hoists had to be dug out of the ground, and the oil and debris had to be cleared away. Second, the roof was raised to create a dramatic entrance to the museum, recognizable from the exterior. Today, this section of the building serves as the main entrance to the museum. "We wanted the entrance to have an impact that people would remember, and would recognize right away when they saw pictures

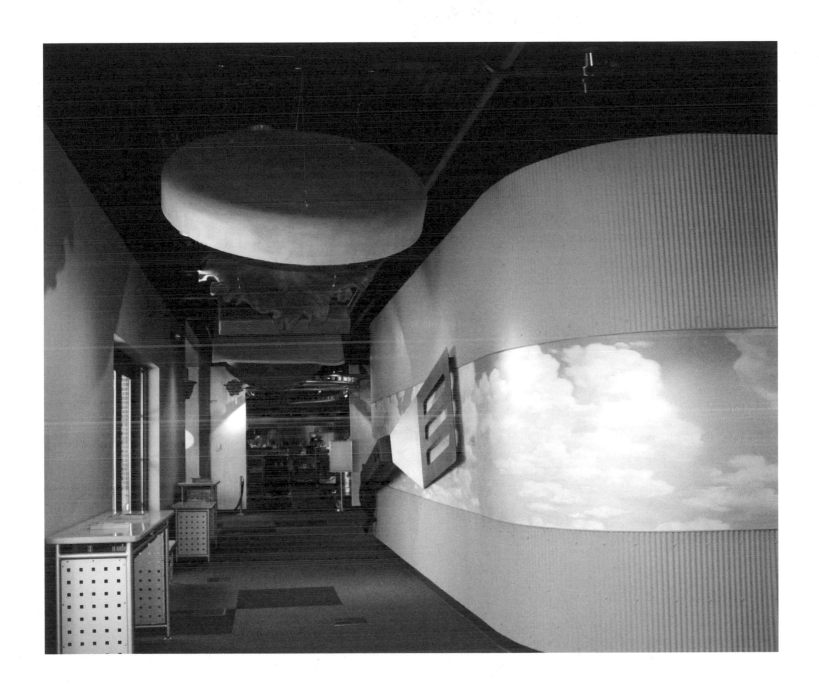

6.12 Front hallway in museum, with components of a Spam Burger suspended from the ceiling.

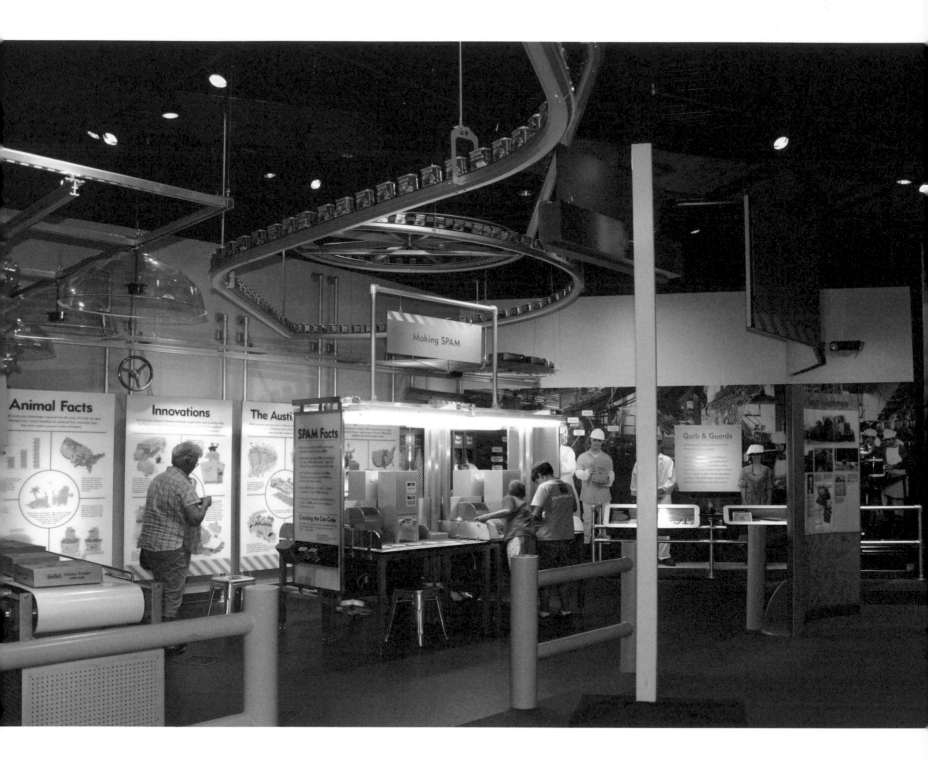

6.13 Spam Facts: Exhibit at the Spam Museum.

later," says Eric Lennartson, an architectural designer at Paulsen. The interior of this foyer is composed of an example of architect-exhibit design collaboration, the dramatic Wall of Spam. This is a wall made entirely of cans of Spam. The exhibit team drew up the idea, and then Paulsen worked it into their entrance design. The result is a drastically tall wall made up of thousands of cans of Spam, hanging between the ceiling and just above the front doors.

A theater in the center of the museum space shows a Spam history movie every thirty minutes. A retro Spam diner is situated outside the theater, with computer screens for menus. A serving of eggs, sunny side up, functions as your mouse ball as you scroll through Spam history on CD-ROMs, and the pat of butter on the toast acts as your mouse's button. A conveyor belt carrying cans of Spam travels overhead throughout the museum, adding kinetic flair to the experience of the space. Exhibits tell the story of Spam lore and development, including the evolution of the can and the historical introduction of Spam Lite. Visitors learn how Hormel came to Austin, Minnesota, in the first place, and how the pork company got its start. The museum also addresses Hormel's impact on world politics by including an exhibit in which a life-sized video image of a soldier tells the story of how Spam was the food that fed the American troops in World War II.

The gift shop is, as is often the case in corporate museums, a veritable celebration of the featured product. The Spam Museum gift shop features every item you can imagine that could possibly be branded with the Spam logo. It is a blue and gold sea of marketing, a deep well of Spam merchandise. Spam shot glasses, Spam golf balls, Spam history books, Spam dishes, Spam coolers, Spam socks, Spam underwear. There was a certain item that I myself could not resist: a painted ceramic light-up model of the Spam Museum structure itself, which sits about ten inches high and ten inches across. When you click the switch, its windows light up. It is sitting on my desk right now. It is such a remarkable souvenir: a manufactured miniature model of a museum, dedicated to a locally operated global corporation's product, symbolizing Americana, in what was once was a Kmart building. On the bottom of the model is a familiar sticker, "Made in China." This souvenir of central Minnesota is actually a souvenir of the globe.

From a sustainability standpoint, reuse itself has a major impact on the landscape of the future. As we know, urban reuse has been happening since people began organizing themselves within their built environment, and it is a natural phenomenon in the development of cities and towns. We often think of sustainability in terms of saving energy, employing alternative energy sources, creating as small a carbon footprint possible

upon the Earth. As the environmental impact of sprawling cities becomes more danger-
ous, we also must think of sustainability in terms of reuse. Adaptive reuse is an impor-
tant tool in combating the threats of sprawl. In fact, adaptive reuse should be considered
in the initial design of buildings; flexibility for future use should be embedded into the
construction of anything new, especially in terms of big box retailers. For every building
that is reused, another building is not constructed on green space.

"Green design" is vaguely ironic within the phenomenon of big box reuse, since the
buildings themselves are so environmentally unfriendly that reusing them seems only
to perpetuate the destructive loop. Corporations are currently not held accountable on a
federal level for the construction of buildings that will inevitably be abandoned relatively
quickly, or for the construction of buildings that have such a major environmental foot-
print on the Earth. Jennifer Cowley, assistant professor of planning at the University of
Ohio in Columbus, has written a report for the American Planning Association entitled
"Meeting the Big Box Challenge: Planning, Design, and Regulatory Strategies." This report
offers tips and strategies for communities attempting to demand that big box retailers
adhere to certain guidelines in local building techniques. At this point, these scenarios
still have to be dealt with locally, on a case-by-case basis, since there are no national
standards or laws for big box construction.

At the Spam Museum, the LEED-certified Paulsen Architects were able to conceptual-
ize sustainability in terms of energy and spatial flexibility, so that the interior flow of the
space can be updated as times change. This ensures that the use of the space is sustain-
able over time, and that the Hormel offices will never have to move out because of
cramped space or renovation problems.

The design allows room for growth in the future. In this scenario, as in all big box
reuse cases that I have seen, the users who are appropriating the building are very much
involved in the design process. Participation of Hormel employees and exhibit designers
in the actual development project is a key to the future success of this building. They are,
after all, the people who will be using the building—long after Paulsen Architects or their
various contractors have left the project. Allowing employees to participate in the design
of their office empowers them to realize their control over design issues, so that the
users are more apt to fix or change something about the structure themselves. The em-
ployees at the site have a compelling understanding of the building: they know how
things work, and they know how to alter components to suit their work needs.

The HVAC and electrical systems of the entire structure—museum side and office
side—are housed beneath the floor. The floor is raised twelve inches above the ground,

and it is laid in panels that allow easy access to the workings of the HVAC. This is a LEED-certified technique that scores highly in the categories of Ventilation Effectiveness, Thermal Comfort, and Optimized Energy Performance. The system offers flexibility and is easily maintained and altered by the users of the space. The flow of hot and cool air can be determined based on where people are located in the office, simply by moving floor tiles. On the museum side of the building, the access floor means that exhibits can be moved in the future, and electricity can be easily accessed from any point throughout the museum. The electricity factor is also helpful on the office side, so that in their "non-corporate-feeling" office, employees are able to drag a chair to a corner near a skylight, if they want, and plug in a laptop at any point throughout the building. Meanwhile, the floor is built above the floodplain, so the exhibits are defended from future floods.

Julie Craven, publicity representative for Spam, tells me, "We are going to be in this building for a long, long time. Our building has a story; it is a story about our town and our corporation. The renovation of the Kmart building into what you see here today has the drama of a great epic. And we love it here. We love to tell people our story." I am not sure if the story is more about the building, or the people in the building. In a successful renovation, though, maybe the building is a mirror reflection of the people.

As Radford puts it, "We are Spam Town USA. This building reflects our town pride and our town history. It will not go down in history as a vacant Kmart, but as the Spam Museum, telling the story of the product that put us on the map." A museum is a vessel that holds artifacts of the past and the present in order to inform the future. The very walls of this museum are doing just that.

7.1 The Lebanon-Laclede County Library, in a renovated Kmart building in Lebanon, Missouri. The building is also home to the Route 66 Museum and Library and to Maria's Café.

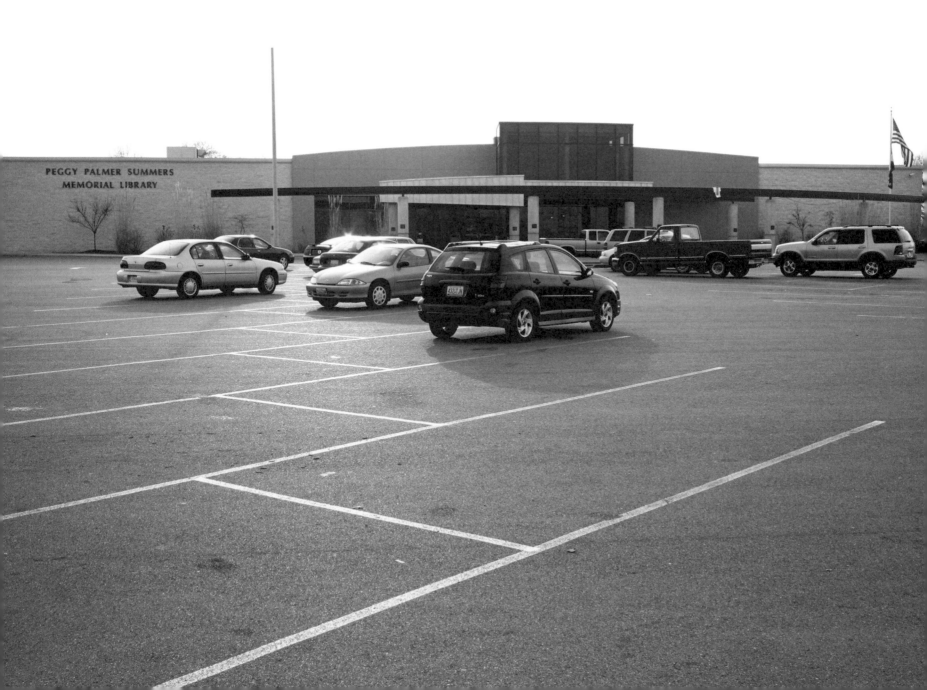

THE LEBANON-LACLEDE COUNTY LIBRARY

7

REUSED KMART BUILDING
LEBANON, MISSOURI

When I spoke with the library director on the phone, I was told that the site was on "Main Street." These days, "Main Street" is not just the name of a road, but an identifier for an entire concept, expressing nostalgia for the pedestrian's city and the days when local commerce prevailed. In Bentonville, Arkansas, home of the globally reaching Wal-Mart Headquarters, the town has a sign on its own main square that says "Main Street: Preserving the Past, Enhancing in the Present, Ensuring the Future." Bentonville's own downtown is an exaggerated version of an early-twentieth-century Main Street, with a common park square in the center and gingerbread façades lining the streets. Each of these buildings house locally owned shops—including Walton's Five and Dime, the original Wal-Mart store, (which happens to be locally owned in Bentonville). The building now serves as a museum about Wal-Mart. An active Main Street is supposed to secure a town with a friendly community and, most important, local business, which is generally thought to occur downtown. Everyone is walking on sidewalks, and assumedly, interacting, forming community and local identity. National chains—like Wal-Mart—are supposed to operate safely on the edge of town, preserving Main Street.

I arrive in Lebanon, Missouri, to find that this town is updating the term. The main street here is perhaps more traditionally termed the main "drag," or the main "strip": a street lined with gas stations, big box stores, strip malls, movie theaters, and national drugstore chains. To the people who live here though, this is Main Street, with its Walgreen's Pharmacy and its Wal-Mart, with its Chili's and its Western Sizzlin Restaurant. After years of driving across the country visiting towns like this one, the field reports show: this is the new iteration of Main Street, U.S.A.

It makes sense that the county library should relocate here. The Peggy Palmer Summers Memorial Library, commonly known as the Lebanon-Laclede County Library, shares a renovated Kmart building with the Lebanon Route 66 Museum and Maria's Route 66 Café. The reuse is, in the words of Maria Stone, owner of the library's café, "the best thing that has happened to this town in a long, long time." As I would soon find out, the reuse in this scenario was truly a community affair, and it took the enthusiastic efforts of literally thousands of locals to make it happen. The community-building experience of the reuse process has changed the town's history.

The care that has gone into the renovation of this site is clear to me from the moment I walk through the doors. Upon entering the space, my attention is immediately drawn to the wall on the right side of the lobby, which contains a spectacular relief of a large hand-carved tree. The tree is decorated with hundreds of dangling golden leaves, each inscribed with the name of someone who donated funds to the library. Upon arrival, I am to meet with several key players in the library's implementation: Cathy Dame, library director; Dan True, project manager on the site; Joan True, interior designer; Charlie Johnson, architect; Sam Allen, fund-raiser; and Bill Wheeler, fund-raiser. Wheeler also doubles as the local Route 66 expert, heading up the curatorial work at the Route 66 Museum that shares the building with the library. The hand-carved tree that I passed prompts my first question: How many names are hanging there, etched in gold? How many people in this community actually donated to the library building? The answer comes from Dan True: "It honestly would probably be easier to count the people in this town who didn't help."

Not that True is upset about the few people who didn't help; he makes a point of graciously saying that there were some people who just could not get involved for one reason or another. But the fact is, basically everyone in the community of Lebanon really was involved in the renovation and design of this site. Public school students designed and painted the murals, local electricians designed systems and wired light fixtures, local artisans laid carpet and even designed mosaic tile floors for the hallways. The community here came out for the cause, donating time, money, and services to the development of its new county library.

The leaves hanging from that hand-carved tree (which was made free of charge by a local artist) cost only $25 each to buy, a price that many people in town could afford in order to help build the new library. The important thing about this fund-raising technique is not just how little individuals could contribute, but the fact that people who paid that small price were forever memorialized on the wall of the building. Therein lies

7.2 Hand-carved tree relief decorated with golden leaves, each etched
with names of individuals who donated money to the library project.

an important key in this site's success: everyone here got recognition for donating, no matter how small his or her contribution. The encompassing community-building style of fund-raising had a strong impact on Lebanon, making people to want to contribute, each person inspiring the next, until contributions spread like wildfire.

"The real key to our story is the success of our fund-raising drive," Allen tells me. The project was a long time coming. This new library took years to gestate, and the plans went through many forms before arriving at the unlikely reuse of the old Kmart building. But when the project finally took off, the breadth of participation at this location mirrored the scope of the process—that of turning a big box retail site into a community site, a library.

The original library in Laclede County was built in the 1950s. It spanned 4,500 square feet until the Americans with Disabilities Act came into effect in 1990, when it was expanded to become fully wheelchair accessible. "But even after the expansion," says Dame, "it got to the point where books were stacked floor to ceiling, and they looked like they were going to tumble down on you any minute." Discussion about enlarging the library began even earlier, in the 1980s. But the library needed a major expansion. Even doubling the existing space would clearly not make enough room. In the coming years, the library committee met and talked about the expansion frequently.

For some time, there was just that—a lot of talk. The library board talked, the community talked, the library staff talked. But there was no library movement. In 1986, a charitable gift was made to the library by the will of the late Peggy Summers, who had left a sum of money for the continuing development of the Lebanon County Library. The Charles E. Hughes Foundation, a charitable organization that generally makes grants available for the well-being of the elderly, managed the funds. This lump sum of money, a library nest egg of sorts, began a new campaign for the future of the library.

And so, everyone continued to talk. The library board had big plans: a new, modern library would be built in Lebanon from the ground up, on green space. (People kept talking.) Donations needed to emerge. The nest egg made the talking seem more substantial, but it was not enough. Land was donated to the cause, but the thoughtful donors had stipulated a time-sensitive clause: the land must be used within a certain amount of time or the gift would be revoked. The goal of this deadline was to get the board to act rather than hover at the drawing board. Plans were made for a new, dramatic modern building. The new library would cost over $6 million to build. (People kept talking.)

But $6 million was a figure well beyond the means of the library board's budget, even with the donated land and the late Peggy Summers's money. (People kept talking.) As the

months flew by, the community became apprehensive and increasingly less supportive of the new library.

Eventually the land was taken back. With their ceaseless talking, the community, the library board, and the library staff did not meet the deadline for the use of the donation.

Then, the new library plan ground to a complete halt.

In the winter of 1999, Kmart abandoned the building just after the Christmas season. The store had been operating there since 1976. It was closed as part of a major overhaul that Kmart was attempting in the late 1990s, when the company began opening larger Kmarts (called Big K stores) and the corporation began focusing more on the other companies that they owned (such as Sports Authority, Builders Square, and Waldenbooks). The Kmart building in Lebanon is 41,000 square feet, and it shared a parking lot with the local movie theater and the Western Sizzlin Restaurant. It was 2002—three years after its abandonment—when someone on the library board first brought up the empty Kmart building. Was it plausible to move the library into that structure?

Two gentlemen, neither of them local, owned the structure. Mr. X owned one-third of the building, and Mr. Z owned two-thirds. After Kmart left the building, Mr. X held on to his share of the ownership, and Mr. Z donated his majority share to the local public school system, as a tax write-off. That two-thirds of the ownership was donated to Maplecrest Elementary School, which sat directly behind the Kmart property. The intent was for the school to use the building, or at least two-thirds of it, as storage. The school board tossed around the idea of creating a new administrative office there. Mr. X hung on to his share of ownership.

The building was so large, and in such shabby condition, that the school reuse never went anywhere. Maplecrest did use it as storage, to some extent, but ultimately the school did not use the building enough to justify actually owning the property. The school removed its stored materials from the structure, and the school board decided to rid itself of the building, or at least its two-thirds of the building. The awkward ownership scenario had also made it challenging to conceptualize the reuse of the space, considering there was always a mysterious owner lurking over a third of the space. After all, there were no clear lines dividing the building into thirds. Which two-thirds belonged to the school?

Now it was the school board's turn to talk. How would this public school system deal with selling 66.6 percent of a piece of commercial property that had been donated to it by a businessman in another state? And then school board members all realized that the library committee was still talking about finding a new location.

7.3 Inform, Educate, Inspire, Entertain: Short form of the library's mission.

The puzzle fell into place.

The Kmart building was directly adjacent to the elementary school, right in the center of town. Because of its similar public, nonprofit status, the property could be easily turned over from the school to the library fund. Reuse of the space had fleetingly come up before at library board meetings, so the answer seemed hard to ignore.

It did not take long to strike the deal.

The school donated its two-thirds of the building to the library fund. The library board purchased the other third from mysterious Mr. X. The Lebanon-Laclede County Library owned the building as of May 2002. The community was apprehensive. At this point talk about the new library had been going on for years, and the town had become cynical about the fruition of the whole operation. And what about that beautiful, modern library building they had seen pictures of a decade before? The purchase of an abandoned Kmart building for the shiny new library was not exactly the impetus for renewed community morale. "We had a vision," says Dame, "and we were up to the challenge of convincing the community to see what we were seeing in that space."

What the community saw was that the building was a mess. It had a bad roof. "You could kick a hole right through it," recalls Charlie Johnson, architect on the site. But there was a gleam in the eye of Cathy Dame, library director, and Dan True, local engineer and contractor by trade, who actually donated his services to the project as head project manager. Johnson had worked with True in Lebanon on several projects before, including furniture stores, government buildings, and the country club. When Johnson was approached about working on the library project, he said he was immediately drawn in by the determination that he intuited among the small planning core. He agreed to donate his services for the architectural redevelopment of the site, too.

The major challenges were going to be convincing the town that its new library was not going to look like a Kmart building, and convincing them that yes, something was finally happening with the static twenty-year-old library discussion. Sam Allen, community organizer and fund-raiser for the project, first got the buzz going on the street, so that people in town were talking about the project. From the very beginning, he advertised the reuse project as a community effort. The only way this library was going to be built was if the whole town pitched in. "We have found that people get really excited about helping with a project that will improve the quality of their lives, when they can actually see the results of their own efforts," he says. In support of this notion, Allen advertised that every donation, large or small, would be somehow immortalized in the building. He was talking about plaques, he was talking about statues, he was talking

about golden leaves hanging from hand-carved trees. This fund-raising tact not only had a huge impact on the funds drive, but also really did work to instill a sense of community among the donors. By giving money and energy to the library fund, the donor was becoming part of the library-seeking community. Allen also touted the redevelopment of the Kmart site as a creative act that would improve the quality of life in Lebanon, if only to fill a hole that they had all been looking at for so many years.

The local newspaper and radio station became fast advocates for the project, which Dame cites as the first key in any community fund-raising drive. "When I speak at library conventions or community organization conventions about fund-raising, the first question I ask my audience is: who is the editor of your local newspaper, and who runs your local radio station?" As we learned in chapter 3 (on the Centralia Senior Resource Center in Wisconsin Rapids), the power of local media can be harnessed in community endeavors, not only to encourage enthusiasm and communication, but to produce a public document about a public issue. Because the local media was on board, everything about the process was made public, through written articles and recorded interviews on the airwaves, all archived for future fund-raising drives to use. Local press creates proof of a community's need for the project. Enough cannot be said in situations such as this one about the power of the local media to instill solidarity and enthusiasm within a community. This solidarity initiates group identity, leading to a shared benevolence within the town and leading people to work together for positive change. The media presented the reuse project as a creative, positive act, making lemonade out of a giant, abandoned, ugly, cement lemon.

The days of "talking" were over. Action was at hand. The community understood the mission ahead, despite lingering apprehensions.

Johnson tells me that the first order of design was to redevelop the exterior of the building. By the time I visited the future site of the Lebanon-Laclede County Library, I had visited upward of thirty reuse sites nationwide, and I told Johnson that, in my experience, it seemed unusual to start with the exterior. Most of the sites I had visited renovated the interior first, for function's sake, so that the building could be used quickly. The exterior was usually redeveloped when time and money allowed. But not in Lebanon. Recalls Johnson, "Our first priority all along was to get the community behind us. They had been waiting so long for the new library and people were still apprehensive that anything was going to happen at the Kmart site, even with all the publicity that Sam had gotten going. We had to start right away with the outside so that they could see that something was happening." The issue of exterior aesthetics would be addressed imme-

diately by beginning work on the façade. "It was crucial for them to see that the library was not going to look like an old Kmart," contends Johnson.

Today, the façade of the building has been completely resurfaced, in a modern arrangement of metal pieces in red, blue, and yellow, the bright, primary color scheme used throughout the building. The signage on the road in place of the old Kmart sign lights up and has a retro feel with its sharp lightning-bolt-like points and bold lettering announcing the library. Johnson says, "Once we had the façade in place, people really did understand that we were no longer wasting everyone's time, and that changes were afoot. And the building looked great, so perceptions began to change."

The function of the "public library" has remained largely the same throughout the ages. It is impossible to track the origin of the first "public library," a claim made by many American cities and towns (although of course public libraries appear throughout recorded history, including in ancient Roman and Middle Eastern civilizations). A library moves through phases as it ages. In his paper "Stimulating Growth and Renewal of Public Libraries: The Natural Life Cycle as Framework," Norm Parry compares the library to a living organism, with characteristics relative to its age, much like the life cycle of a human being.[1] The library, he says, in an entropic organism, so its collection and its building must constantly receive infusions of energy in order to survive. The library moves through cycles of infancy, growth, maturity, and the golden years, when the library has reached a phase of comfortable efficiency for its community.

But inevitably, the public library cannot remain golden forever, no matter how comfortable its role becomes. The community still changes, and the library must always find ways to accommodate the people it serves. "If a library no longer serves its charter, mission, or purpose, it is a prime target for budget cuts, downsizing, and consolidation," says Parry. It is imperative to rethink the public's needs in order to reconsider the role of the local library and, simultaneously, to review the library's needs in order to appropriately serve the community.

Conceptually, the very idea of what a library could—or should—be was very malleable to the team at this point in the design process, since nobody involved had ever been to a library in a big box before. This structure needed to be heavily reimagined to make a fluid transition to its new use, allowing the designers to rethink what a library is meant to do and what the institution is meant to be, beyond acting as a stockpile of books and media sources. New precedents were about to be set, and as long as they were forward-thinking enough to reconceptualize the Kmart building, the library board was open to expanding the very idea of what a library is supposed to be.

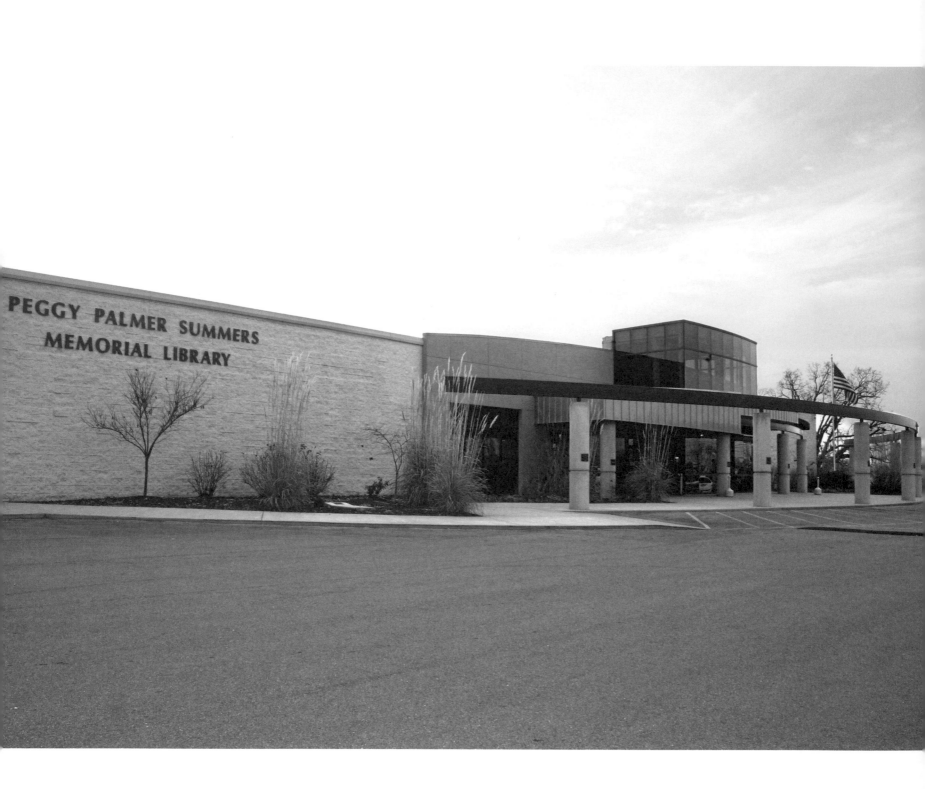

7.4 New façade for the library, the first order of this renovation's completion.

7.5 Signage for the library complex.

In essence, the Lebanon-Laclede County Library had returned to its infancy after it had spent time in its golden years, and the library was about to travel through a new life cycle, having the experience of a fifty-year-old. Typically the library has acted as a community center, serving as a base for public meetings, lectures, and debates. This was definitely going to be the case in this new big box library, whose space and centrality would shelter a broad range of civic activities.

Wheeler approached Dame with the idea of establishing a Route 66 Museum in Lebanon. Lebanon is just off the old 66, which is now Interstate 44 at the portion near the town, having undergone a major "reuse" itself. Route 66 had been established on November 11, 1926, and 301 miles of it ran through the state of Missouri. The route was removed from the national highway system in 1985 when the United States deemed that 66 was no longer relevant to the way people traveled. The legendary road is immortalized in American literature, music, television and the movies as the Mother Road of America. After its decertification in 1985, it did not take long for enthusiasts to develop a Route 66 movement, memorializing Route 66 nostalgia and history. In effect, by removing the highway from the official national highway system, a whole new tourist industry was born.

Route 66 associations began to appear as early as 1990; the state of Missouri deemed the road a "State Historic Route" that year. Wheeler had been involved for six years with the local Route 66 Festival, a weeklong event that included a mobile "museum," an exhibit of Route 66 paraphernalia that had been collected by local enthusiasts. These enthusiasts acted as the collective curator for the "museum," and they donated new objects to the exhibit every year for the duration of the festival. "It was the most popular part of the whole event," Wheeler tells me. He was not aware of the existence of other Route 66 museums at the time, but he had a hunch that a permanent museum in Lebanon would attract the Route 66 enthusiasts who travel the historic road year-round. His idea was to begin a stationary museum, starting with the collection that appeared in the yearly festival exhibit, expanding as time, money, and space became available. Wheeler suggested to Dame that the museum share the building with the library, incorporating a tourist attraction and a local theme into the new library.

"I thought it was a crazy idea," says Dame. "I had no idea who this fellow was, and I said to him exactly what I say to all the crazy ideas thrown at me: 'Let me talk to my board.'" And to her surprise, her board loved it. Board members had talked about using the extra space in the building for something like a Staples office supply store, or a CVS drugstore, or some other national chain that would bring in income for the building. But

7.6 Mosaic floor, designed and implemented by local artisans who donated time and money to the library's construction.

the idea of a local history museum was indeed a compelling tourist attraction, and it could actually bring business not only to the building but to the entire town. Dame listened to her board, although she was still apprehensive. Then, like the good librarian that she is, she did some research.

Dame made a surprising announcement to the project team: they were getting on a plane and going to Clinton, Oklahoma, for two days. "What the heck are we doing now?" laughed Johnson as the group recounts the story to me, all smiling mischievously and looking at one another, clearly reveling in the unforgettable adventure they had gone through together. Every moment of the Kmart redevelopment was a foray into new waters; they simply had no precedence for what they were doing. Part of the team's enthusiasm was very apparently driven by the visionary, improvisatory nature of its decisions. The risk taking was an important force behind this team's love of the game. The sudden trip to Oklahoma was no different.

The trip was prompted by Dame's discovery of a Route 66 Museum in Clinton, Oklahoma, that she wanted everybody to see. She thought that a live experience within an actual Route 66 museum was necessary before they could dive into making any major decisions about their own museum venture in the big box.

When they arrived in Oklahoma, everyone was awe-inspired by the sight of the Clinton museum, a premier Route 66 shrine of beautiful design and sleek traditional museum qualities. The team was now able to envision what it wanted and to appreciate the potential of its own museum. The trip had worked; the team was convinced that the city of Lebanon needed a Route 66 Museum. But team members were not the only ones to hit upon the idea—a myriad (or, rather, a network) of Route 66 museums was popping up along the highway, museums borne of the celebration of our past network of highways. The team in Lebanon was forced to identify what would make its museum unique among this network of museums.

"The fact that we were a museum merging with a library made the structure of our setup different than any other Route 66 Museum," says Wheeler. Since the institutions were merging, it was decided that the relationship was mutual: not only would the library have a museum, but the museum would also have a library. And so, the Route 66 Museum in Lebanon features an extensive, thorough library about Route 66 lore and history. In fact, the Route 66 Museum is touted as one of the most comprehensive Route 66 libraries in the United States. "Several PhD's have come out of that room," says Wheeler, pointing to the library, a comfortable space with easy chairs and light tables. The walls are covered with antique road maps, each showing how the American landscape was

carved by the long ribbon of highway labeled "66." Thousands of people are drawn to this old Kmart building every year, just to view the Route 66 library. This library is an archive of paraphernalia celebrating the old highway network supported by Route 66. When these Route 66 lovers arrive, many resources are available for them in the main library as well, including another collection specific to this library, a very comprehensive Missouri state genealogy collection. The library committee had anticipated this crossover between library and museum clienteles.

"Many libraries are becoming what we call 'destination libraries,'" says Dame, as she begins to tell me about the Lebanon-Laclede County Library's decision to merge with a local history museum. "Destination libraries draw people into the structure for reasons beyond just checking out books, and usually they involve some sort of money-making venture to sustain the library." As such, destination libraries usually have a theme, permanent or temporary (i.e., changing every month), and have bookstores or cafés attached. The idea is to get people in the door and then give them a reason to stay all day. The hardest part is getting people through those doors; once they are inside, they can take part in a variety of activities and perhaps even spend money at the shops and cafés. The idea merges the traditional platform of the public library with merchandising and marketing principles. Perhaps the library's integration into the commercial landscape of the big box has gone beyond physical reuse, as capitalism drips into a public institution, the local public library. But the fact is, says Dame, "Libraries simply do not receive enough money to survive on their own these days. They need income."

Johnson tells me that the two main architectural challenges were (1) although the library was expanding from 9,000 to 41,000 square feet, it could not add any staff, and (2) the building was absolutely not to look like a Kmart store. Resurfacing the exterior had at least superficially addressed the second objective, and Johnson imagined less of an aesthetic challenge on the inside: "The large, open space offered flexibility and a lot of room for creativity, and it was not going to look like a store inside." Maintaining a small staff in a big building offered an interesting challenge. With a space so large, how could a small number of library technicians keep a handle on the goings-on in the building without being everywhere, all the time?

"A new idea is like a pebble being dropped in the water, and a ripple effect takes place as the new idea catches on," Johnson tells me. "One wave after another, the original idea reaches more and more people, endless ripples, surrounding the idea's origin. That was the simple concept that gave birth to the design in this building." Johnson and True believed that this was not only applicable to the development project at hand, but the very

7.7 The main gallery of the Route 66 Museum.

7.8 Gas station exhibit at the Route 66 Museum. The cargo door in the back of this exhibit is Kmart's cargo door. The museum exhibit designers saw the overhead door as a design opportunity.

purpose of a library in the first place. They remained faithful to that idea throughout the site, and they tried to manifest it in the site plans.

The drawings look as if a pebble were dropped at the desk of the library, and from there, everything ripples out into the space. A point right behind the library's desk serves as the pebble's origin, and the rest of the library is designed in rounded waves surrounding that point, much like the panoptican, the prison design suggested by Jeremy Bentham in the late eighteenth century.[2] Considering the extensive surveillance saturation embedded in big box buildings during their original use as corporate retail stores, the panoptican form is a fascinating transition. (Wal-Mart and Kmart remove scores of video cameras from their big box buildings when they vacate the premises.) This layout allows for an open view of the entire volume of space from a single point, without the use of a camera. You can see every inch of the library from the center of the room, as far as the outer walls on every side. This hub-and-spoke model extends throughout the building. Those initial drawings were so well thought out that they are true to the library plans that exist today, and the response from the public is that this design gives the library a comforting feeling—there are no corners, no edges, only open, rounded space.

Once the drawings were complete, Dame got out some sidewalk chalk and drew the plans directly on to the Kmart floor, so she could visualize what her new library would look like. Then, she began to invite others in to see the space. In 2002, Dame staged a dynamic media event to symbolize the "groundbreaking" of the new library site. She hauled a pile of dirt into the center of the building, and she handed out hard hats at the door. Standing in the floodlights of an empty big box with chalk drawings all over the floor, in front of the community, radio announcers, local journalists, and potential fundraisers, Dame raised a shovel and began moving dirt. This was one in a series of media events meant to demonstrate to the community milestones in the renovation efforts. Recalls Dame, "We had no ground to break, since the actual dirt had long been covered by the Kmart building! But in order to inspire community excitement, we created these events that got people inside of the building, so that they could actually begin to visualize what was about to happen." She and Wheeler were constantly taking people through the site, and everyone was seen as a potential donor. They estimate that they took five thousand people through the site, even on holidays, even on Sundays. In that 41,000-square-foot volume of space, with chalk lines drawn on the floor, the project team knew that this project was marketable, and the development was going to sell.

This group raised a total of $2 million through local donations. The in-kind donations of labor are absolutely incalculable, according to True, who himself donated two years of

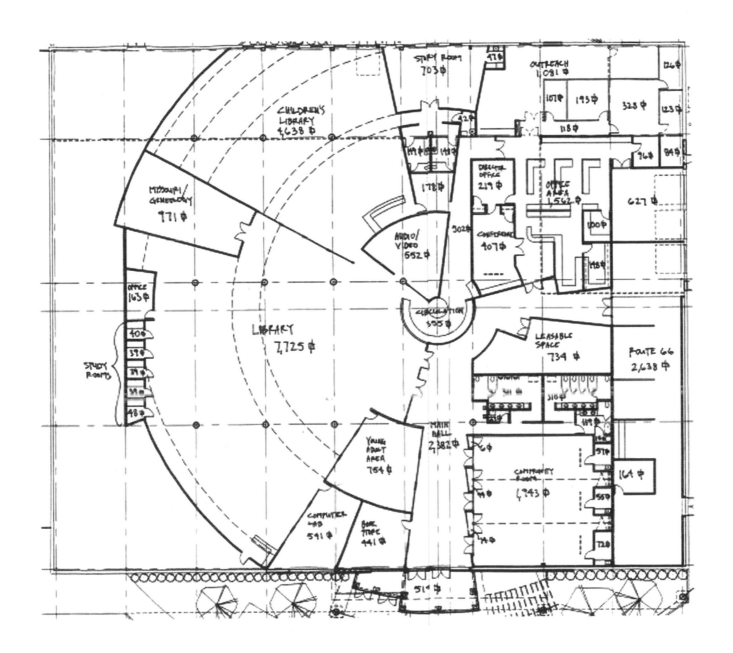

7.9 The building plan, designed and drawn by JPS and Associates. Courtesy of JPS Associates and the Lebanon-Laclede County Library.

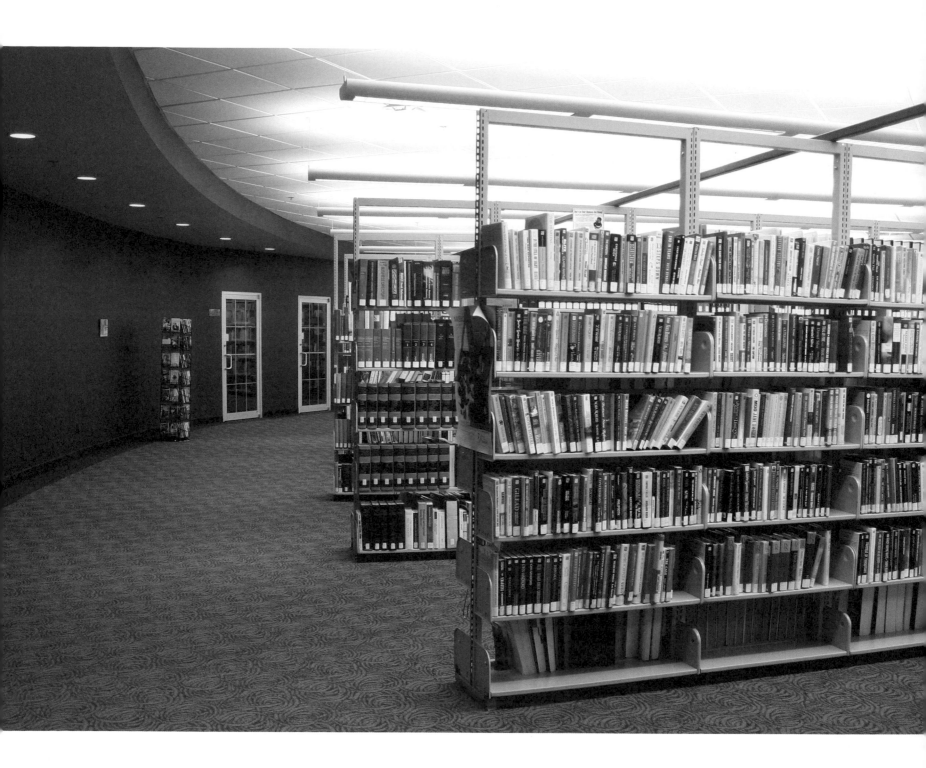

7.10 Interior of the library space. The rounded ceiling and outer
walls exhibit the "ripple effect."

his life to the project. His wife, Joan, donated her services as interior designer, working additionally as constant companion to her husband, the project manager. "We ate, slept, and breathed this library into existence. This is what we talked about at breakfast. This is what we recapped at night before we fell asleep: what had happened that day, and what was on the agenda for tomorrow," says Ms. True.

Students raised $4,000 in pennies for the site. The hand-carved tree mentioned at the beginning of this chapter filled up so fast that new ideas had to be invented, and the group started to fill up hand-carved bookmarks with gold nametags as well. Meeting rooms were "sold," story rooms were "sold," and study cubbies were "sold"—each designated with an appropriate plaque. The team joked that it was going to begin selling commodes. There are so many names on the walls of this library, over every door and in every corner. Students from the nearby public school painted the murals in the children's library, and each of them hid his or her name in the paintings, so that a grouping of clouds might say "Sarah," or the bubbles floating out of a fish's mouth might spell "Johnny." Literally thousands of names are embedded here, and the efforts of the people are immortalized in their library.

The six meeting rooms in the building are constantly in use, free to the public. Boy Scout and Girl Scout troops, knitting clubs, quilting clubs, the Literacy Council, and several other local clubs use the space constantly. Police troops even meet there from time to time. A restaurant is also located in the library as well, Maria's Route 66 Café, which caters events held in the library and around town. I have lunch with the project team at Maria's Route 66 Café, the library's restaurant. The menu consists of Southern and Latin fare. Maria Stone has a full-time staff of four, plus herself, plus part-time people who work at catering events.

I have a cup of coffee with Stone in her café, later in the afternoon when things slowed down a little, to learn more about her involvement with the library and how it relates to the community in Lebanon. Stone tells me she was a social worker in her native Costa Rica, but when she moved here to Lebanon to be with her husband, she took a job at the Lee Jeans factory. Lee was the top employer in the area, prior to its 2002 move overseas. Stone was sent to Mexico with the businesspeople who were implementing the factory there in order to explain the work to the new employees, since she spoke the language fluently. Seven hundred and fifty employees in Lebanon lost their jobs with the factory's move to Mexico. "It was devastating when Lee left; it was such a good job here in Lebanon," Maria tells me. In the local factory employees had cut the denim, then sent the

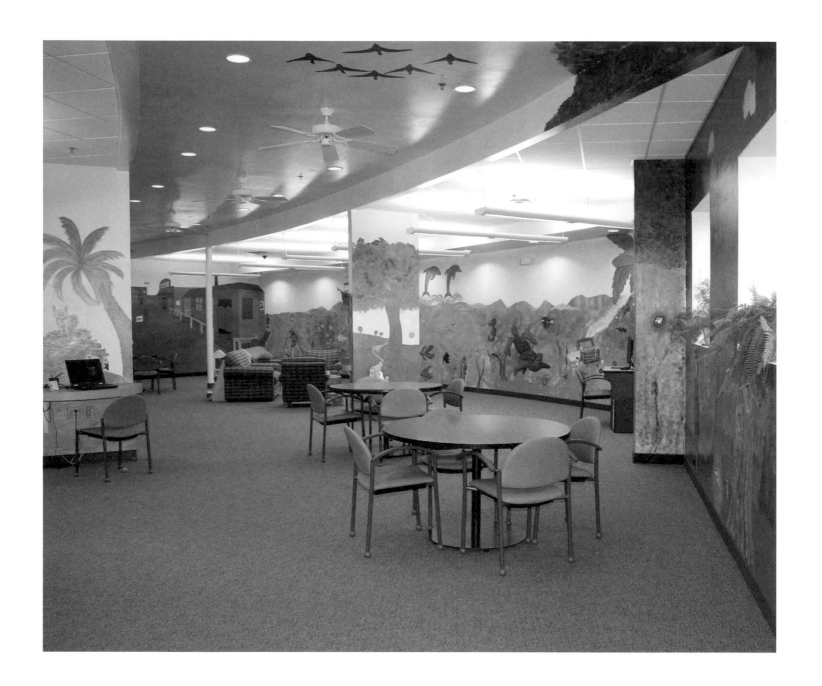

7.11 Children's section, covered in murals painted by local students. Again, the outer walls and the ceiling show the rounded structure of the big box's new interior.

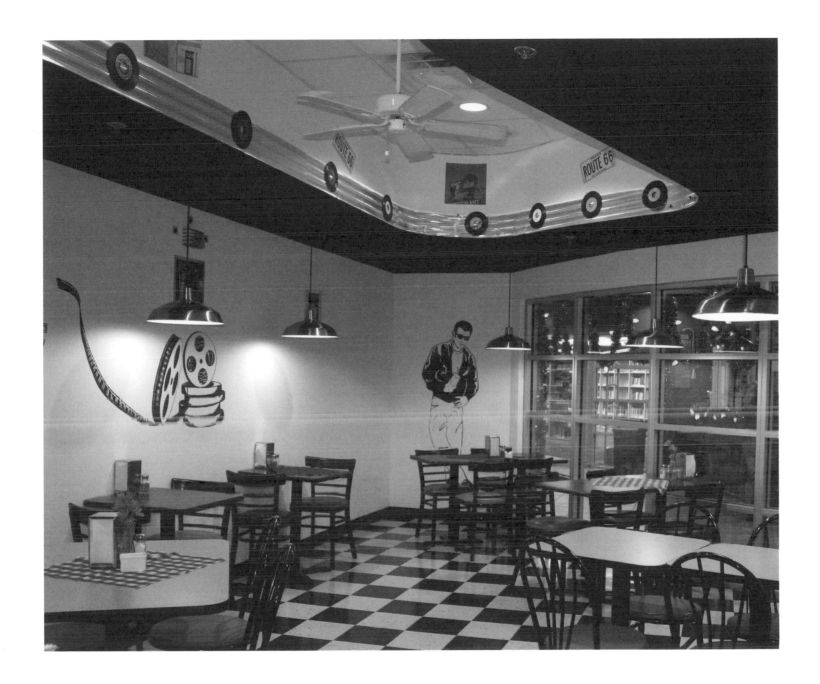

7.12 Maria's Café, the complex's restaurant featuring food by chef Maria Stone.

fabric pieces overseas for assembly. The product then came back to Lebanon, where it was finished.

"Imagine the impact on the town, when a substantial percentage of the population is suddenly forced to rethink their lives. People had been working at the factory for ten, twenty years, and when it closed, everyone had to stop and think: what do I do now?" she says. Stone explains how these employees filtered into various workforces in the area; some became nurses or retail workers, others became teachers, and still others went back to school. This included Stone herself, who decided to go to culinary college to become a chef. This scenario is not unique to Lebanon, as towns all across the United States are facing the removal of labor as factories move overseas. As I was sitting and speaking with Stone, a business owner, in her successful restaurant, I became very aware of the ground-truth that I was experiencing: I was talking with an immigrant Costa Rican social worker, in rural southwestern Missouri, who had lost her job at a global blue jeans corporation when it shifted its manufacturing to overseas. We were drinking coffee at a table in her Americana-themed restaurant, housed in the town's public library, which existed in what used to be a franchise of the internationally recognized Kmart Corporation.

True and Wheeler double as city council members, and they are proud to tell me that the workforce is currently burgeoning once again in the area. They tell me that over seven hundred jobs in the county are available to workers, and that seven thousand people work in the county's local industry. This includes Detrio Tool, Case Knife, Durham Manufacturing, and the largest oak whiskey barrel factory in the nation.

Maria's Café is painted with murals of 1950s waitresses on roller skates, black-and-white check floors accented by a black-and-white piano keyboard streaking across the walking space. There are mugs for sale, as well as cookbooks compiled by the local Literacy Council, which is also headquartered at the library. Stone thinks of herself as lucky, saying she could not want anything more than the business she has fallen into at the library site. Originally she was going to build a shed behind her house and start a catering company from home, but when she heard this restaurant possibility was available, she jumped on it. "Business is so good here, and it is just great being here everyday, taking part in this community center," she concludes.

In Lebanon, the movement into the new building is a compelling example of the life cycle of a library renewing itself. This story is a snapshot of a library's entropy within the current dynamic structure of the twenty-first-century American town. The building itself was moving to a new site, on the alleged new Main Street in town. The library also

had an obvious characteristic common among the big box reuses I have documented—this new library was of gigantic scale. The supersizing of American institutions is catching on all over the United States, and the library in Lebanon had followed suit. There was also plenty of parking, the most typical twenty-first-century shift in civic necessities, as "Main Street" becomes less of a place of for people to walk and more of a place for people to park. The building's placement in an auto-centric location on this new Main Street allowed traffic to flow easily in and out of the lot, connecting the building once again central to civic life, in the new form of a library.

Because this new library houses several smaller agencies, the operation has gone from a community institution to a community center. The fabric of the monolithic structure itself is being reconceptualized, as the human tendency to connect activities and patterns comes together under one giant roof. The space in this giant building is creating not only a supersized library but also a textured community center, with many destinations dwelling together simultaneously.

"We did not reinvent the wheel," Dame says. "We were well aware that new libraries are often starting with a trick up their sleeves, a draw beyond the books. Route 66 is a part of our local history." The Lebanon-Laclede County Library ties the town's past local Main Street to its new global Main Street. America's historical Main Street—Route 66—happens to coincide.

8.1 Signage for the Calvary Chapel in its Winn-Dixie location. The grocery store-turned-chapel is in the background. This building is currently vacant, after briefly being occupied by another church.

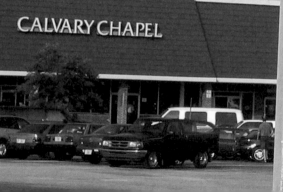

MAINLANDS PLAZA
9001-9185

POST OFFICE | SCREEN TEST
BELIEVER'S WORLD | COMPUTER VIDEO

HAIR DESIGN | AUCTION
CHEF TIM'S DELI | REAL ESTATE

OFFICE SUITES
FROM $225 PER MO.
UTIL. & SECU. INCL.
727-577-3862

CALVARY CHAPEL
SERVICE TIMES
Sat 6:00p.m. Sun 9:00a.m. 11:00a.m. Wed 7:00p.m.

www.ccstpete.com

CALVARY CHAPEL

THE CALVARY CHAPEL

REUSED WAL-MART BUILDING
PINELLAS PARK, FLORIDA

I drive along a commercial road that cuts through a rare orchid preserve. I sleep at a campground covered in asphalt, situated next to a river swimming with wild manatees. When I awake, there is a rocket launching over sleepy willow trees in the distance. Strip malls magically rise out of savage swamplands; firework stands are nestled between boutiques selling evening gowns.

I am in Florida. Buildings bubble here like foam on the ocean, and the landscape grows over itself in its sleep. My destination is Pinellas Park, the city between St. Petersburg and Clearwater in the sprawling Tampa Bay area. Pinellas Park is home to the region's Calvary Chapel ministry. During my first visit here in 2002, the church holds its congregational meetings in a renovated Winn-Dixie grocery store on U.S. 19, the most heavily traveled north–south road in Pinellas County. When I arrive in Tampa it is late at night, but traffic across the bridge is thick. With the windows down I am aware of hundreds of cars, and the street is alive with the buzz of four times as many tires. The hot concrete orchestrates the heavy, dull noise of sprawl.

The sound of sprawl is created primarily by movement. It is made up of people traversing from one point to the next within a maze of development. Sprawl inevitably offers unique notions of "community," with so many people constantly moving over a large land mass. The state of Florida has a long tradition of fabricating dwelling compounds, experiments in community revolving around air conditioning and the automobile. A handful of recent iterations of the community compound, the new urbanist designs, attempt to minimize the reliance on automobiles. Generally these designers strategize the displacement of cars by creating multiuse developments with zoning

laws built right in, and structures are often connected by a form of public transportation. I have seen retirement communities and age-restricted villages composed of identical homes where everyone drives around in golf carts while their cars are parked in the driveway. I have visited living communities built on man-made urban canals lined with Astroturf lawns, where neighbors are meant to get to their shared grocery store and croquet court by boat. Retail, education, and health care are often within walking distance of the token front porch—possibly everything one would ever need in order to live. Often, the stores, schools, and medical clinics are owned by the developers themselves, or by another corporation who benefits through a mutually lucrative deal. In Seaside, Florida, the most famous incarnation of the new urbanist agenda, ample sidewalks are intended to remove the need for a car altogether.

The New York Times reports, however, that Seaside has become a major tourist attraction and is a second home for most citizens, so that "now thousands of people pass through Seaside every summer day. And many of them stop to visit its shops and restaurants. The result: cars are parked everywhere, and S.U.V.'s clog streets designed for bicycles and feet."[1]

Here in the Tampa Bay, as I drive over the five-mile bridge to Pinellas Park, the number of cars still on the road at midnight tells me that this population is on the move. Regardless of Florida's isolated pedestrian-friendly living experiments, this state's citizens continue to proclaim their love for the automobile. These highways are home to constant movement—this is the one place in town where everyone spends time together.

I think back to my childhood in Bardstown, Kentucky, where historically the city's churches, hospitals, and most schools were within walking distance. In a town where walking is still an efficient means of transportation, neighborly exchange takes place in the great outdoors. Sidewalks and street corners provide a forum for interaction. In her 1961 book *The Death and Life of Great American Cities,* Jane Jacobs writes, "A city sidewalk by itself is nothing. It is an abstraction. It means something only in conjunction with the building and other uses that border it, or border other sidewalks very near it . . . Streets and sidewalks, the main public spaces of a city, are its most vital organs."[2] The sidewalks in the traditional Main Street scenario are an extension of the businesses and churches that are connected by said sidewalk, a shared "front porch," allowing human interaction to contexualize the structures within the urban fabric.

Here on U.S. 19 in Pinellas Park, Florida, the home of the Calvary Chapel, no one walks to church. In fact, according to the Pinellas County Metropolitan Planning Organization, twelve pedestrian deaths and fifty-two pedestrian casualties occurred on U.S. 19 be-

tween 2004 and 2005.[3] The Calvary Chapel is a parish of commuters, people who drive from all over the Tampa Bay area to get to service. The most important thing about the context of this structure is the extensive infrastructure for automobiles that surrounds it. Some drive from fifty miles away, some drive from twenty miles away, some have to pick up the kids from soccer practice before crossing a bridge, some stop by the new Super Wal-Mart prior to church to pick up snacks for Sunday school. Calvary Chapel members arrive at separate times, in separate cars, all coming from separate points of origin.

"The Pinellas Park location is perfect for our church. We are not dependent on the traffic. We are just trying to move roughly a thousand people from all over the Tampa bay to the parking lot of one building, simultaneously," says Bob Corry, associate pastor. Corry and his assistant, Cindy Neidert, are my astute and friendly tour guides when I visit the church. They are incredibly knowledgeable about the entire renovation process, and Corry himself was very much a part of the design team, as was the rest of the ministry staff.

The church moved into the Winn-Dixie with a congregation of roughly seven hundred people, taking over the lease from Winn-Dixie, who was in the fifth year of a twenty-year lease. The 43,000-square-foot building had enough space for the auditorium, the lobby, twentysomething classrooms, several conference rooms, and a bookstore.

The first thing I notice when I walk through the doors of the Winn-Dixie church is the gigantic lobby. When I witness a service a couple of days later, I see why the lobby is so big—most of the parish arrives well before the service begins. Some have a seat at the café, some grab a cup of free coffee from the coffee station, some hang out in grouped chairs scattered around the space. The crowd grows slowly, so that over the course of two hours a congregation of two thousand parishioners will arrive. They slowly fill up what used to be the pharmacy and meat departments of the Winn-Dixie store, departments of the market large enough to create a lobby for this number of people. "The lobby promotes fellowship, and fellowship promotes relationships. And that is what is at the core of our church," says Corry.

A large parking lot accommodates the hundreds of cars in which the parishioners will arrive. And perhaps most important, the building is at a location equidistant from most anywhere in the Tampa Bay area.

Behind the lobby is the largest room in the building, the auditorium, where services actually take place. It is consciously called the auditorium rather than the sanctuary, reflecting Calvary Chapel's self-described philosophy of a "laid-back Florida church." Corry explains, "As soon as you start including icons and steeples in your buildings, things people just don't understand, the more estranged the congregation becomes when they

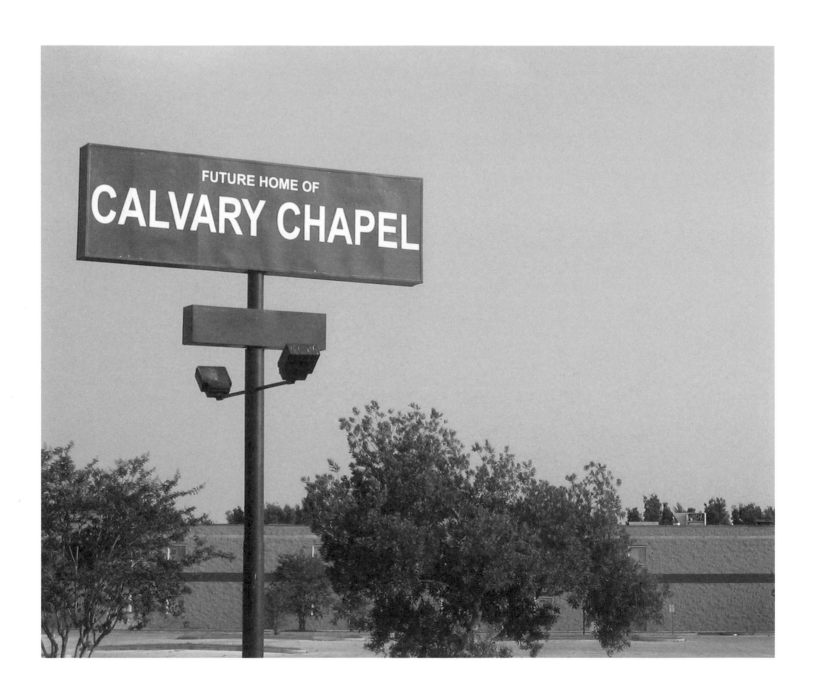

8.2 Reused Wal-Mart signage directly across the street in 2003, after the church had bought the Wal-Mart building and was just beginning to renovate. The words on the original Wal-Mart sign announce "Future Home of Calvary Chapel."

walk in the door. So here, you'll find an 'auditorium,' and it looks like an 'auditorium.' We don't want iconography to be the reason that people stop going to church, we don't want to set up obstacles that we think will push them away." This is not a new philosophy for evangelical Christian faiths, which have always been known for emphasizing the congregation over the building. In this context, the big box is perhaps the revival tent of the twenty-first century.

This auditorium, as it turns out, is in what used to be the produce section of the church. This is, in fact, the third time I have heard of big box churches placing the sanctuary in the produce section. The produce aisle of the grocery store is the section that has the fewest pillars, so sanctuaries—or auditoriums—are often laid right into that space. (I have personally never been able to look at a produce aisle quite the same since I learned about this design trend.) "When we drew the stage and the first few rows over the blueprints," says Corry, "the whole thing laid out real nice." The auditorium includes a large stage along the front wall, housing over a thousand seats. There is a full sound system, a video projector and screen on the stage, and a full band that plays during services.

According to Corry, the renovation was a success, especially as a learning experience. This was not the chapel's first renovation; it had held services in other warehouse spaces before this one. There was never going to be the opportunity to buy the Winn-Dixie building though, which was owned by a real estate company in Germany. The church was growing at an extraordinary rate, and 43,000 square feet was not going to work much longer. Big box retailers generally stay in their buildings for five to seven years before moving into bigger supercenters. This statistic was holding true for this church as well, and as it absorbed the big-boxed landscape surrounding it, the Calvary Chapel also needed to expand its square footage.

When the adjacent Wal-Mart franchise on U.S. 19 closed its doors after nine years of operation, the administration at the Calvary Chapel shook their heads and laughed, "What if . . ." They made a bid on the space. Word had it that they were being outbid by a number of parties, but they held on. In this case, Wal-Mart was requiring $50,000 upfront to even bid on the property, and if the bid was accepted, that money was hard, meaning it would go directly to the downpayment. It is impossible to know the logistical reason the Calvary Chapel triumphed in the end, despite lurking higher bidders. The church attributes its luck to the grace of God, and my questions to Wal-Mart have gone unanswered. Maybe it was because these other bidders allegedly requested zoning changes that would have caused Wal-Mart time and money; maybe it was because the Calvary Chapel had all its ducks in a row, cash for the property, and a sparkling real estate record;

maybe it was an image-booster for Wal-Mart to put a church in an old building. Whatever the reason, the Calvary Chapel was able to purchase fourteen acres of Wal-Mart's abandoned property at a very low price. It bought the building while Wal-Mart was still occupying it. Wal-Mart moved out in October 2001, and the Calvary Chapel took control of the building in February 2002.

Corry and Neidert take me across the street to view the Wal-Mart structure, which is just being gutted. We drive across the street (which has four lanes for traffic, plus several turning lanes) to get to the up-and-coming church building. This is my first experience in an empty big box building. No camera or words can describe the vastness of that space, the hollow, dark, cold steel cavern of Wal-Mart's wake, tens of thousands of square feet. Wal-Mart had moved just up the road on to a five-acre lot of land that it bought from United Artists, for which they paid hundreds of thousands of dollars more than the Calvary Chapel had paid for this building, which was on seven acres of land. Construction workers were milling about the gigantic dark space, measuring distances, clearing debris, hauling barrels of scraps, and filling dumpsters of trash. They were busy with the various tasks of transforming a big box building into a church.

The original Wal-Mart sign still lingers in the parking lot at this empty building, and it has simply been painted over so that it now says "Future Home of Calvary Chapel." I ask Corry if the reuse of that sign would draw new parishioners. Was Wal-Mart's symbolism being adopted by the church, making an entryway into the parish for people who possibly felt more comfortable in the Wal-Mart building than they would in a traditional church? "People are definitely curious," says Corry. "Do you know how many people drive by there everyday, and see the old Wal-Mart sign saying 'Future Home of Calvary Chapel?' The curiosity factor has got 'em: what did we do to make the store into a church?"

Four years later, I have come back to Pinellas Park to document updates at the new site. "Who's that person hanging off the entrance post?" laughs Bob Corry, as he and his wife jump out of the parking shuttle to greet me. I am indeed precariously hanging off a street post with my camera trying to get a good shot of the cars filling up this parking lot. The Calvary Chapel is now fully located in the Wal-Mart store. The Corrys are excited to show me what they've done with the place, and likewise, I anticipate seeing what has happened within those walls. "Everything that you will see in this building is an evolution from a past experiment," Corry explains excitedly as I climb down from the street post. "Our church went from a warehouse with a coffee table and donuts, to the little box across the street, and now, over to this big box. This time, we're doing it right."

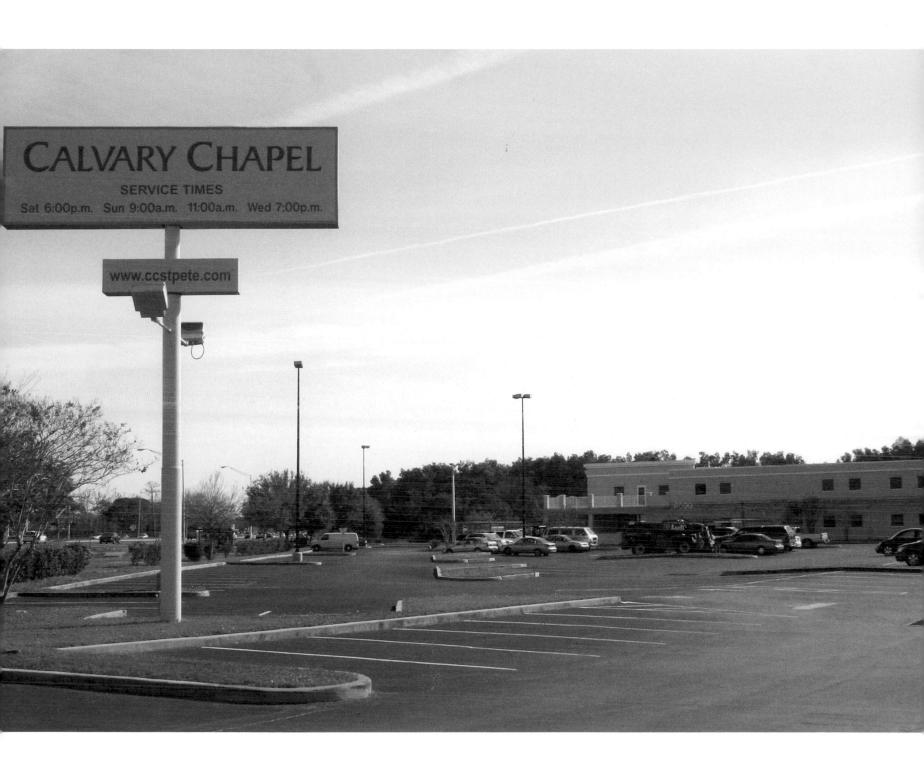

8.3 Same sign in 2007, by which time the church had completely renovated and moved into the Wal-Mart building.

8.4 View of the church's parking lot from the veranda on top of the renovated Wal-Mart building.

The hundreds of cars in the parking lot indicate that the flock agrees. The congregation here has grown from 700 to 3,330 since its days in the Winn-Dixie building. (That structure, incidentally, became yet another church, Grace Chapel, after the Calvary Chapel abandoned it. Grace Chapel, however, did not survive, and so this church building is currently on the market.) Corry and his wife take me upstairs to the new veranda on the roof of the old Wal-Mart so that I can get the shot of the parking lot that I was looking for. About 1,000 square feet of space atop the east side of the Wal-Mart building has been turned into a patio, with a white picket fence surrounding it. The perimeter of the patio is lined with tan marble bar top tables, and stools will be placed up here for people to hang out. The veranda overlooks the parking lot to the north side, and it faces the children's playground and large skatepark to the east.

The skatepark and playground, which includes a covered sandbox for use in inclement weather, are situated in what was once the outdoor portion of Wal-Mart's gardening section. The recreation area continues inside to fill the interior of the garden area as well. The lower level houses courts used for basketball, dodgeball, racquetball, and volleyball. The church also constructed a second level in this area, used for pool tables. From the poolroom, a visitor can access the veranda. The youth area extends into the northeastern corner of building, where the youth have two state-of-the-art ninety-six-seat theaters, called The Summits, to use for screenings and music. I also wander into a hangout room called The Cave, dressed up in hip décor, retro 1970s, very Urban Outfitters.

By experiencing this youth center, and walking out on the veranda where people mill about and stand at tables looking out over the parking lot while having refreshments, I realize that this big box has become more than just a church. Like the other big box reuses, this is a community center. The sliding definition of public and private space is blurred within these buildings, as community is formed within the dispersed private envelope of the big box retailer. I tell Corry that everywhere I go, I seem to find that the building becomes more than just the church, or the library, or the health care facility. It becomes a center for community as well.

"When you are using this much space," says Corry, "it is either because you are an incredibly extravagant person who needs a lot of space to, say, drive a model train around, or because you simply need the space and the location for practicality. We fall into that second category. We are here because it makes sense, and we use every square inch."

The church's building plan brochure states, "Our purpose has always been to make ministry to people the number one priority. We realize the necessity of a church building. We simply want to make sure that the building never becomes the ministry, only a



8.5 The garden section of the Wal-Mart building, which has now become the youth center. Traces of overhead cargo doors can be seen in the walls in this room. The youth center now hosts many activities and features basketball and racquetball courts.

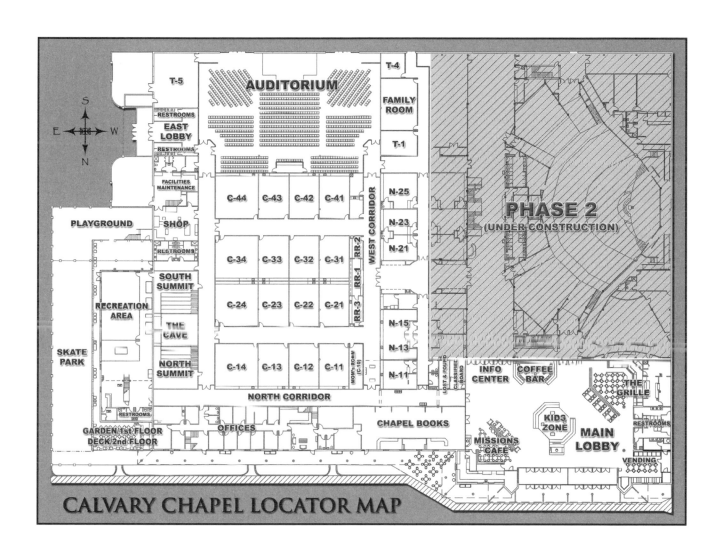

8.6 The building plans, including the first and second phases of development. Courtesy of the Calvary Chapel.

means to that end." The brochure goes on to explain that renovation here is occurring in phases. The necessities were taken care of in phase 1, larger meeting spaces and structural improvements that will allow for growth. Now that they are moving into phase 2, the renovation will be completed on a pay-as-you-go basis. The church hopes to keep debt low and never wants money to be at the forefront of its ministry. "Money is not our problem; we leave that up to God. If we don't have the cash, oh well. That is our philosophy. Keeps things simple," says Corry.

Design is a process at the Calvary Chapel. "We are not a public school or a governmental agency with a 'proper' way of doing things. We have no set plans or set design that we have to follow," says Corry. "Because we are a church, a congregation of people with specific needs and the wherewithal to fulfill them, the building is evolving along with us." The building plan was designed so that renovation would occur in phases, as time and money allowed. Although the congregation is on a tremendous course of renovation, plowing through an immense evolution of the building, its members are taking it "in God's time," in the words of one associate pastor. With careful forethought, phases of development have been planned so that the church will never have to backtrack; no completed renovation will ever be torn up in order to execute the next task.

There are hints of phase 2 embedded within the renovations of phase 1. The future auditorium looks much as it did when I visited the building prior to the chapel's reuse, when it was still a great big empty Wal-Mart. The future auditorium, today, is still raw space. Cindy Neidert tells me that the room is used mostly for storage and staging now, so it is useful. "But when we get to renovating this portion of the building, we will blow off the roof and add a second story. There will be new adult classrooms upstairs, and the auditorium itself will have very high ceilings, and theater-style seating."

Corry points out a seam in the cement floor near the wall that separates the lobby from the future auditorium. "When we built the wall for the lobby, we installed a reinforced steel footer beneath it. We knew that in the future we would be turning this space into an auditorium. Everything was planned in advance, so we also knew that there is going to be a second floor here. When we built this wall we built it for the future, we reinforced it. It is already strong enough to support that second floor, even though it may be years before it does so. We will not have to tear up this wall or the lobby in order to work on the auditorium for phase 2."

I see these clues in other parts of the building as well. Certain halls are decorated on one wall but not on the other, a telling sign that more renovation awaits behind the plain wall. Near the youth classrooms, Neidert, Corry, and I sit for a minute in a grouping of

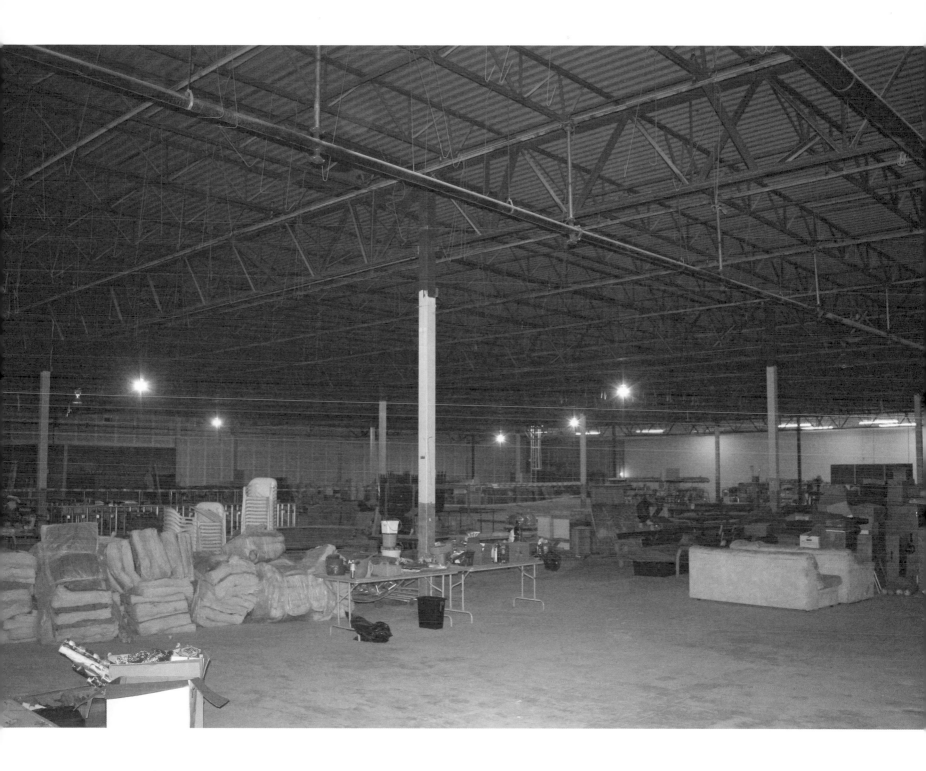

8.7 The future auditorium, which is now used as a storage and staging area.

chairs placed under a half-circle of molding on the ceiling. Corry explains that this is half of a future rotunda. On the other side of the wall is the other half, and the wall will be blown in phase 2, exposing the entire 360 degrees of molding. Then the roof will be expanded vertically, so that the circle will become a rotunda.

Several people on staff are directly involved with the renovation, adding even more flexibility and knowledge to the building process. Associate Pastor Frank Dehn is a licensed general contractor who oversees mission-oriented disaster relief construction projects in Florida, Louisiana, Mississippi, and elsewhere. He also acts as building construction and maintenance supervisor at the church site. "When I first joined the church, I almost quit my construction job immediately," he recalls. "Right away, I wanted to go and feed the poor and help the sick, do the things that I thought new Christians are supposed to do. But I prayed about it, I asked others for guidance. I was getting the message that I needed to stay in construction for a little bit longer, that there was more for me to learn there. I worked at my construction company for seven more years, and I started to move up the ladder at the company. I wound up as the superintendent on the construction team—and during that time, I oversaw the construction of four Wal-Mart and Super Wal-Mart buildings."

The real kicker came twelve years later, when the Calvary Chapel bought the Wal-Mart building. Dehn says, "I never imagined that I would be superintendent at one of these buildings again, but this time, renovating it, building a new church for my congregation."

The exterior of the building has been painted tan. The front porch extends the length of the building, as it did when it was the retail store, but now it is covered with an awning. There is rain in Pinellas County, and getting from your car at the far end of the parking lot to the door can be a wet trip in stormy weather. So there are parking shuttles, short buses that cruise the lot, taking people to the building. The brand-new doors are placed exactly where Wal-Mart's doors were. And through these doors, I enter the lobby.

Corry tells me they learned from their experience in "the little box" that the Calvary Chapel needs lots of room for circulation. "When you are designing a building for this many people, you have to visualize the people just as much as the walls or the rooms," says this pastor-turned-planner. "When you visualize thousands of people in a volume of space, you have to imagine there will be people waiting around, there will be people needing to eat, there will be people working, and there will be people moving." The new iteration of the church in the Wal-Mart building has larger halls (12 feet wide), a larger auditorium (with an even larger one on the way in phase 2), and this gigantic lobby.

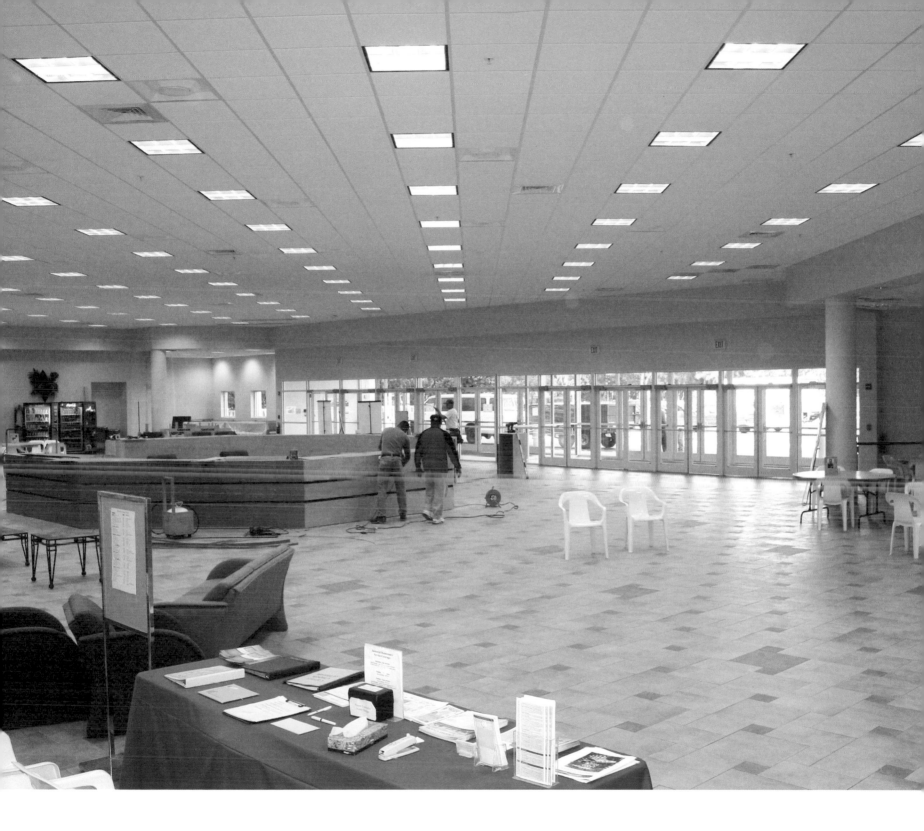

8.8 The 3,200-square-foot lobby. The children's play area in the center of the room is still under construction.

8.9 The Calvary Chapel's North Corridor. Each section in the corridor is painted a slightly different hue, breaking up the visual monotony of the long hall. This hall runs along the front of the building, and leads to most points throughout the entire structure.

The lobby is 3,200 square feet. A children's play area is being added to the center of the space, so that children are never shoved off to the side somewhere; they are always in the center of the space. The future auditorium sits right behind the lobby. The lobby hosts a full grill, open for business throughout the week and before and after every service. It is open to the public, and people come for lunch from the surrounding businesses. A Caesar salad with chicken is $4.00—no tax, of course, since in the United States, most churches are tax-exempt nonprofit entities. On the other side of the lobby is the bookstore. The store is also open all week and before and after every service, selling books by Calvary Chapel authors, Bibles, and religious trinkets. When I ask how many square feet the store is, Corry looks up and starts counting ceiling tiles, then gives me a concise 2,400 square feet. The associate pastor knows his building.

The lobby has a free coffee bar and a full selection of ice cream and pastries. Groupings of chairs are scattered throughout the lobby, and there are clear lines for circulation from the front doors directly to the auditorium and directly to the long hallway that begins on the east side of the lobby. This hallway is so long that the designers decided to change the color on the walls every fifteen feet or so, light, medium, medium, dark, dark, medium, and so forth. This gives the long hall the illusion of having several sections. "It looked so long when it was all one tone, just massive," said Neidert. "And institutional."

This hallway extends across the entire front of the building. It leads to the fellowship hall, the classrooms for Sunday school, and to the fully functioning preschool. The preschool meets every day from 7:00 a.m. to 6:00 p.m., serves forty-five students, and uses twelve rotating teachers, plus Kem Busbee, the preschool coordinator. It uses four of the twenty-five classrooms, plus three other meeting rooms. In phase 2 the church will see the addition of ten more classrooms, bringing the count to thirty-five. Explains Neidert, "Our church has a strong emphasis on age-specific teaching. No children under six are allowed into the service. Danny, our teacher, is not gearing his sermon to that demographic. We have teachers that are trained to work with that age group. This building allows us to conduct classes for every age range, there is room for everyone." The halls in the preschool area have been decorated with colorful murals, painted by a local company that does mural work for churches and hospitals. I have seen murals covering walls in big box churches all over the United States, as well as in big box libraries, museums, and medical centers. Ceilings are anywhere from twelve to eighteen feet high in these buildings, and large walls apparently often trigger people to paint.

We head into the current auditorium. The stage contains a setup for a full band. I witness the service on a Sunday morning, when the band is playing. Corry is the coordinator

8.10 The auditorium.

8.11 The auditorium.

of music for the fellowship, and he leads the band on amplified acoustic guitar. The church service begins with Corry asking the congregation to rise, and in unison, they sing a contemporary Christian rock song asking God to come and fill the space, the space that was once a retail store. There are about 1,500 people in the room, singing in unison.

This congregation does not function on a Sunday service alone. I think again to Bardstown, my small hometown with its traditional Main Street, where it was actually possible for churchgoers to choose a church closest to their home and walk there on Sunday mornings. The congregation was probably made up of other people who lived near them, and if the congregation wanted to have fellowship throughout the week, they could walk to their neighbors' homes. The church community could potentially be based on geography.

This congregation is a group of people who have found each other through the structure of this church, amid Florida's famous urban sprawl. This community does not have close proximity in common. Even students in the preschool come from several different towns surrounding Clearwater, St. Petersburg, and Tampa. Pinellas Park is in the center of this sprawl, and due to Wal-Mart's razor-sharp logistics department, this building is in a perfectly accessible location. This geographically dispersed community finds its common space here. The lobby inside serves as its new street corner, the place where people stop to say hello.

I ask Dehn if, in his construction days, he ever thought about the reuse of the Wal-Mart buildings when they were going up. "Never even crossed my mind. The thought never entered my consciousness. I had never seen anything like this, so I did not know how to imagine it. We were just concerned with getting the new buildings up by Wal-Mart's deadline," Dehn responds. "When I was working on my last building, Wal-Mart had a building a day opening in Florida, and we had a race going with the guys in Titusville. We were not thinking about the future of the buildings at all, just racing to see who could build their Wal-Mart faster."

FUTURE

The Clock of the Long Now: Time and Responsibility is the treatise of the Long Now Foundation, an organization that hopes to promote long-term thinking and responsibility. In this book, Stuart Brand writes, "People already refer to the near future in months instead of years, and to the distant future in years instead of decades or centuries. What may happen decades from now—beyond the imagined event horizon—is treated not only as unknown, but unknowable. Under such conditions speed becomes glorified. Haste switches from a vice to a virtue; behavior that once might have been called reckless and irresponsible becomes swift and decisive action."[1]

The accepted presence of the ephemeral big box buildings speaks to this perceptual time frame. We are living in the moment, without much consideration or understanding of our relationship to the future, as we remove mile after mile of green space, open space, public space.

Our networked world and vast modes of instant communication have helped to collapse our perception of time. The information age has sped up communication and invention, so much so that we imagine a technological or political change that can eradicate our losses. "Swift and decisive" decisions are choices that keep us in the very narrow perception of the "short now," as our global decision-making processes become quicker and more dramatic. Today is treated like an isolated incident that will be washed out by the next swift and decisive action. It is impossible for us, as a universal cultural community, to predict the technological advance that we are expecting to save us from our own disaster.

Moore's Law is perhaps the closest thing we have to a prophetic equation for technological development. In his 1965 paper "Cramming More Components onto Integrated Circuits,"[2] Intel cofounder Gordon E. Moore discussed the trend that computer chips had "doubled in power" every year between 1959 and 1965, determined by the sole fact that engineers had been able to "cram" twice as many components onto an integrated circuit each year. Moore's prophecy was that the computer chip would continue to double in its power every year for the next ten years, until 1975.

Ten years. A decade. Moore's Law attempted to place a congruous, linear construct of time on the exponential growth of technology, setting a decade as the knowable future time construct. What we have found, of course, is that advances in technology are qualitative as well as quantitative, so that the number of transistors potentially "crammed" onto a computer chip is barely the sole indicator of technological advance. With every doubling of components, related technological advances are made more cheaply and more easily, simultaneously causing parallel shifts in any number of other technologi-

cal fields, well beyond the science of architecting the almighty computer chip. Meanwhile, Moore's decade has long since passed us by, and we are still seeing endless exponential growth of technology.

According to the oral tradition of the "Great Law of the Iroquois," in every deliberation, we must consider the impact on the next seven generations. Even seven generations is not long enough really. We must break through our construct of time, and just consider the impact of today on time's passing into forever. The Foundation for the Long Now has decided that ten thousand years is a good amount of time to conceptually work with, long enough for us to imagine it as "forever," and short enough for us to still have an idea of what was going on ten thousand years ago. Perhaps "forever" is only conceivable if we put a time frame on it. And that is fine; we are only humans.

At the beginning of this book, I talked about how reuse infers three tenses of time: the past, the present, and the future. However, every case study in this book is an examination of something that is actually happening right now, in the present. The point is, we must look at what is happening on the ground, in our own subjective truths and realities, in order to think critically about how each and every action relates not only to the past but also to the future.

The two case studies in part IV unfolded in the same time period that every other case study in this book has taken place—now, in the first decade of the new millennium. But I examine these two stories in the context of the future, possibly because my experience at these sites most made me feel as if I were living "in the future." These landscapes are like cyberpunk realities. As always, I encourage you to go back through this book and read the rest of the case studies and imagine their future impact, too.

And I will say it again: I encourage you to put the book down, go outside, and look around. Forget about the clock on the wall in front you (actually, take a moment to also consider that wall on which the clock hangs, and ask yourself, how did it get there?). Forget about the second hand and the hour hand, and consider the "long now" that the clock is not constructed to tell you about. Let your mind go. Think about the glacially moving larger sense of time, beyond semesters or quarters or weekends or moon cycles, beyond even decades or centuries, and think about how your life, your ground, your truth, is absolutely a part of that long, long line of time.

9.1 Wal-Mart building in St. Bernard Parish.
The store closed shortly after Hurricane Katrina.

THE ST. BERNARD HEALTH CENTER

PARKING LOT OF CLOSED WAL-MART BUILDING
CHALMETTE, LOUISIANA

The devastation in St. Bernard Parish, directly across the canal from the Ninth Ward in New Orleans, is stark. Around the world, we saw the pictures of destruction when Katrina hit town: houses with their roofs smashed on the front yard, windows broken, boats hanging in trees, spray painted messages covering house façades alerting officials about missing animals and household occupants.

The amazing reality is that as of this writing, in late 2007, it still looks like this. The concept that no picture can convey, and no video screen can capture within its frame, is the sheer depth of this vast devastation. Destruction goes on for as far as the eye can see, mile after torn-down mile. Houses are still lying on the ground in halves, and piles of dirt and trash are scattered around everywhere. Wandering around muddy sidewalks in Chalmette, the seat of St. Bernard Parish, I occasionally see a house being worked on by a group of locals, or groups of volunteers from outside of town, neighborhoods collectively rebuilding, people pooling their resources and helping each other.

For the most part though, this section of the New Orleans metropolis feels vacant. There are not many houses, not many jobs, and families have dispersed throughout the United States in a diaspora approximately 250,000 bodies strong.

The locally operated St. Bernard Health Center opened in a double-wide trailer supplied by the Federal Emergency Management Agency (FEMA) on the parking lot of Chalmette's closed Wal-Mart store, approximately fifty days after Hurricane Katrina hit the Gulf Coast. The Wal-Mart store had opened just a few months before the devastation that followed Hurricane Katrina shut it down. Still, it sits vacant, a huge brand-new empty building, with a trailer-turned-hospital in its parking lot.

The original Chalmette Medical Center of St. Bernard Parish was completely flooded by Hurricane Katrina. St. Bernard is located in East New Orleans, on the east side of the Inner Harbor Navigational Canal. The parish runs flush to the line of the Lower Ninth Ward; before the storm St. Bernard Parish's population was estimated at over 67,000, and in 2005 the population was estimated at 25,489, or roughly 38 percent of its pre-Katrina residents.[1] As of April 2008, the makeshift St. Bernard Health Center was still in operation, in a series of trailers that appeared to be even more ephemeral than the giant empty building that sat behind it. The clinic administration does not foresee movement anytime soon. The dust has settled now, and the trailers are firmly planted on the corner of the giant parking lot. The arrangement of trailers offers 72,000 square feet of space. The parking lot and the building, close to ten acres.

When Hurricane Katrina ravaged the Gulf Coast on August 28, 2005, the media was immediately abuzz with reports about big box retailers playing a role in recovery efforts, especially Wal-Mart and The Home Depot. How was it that these retailers were able to establish such relief efforts so quickly, and what motivated them to do so? And were they really able to help, or was this just another media buzz that the retailers had developed for themselves? How did the big box buildings, or the network of buildings, play into the relief efforts? Furthermore, how did a Wal-Mart parking lot come to host a health clinic in a major American city, in the twenty-first century?

Wal-Mart's entire Katrina operation was grounded in the corporation's system of distribution centers (DCs), and their surrounding buildings. Wal-Mart establishes a central DC first, and then is able to open and close buildings surrounding the distribution center at a relatively low cost, as they identify changing markets and demographics of its patrons. The surrounding stores make up a solar system of big boxes, and the DC acts as the sun. Goods are delivered from the distribution center to the stores nearby via the thousands of trucks that visit the DC every day.

I culled together a list of Wal-Mart buildings that were used as Katrina relief sites, and drove among them myself, to garner what I could about their connectivity. I did not have much luck finding information at the buildings themselves, since most of them had just been turned back into retail stores. It was hard to find anyone to talk to about the relief efforts that had taken place there; managers did not really know what I was talking about, nor did store clerks or passersby. The memory of the relief efforts at these stores was less in the minds of those on the ground, apparently, than it was in the papers or on the television or on Wal-Mart's Katrina-devoted website.

After I had driven to four stores, I thought I would try just one more site before returning to New Orleans. I assumed I was heading to another normal retail store that had been used as a "supply distribution center." I got a little confused by my Google Maps directions as I drove there. I seemed to be heading out of the town, Opelousas, and deeper into the country. Suddenly, I came upon a huge surprise, an interchange of several highways in what appeared to be the center of nowhere, surrounded by marshy Louisiana countryside. There was no activity here that could warrant the sudden mesh of bypasses and off-ramps.

Then I saw it, lurking behind the highways, flanked by hundreds of trucks and half as many cars. It was the distribution center. I had never been inside of one of these buildings before, and I had only seen them from the highway. Being in the parking lot, up close, the building was overpowering, set against the bare marsh of central Louisiana. Over the front door was a sign that read, "Through these doors pass ordinary people on their way to do extraordinary things." I parked my car, grabbed my notebook, and in my t-shirt and sandaled feet, walked in and announced my intentions.

My introduction got me through the first two levels of security in the building. I was then introduced to the PR administrator who could handle my situation. She told me we were not to talk until we got to her office. When we got there, she asked me who I was, how I got into the building, and who had sent me. She told me that usually nobody is let into this building, especially not a writer without a press pass, and that she needed my identification. I told her my story, told her I felt uncomfortable giving her my driver's license, and gave her the name of Kevin Thornton, the real estate spokesperson from Wal-Mart I had spoken with, along with the name of my book and my publisher.

My Wal-Mart contact's name did not ring a bell with her, nor did my book or my publisher. She told me that there was nothing she was able to talk about with me, and that I would have to leave the building immediately. I tried to tell her that I was only in Opelousas for the day and had traveled all the way from New York, and she continued to tell me that she was absolutely forbidden to talk about anything. That she would show me to the door. And she did. She even opened it for me and shooed me out. So that was that.

Although I did not get to speak with anyone at the DC about the recovery efforts, the whole experience offered deeper insight into how the disaster relief operation took place. Driving from one store to the next allowed me to visualize the network of these buildings, connected by the highway lines I was following on the map. And then coming upon the DC itself brought all of this together. This was the origin for all the big box merchandise in the area, the common denominator. During the disaster relief effort, all the

bottles of water and transistor radios continued to come from here, despite the storm. The disaster response was channeled through Wal-Mart's retail network. Just as the other reuses in this book have adapted the retail network carved out by the big boxes for their civic purposes, so had this corporate relief effort used that same network during a major American disaster. Fascinating, especially considering such a relief effort was not manifested by the U.S. government.

Wal-Mart's response efforts were facilitated somewhere between its Operations Department, and its Logistics Department, according to Thornton. He explains to me that the Operations Department is made up of the people who are on the ground in each location, who are able to look at the shelves and say, "Oh, I see that we need more shampoo." Operations is then able to link directly to the DC to alert it to the need for shampoo, and immediately that product is placed on a truck headed to that store. Wal-Mart's success is inherently based on its use of information technology. The company collects point-of-sales transactions, allowing real-time tracking of the inventory and sales patterns of all of their products.[2] The satellite and Electronic Data Interchange (EDI) systems at Wal-Mart were the most extensive in the world by 1988.[3] Thornton tells me, "The cooperation between the people on the ground and the people in the DC are what made Wal-Mart's recovery relief happen." Actually, the electronic logistics network is the real force of the communication system, and it is facilitated through the building nodes on the ground.

The structure of this network, and the highways and information systems that connect them, are at the heart of the just-in-time principle. This is the economic backbone of one-stop shopping. Basically, stores only have enough stock for sales in the very near future. This means, in effect, that Wal-Mart's goods are currently on the road all around us, in the trailers of the regional fleet of hundreds of trucks. The plan is simple; it uses the highways, the exits, the local governments—and the shoppers—most efficiently. Wal-Mart is able to constantly reroute its trucks in order to place the goods on the appropriate shelves, throughout the network. As Liza Featherstone pointed out in a 2005 article in *The Nation,* Wal-Mart's logistics system has calculated "that during hurricanes people eat more strawberry Pop-Tarts, [so] Wal-Mart has in the past responded to dire weather predictions in Florida by making sure stores in that region were stocked accordingly."[4] In terms of the relief efforts, when a service center needed bottles of water, "we were able to get them there right away," says Thornton. Of course, in August 2005, Wal-Mart reported that it had closed over 120 stores as a result of Katrina's affects. It was in the company's best interest to get those stores reopened as quickly as possible.

9.2 Road sign pointing to the St. Bernard Health Center.

Ultimately, Wal-Mart performed relief tasks that are generally assumed to be the role of the government, including the distribution of blankets, water, radios, and even strawberry Pop-Tarts. The Wal-Mart corporation has harnessed the infrastructure of the country so effectively that in a time of emergency, a time of disaster, those same networks can be put to use to save lives. These networks have been built for shopping, and as in previous chapters, the reuse of these networks shifts to the civic-minded utilization of our shopping infrastructure. What can Wal-Mart's effective relief effort tell us about the future of the relationship between the private sector and the government? How does this merging of the private and the public play out on the ground?

On my third day in New Orleans, I make my way to the site I was looking for, the St. Bernard Health Center. I have driven past it several times since I arrived in town, while I was busy examining the area that comes into contact with the Inner Harbor Navigation Canal, a part of the Mississippi River Gulf Outlet (MRGO). The MRGO levees were breeched in twenty locations, mostly throughout the Ninth Ward and St. Bernard Parish. Legend has it that every building but one was flooded in St. Bernard Parish. The parish's lone dry structure was that of the Chalmette Refinery, which belongs to Exxon Mobil Corporation.

Mike Pisciotta, head administrator of the St. Bernard Health Center, is a nurse by training, with a background in finance. He was employed at Chalmette Medical Center prior to its closing and was instrumental in the development of the health clinic site in the Wal-Mart parking lot. "There were basically eight entities that had to work together to make this thing happen, eight entities that had never worked together before, or had even considered the possibility of working together," he tells me. This group included the St. Bernard Parish Government, Wal-Mart, the Federal Emergency Management Agency (FEMA), the Franciscan Ministries, Our Lady of the Lake Health Services System, and other volunteer groups. This group was so unlikely because it included government, a nonprofit, a for-profit, volunteers, employees, and a religious sect. "The need was so strong for the clinic here, that these groups were able to set aside differences to work together to create what you see here today," contends Pisciotta.

Driving along Judge Perez Drive, which was once the main commercial road of St. Bernard Parish, I see parking lots full of trailers everywhere. According to Dave Peralta, chief administrative officer of the parish, at least 15,000 of the current 25,000 residents continue to live in trailers. In row after row of identical small trailers, thousands of families are beginning their lives over again, in fenced-in parking lot communities of small trailers. This, after having lost most everything else.

The trailers are flanked by flooded fast food restaurants that actually look as if they have exploded. The restaurants have no windows or walls, so you can see straight through them. Often there are colored seats still affixed to a cement floor, the colors signifying which chain was once located there—red and yellow for McDonalds, orange and brown for Taco Bell, yellow and brown for Subway. There are empty strip malls too, and empty stores, and empty movie theaters. Every now and then a bright-colored sign remains intact, so that amid the rubble, you see the commercialization that once was, the tombs of Chalmette's past retail life, the gravestones of St. Bernard Parish's retail base.

The Wal-Mart sign at the entrance to the St. Bernard Health Center looks just like any other Wal-Mart sign does; it is new and well lit. But beneath it is a second blue sign at the ground level that reads "St. Bernard Health Center." The first noticeable addition to the parking lot is a giant tent, fifty yards long and twenty yards wide. Behind it are the health center's trailers, connected to each other, a maze of trailers. Other trailers house a pharmacy, specialty medical clinics, an orthopedic office, and a pediatrician's office. The Wal-Mart is in perfect shape from the exterior, other than a few missing signs. It is obviously closed and shows no signs of opening.

I walk right into the main clinic, closest to the Wal-Mart entrance, to meet the nurse with whom I have an appointment. Thirty-four people are working on-site, and the trailers are all different divisions of the medical center: mental health, pediatrics, general health, and so forth. There is even a drugstore on the premises. The clinic is not free. The parking lot had been taken over by St. Bernard Parish for use as a medical center after Chalmette Hospital was drowned by the storm. I ask about the giant science-fiction-like tent standing in the front of the parking lot. Its use? "Nothing," says the nurse. "That tent was put there by FEMA and used as a relief center for about a month. They were saying in November 2005 that they would have it down by December. It is December 2006 now, and the tent is still standing there. Doing nothing." FEMA says it might donate the tent to the parish. "I have no idea what we would do with it if they donated it to us," says Peralta. Another structure that sits behind the medical center looks entirely out of place, the parish's sole Katrina Cottage, the housing idea designed by Andres Duany, leader of the New Urbanist movement. "That is the only Katrina Cottage that will ever exist in St. Bernard Parish," contends Peralta. The $35,000 cottage was designed as an alternative to the free FEMA trailer.

Although the health center here is not a reuse of the building itself, and is more accurately described as a "parking lot reuse," it still has several things in common with the other big box reuses I have observed. One similarity is the consolidation of like-minded

9.3 Signage in the vast parking lot, directing traffic through the Wal-Mart
parking lot to the health clinic.

9.4 More signage, with a FEMA tent in the background. The tent has not been in use since 2005, according to parish officials.

9.6 Privately owned pharmacy on the lot.

services, or the insertion of the multiuse fabric on what was once the monolith of the big box corporation. "We started with a few general practitioners, but eventually attracted a pediatrician, an orthopedic, and mental health services," says Pisciotta. Meanwhile, the privately owned pharmacy was initiated because there was no place in the parish to get the drugs that were being prescribed. "Wal-Mart was at first reluctant to allow any retail or commercial development on their parking lot," says Peralta. "But obviously the need for the pharmacy could not be dismissed."

Pisciotta walks me through the maze of trailers to his office. I am amazed at how solid the structure is from the inside; the trailers are connected seamlessly, and the ceilings, walls, and floors are clean and institutional. This is certainly a new form of medical architecture, emerging from this urban big-boxed landscape.

"When we opened the clinic, fifty days after the storm, most people were receiving care for abscesses, skin infections, puncture wounds, things that needed immediate assistance." At that point, the complex consisted of a couple of double-wide trailers. Eventually, FEMA helped set up the arrangement of trailers that are there now. With the expansion of the space, the clinic is able to see more patients.

"Now, patients have a gamut of problems," Pisciotta notes. It is still estimated that 6,700 people who are living in St. Bernard Parish are construction workers, people who have come here to help with the rebuilding, according to Peralta. But Pisciotta says the clinic has seen an increase in chronic illness, heart illness, and back pain, leading him to believe their patrons are becoming more residential. He recalls, "At first we had a lot of emergency clients who had commuted here for the day to work and got hurt on the job. The evolution from emergency injuries to chronic pain tells me that more people are living here, seeking out help for health issues that went uncared for while residents were away."

The thirty-four employees at the clinic live locally, and so do the five doctors on the staff. The clinic has clues to the elusive St. Bernard Parish population in its data, and demography reports are embedded in the clinic's statistics. Pisciotta tells me that the clinic sees an average of eighty-three people a day, when Saturday and Sunday are included in the equation. The weekend is slow, though, meaning that there are possibly more people in town during the week. The average number of people served by the clinic is drastically reduced when those days are included. Monday through Friday, an average of 105 people is served each day. Considering that the population in St. Bernard Parish is currently estimated at approximately 25,000, that means about a half of one percent are seeking medical treatment every day.

9.7 A lone Katrina Cottage, designed by new urbanist Andres Duany, flanked by the health center. The cottage
stands in stark contrast to the parking lot, a drastically different response to disaster. This is the only Katrina
Cottage in the Saint Bernard Parish, with its starting price of $35,000. As of December 2006, 15,000 residents
of St. Bernard were living in FEMA trailers after having lost everything to the aftermath of Katrina.
The cottage's paint is flaking off, and it has a broken window. The health center, situated behind the cottage,
sees over one hundred patients a day.

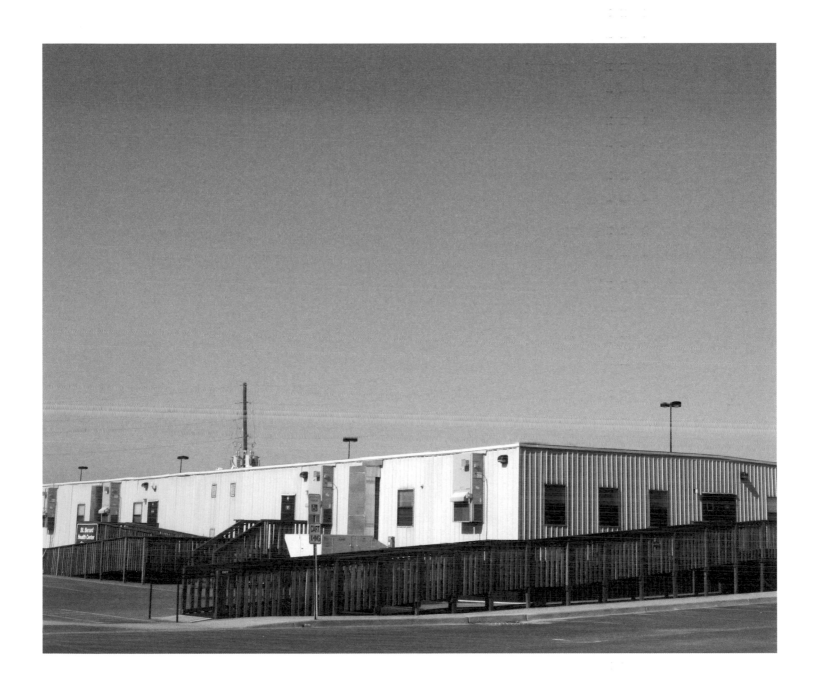

9.8 View of the St. Bernard Health Center, main trailer complex.

Numbers are slippery in New Orleans, and you can often read different statistics about the same issue in three different reports in the same day. Dan Etheridge, program coordinator for the Center for Bioenvironmental Research (CBR) headquartered at Tulane University, tells me, "Population and demography statistics in New Orleans are extremely subjective and uncontrolled at the moment. There might be a block where twenty houses are empty, and then in the twenty-first house one person is a registered resident. But there might actually be twenty-five people living in that house, workers and family members who lost their homes. The statistics will still show the block has one resident."

Etheridge specializes in coastal environmental studies, but beyond his work on how land and water use in New Orleans interact with culture, he is also very involved in community organization. He lists scads of community-driven organizations that are working in neighborhoods throughout the city to rebuild: Neighborhood Housing Services, Urban Build, The Porch Cultural Organization, Urban Conservancy, City Build, and ACORN. In Etheridge's own work, both with the CBR and with various community design groups, he believes in the power of the small victory. In a city so devastated, helping a group of locals rebuild one house, or one sidewalk, or one intersection, lets them remember that every little bit counts and that things actually can get done. "I always tell them," remarks Etheridge, "the longer it takes for the top-down organization to take place, the longer we have to organize from the ground up."

Back in St. Bernard Parish, Peralta agrees. "Any redevelopment that is happening here right now happening by the hands and the money of John and Jane Doe. Our citizens are the ones rebuilding." And slowly, he says, people are coming back. "The population here will not rebuild itself, though, until the MRGO is closed," says Peralta. The seventy-six-mile Mississippi River Gulf Outlet, a man-made waterway that is supposed to act as a shortcut from New Orleans to the gulf, acts as a funnel for storms out on the water, inviting them right into the city of New Orleans through the streets of St. Bernard Parish. On December 15, 2006, scientists from the Army Corps of Engineers sent a report to the United States Congress saying that the gulf should be closed, but they did not give a timeline for the procedure. In it, they cited the economic impact of the outlet as the main reason for closing it. The cost is $12.5 million every year to dredge the outlet, as opposed to the $6.2 million payoff for the use of the waterway.[5] Locals feel that the economic reasons cited for the closure do not place enough pressure on the federal government to enact the procedures necessary for securing the MRGO.[6]

Peralta thinks that a "real" hospital will reopen in the next few years. Pisciotta tells me that everything moves at such glacial speed that it is hard to imagine a timeline for such an endeavor. He recalls that it took nine weeks to get a phone line into the parking lot when FEMA first established it as a service center. "The bureaucracy never ceases to amaze. There is so much red tape for any decision-making process that decisions never get made. I am not bashing anyone. I don't even know who to bash anymore. I am just saying: the reality is that things take too long."

I ask everyone, why the Wal-Mart parking lot? I am given a flat-out response every time: because that was the only large clear space that was in the middle of the urban fabric, and because it was in the middle of everything, everyone could get to it easily. The Wal-Mart parking lot is actually connected to the parking lot of city hall, so you never have to leave the parking lot to get from courthouse to medical center to FEMA tent to Katrina Cottage. The result is an outdoor governmental/medical complex.

St. Bernard Parish covers 1,792 square miles, 465 of which consist of land; the remainder is water. Apparently, of all the space in the parish, the parking lot of a nonfunctioning Wal-Mart store functions most effectively as an accessible center for medical treatment.

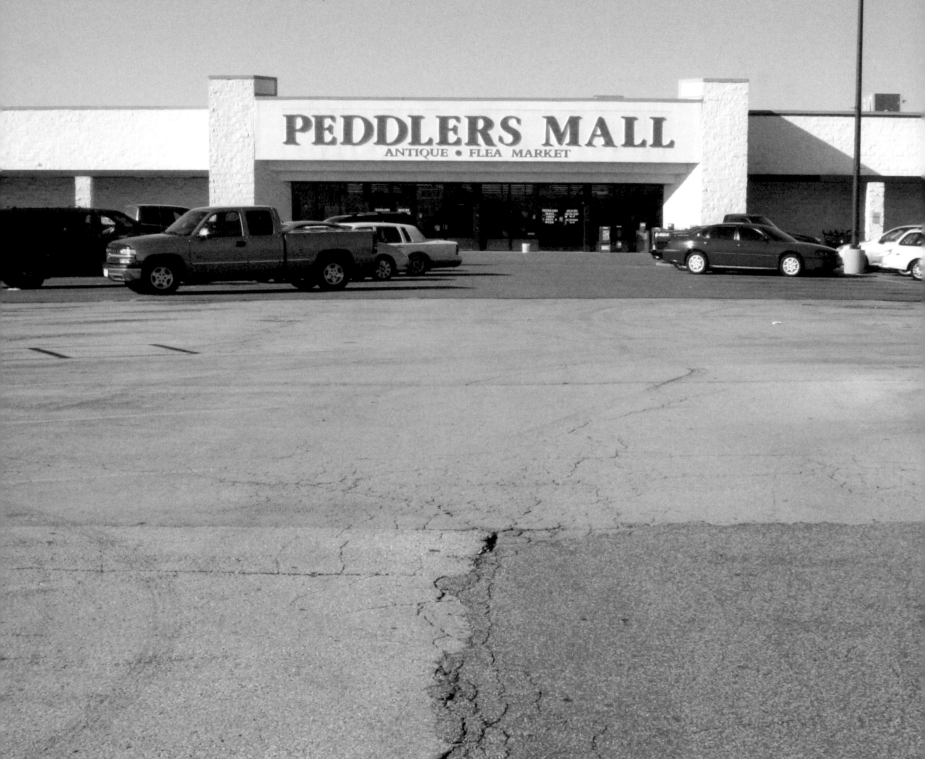

10.1 The Peddler's Mall in Louisville, Kentucky.

"Sometimes Wal-Mart's new shopping carts roll right down the hill and get mixed into our mess of buggies," says Kathy Clem, manager of the Peddler's Mall in Nicholasville, Kentucky. The Peddler's Mall is reusing the old shopping carts that have always been pushed around this building, which was once the first Wal-Mart in Nicholasville. The new Wal-Mart sits directly across the street, at the top of a hill. The staff at the Peddler's Mall returns the shopping carts to the retailer, and they make jokes with the Wal-Mart managers about the carts being confused about which building is home. The carts are not cheap, after all, at roughly $120 apiece.

The Peddler's Mall slogan contends that it is "more than just a flea market." Considering that the store is actually a chain of fifteen stores, it is more accurate to say that the Peddler's Mall is more than just fifteen flea markets. The chain of secondhand stores is the brainchild of Kentuckian John George, who hit upon the idea of renovating big box stores to open up the flea markets in the mid-nineties after he had just lost his entire business in the textiles industry. George had owned three factories in Kentucky that made clothing: a screen-printing factory in Louisville, and two factories for cutting and sewing in nearby Lebanon, Kentucky. The operation had big contracts. In the 1990s, all of those contracts went overseas. The factories lost everything and went bankrupt, and he lost his factories to the emergence of the offshore textiles economy.

Ironically, George soon learned of the empty Wal-Mart buildings across Kentucky, and he began to formulate the idea of opening flea markets inside the abandoned stores. The Peddler's Mall website states, "Wal-Mart Realty is the primary landlord of the Peddler's Mall. As Wal-Mart Stores, Inc. expands and diversifies their stores into Wal-Mart Supercenters

and Neighborhood Markets, additional opportunities could become available."[1] The abandoned buildings seemed to be everywhere in Kentucky. George had previously run a flea market in Pinellas Park, Florida, on U.S. 19 (incidentally, the same road the Calvary Chapel is situated on in chapter 8), so he had an idea of how to get a vendor's mall together. He called Wal-Mart, and to his surprise, the company was pleased to help him get started. His flea market would not pose any competition to the corporation, and no major changes needed to be made to the buildings. He was basically just moving new merchandise into the buildings, creating new superstores in the footprint of the stores that were already there. He opened his first Peddler's Mall in 1997.

"The concept is recession proof," George tells me. "People will always buy recycled items." And there is never a shortage of people with secondhand items to sell. The Peddler's Mall network has over three thousand vendors selling their wares under the roofs of what were once monolithic superstores. A stark contrast exists between this marketplace and the monolithic structure in which it resides. It is as if the Peddler's Mall has detected a small hole in the big box system, the vacant stores, and has inserted a retail system within it that seems almost subversive, given the context. The business plan is simple: George rents the buildings and draws a grid in the interior of the retail space. The "peddlers" then rent the individual spaces from him to vend their wares. Customers pay at a central cash register at the front of the building at the old Wal-Mart's checkout counters. George had a computer system developed that keeps track of each vendor's sales, and they receive biweekly paychecks from the Peddler's Mall. Each vendor keeps 98 percent of what he or she sells, and he takes 2 percent to cover credit card fees, electricity, and other small costs. "Everyone makes money!" says George. The Peddler's Mall chain employs over eighty-five people, and the peddlers collectively use over one million square feet of retail space.

I traveled around Kentucky to visit three of the sites, all of which are Peddler's Malls in renovated Wal-Mart stores: Hillview, Elizabethtown, and Nicholasville. In the past, George operated five other stores in abandoned Wal-Mart buildings. In all of his dealings with Wal-Mart, a third party owned the buildings, and Wal-Mart owned the lease on the structures. He typically rents the lease from Wal-Mart until it runs out, when control of the building defaults to the real estate company who was managing the lease. Then the Peddler's Mall moves on. George feels as if he has had great luck with Wal-Mart, and says that he has fallen into a great fortune. He reports that Wal-Mart makes the subleasing as "soft as they possibly can, and they are not making any money on my subleases."

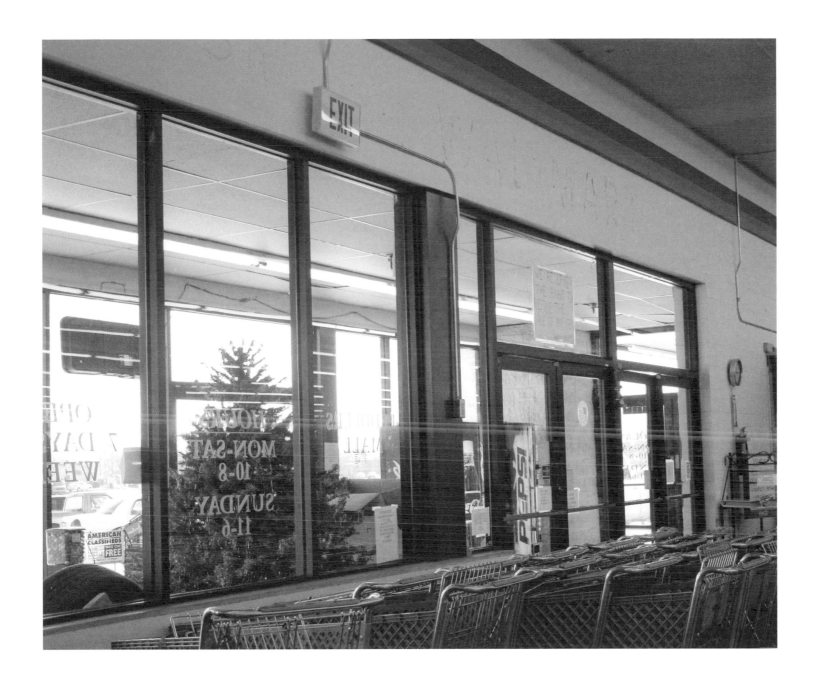

10.2 Elizabethtown, Kentucky. Interior shot of the doors to the exterior. These are original Wal-Mart doors, original Wal-Mart stripes along the ceiling, and original shopping carts. When you look closely above the door here, you can see the outline of the removed sign, which read "Thank you for shopping at Wal-Mart."

The buildings I visit are indeed old Wal-Mart buildings. They are not in very good shape, but they are good enough for the business at hand. My first Peddler's Mall is the site in Hillview, a part of Louisville, where the Wal-Mart stripes still run around the border at the top of the store. On the way out of the building is another Wal-Mart relic, the imprint of the words "Thank you for shopping at Wal-Mart" on the wall above the door, where that entire slogan once appeared in blue and white letters. Here at the Peddler's Mall, though, the word "Wal-Mart" has been knocked off the wall, and simply replaced with the words "Peddler's Mall," so that the slogan and sign have been adapted: "Thank you for shopping at Peddler's Mall." Brenda Thompson, the manager, tells me that "the Wal-Mart folks really loved that."

The Hillview store, which opened on August 1, 2001, has 338 different vendors. Approximately 225 vendors run the booths, some of whom rent more than one spot. "Some of the vendors are cleaning out a garage or a basement, and are only here for a month," Thompson says. But others are here for the long haul; some even make a living by operating booths in the Peddler's Mall. About 50 percent of the vendors here have been here for over a year, and there is currently a waiting list a hundred names long to get a booth in the building. George says that the vendors, on the whole, pull in about $3 a square foot throughout the entire operation.

The Wal-Mart superstore across the street attracts shoppers, which is always promising for surrounding business. George, who has rented ten empty Wal-Mart stores over the years, says that in eight of his experiences, Wal-Mart has moved directly across the street from the store they are abandoning. "It is perfect when Wal-Mart moves in right across the street. That is what I am always hoping for," says George. Thompson tells me, "This is where people go before they go to the Wal-Mart across the street. Sometimes you can find the same items for sale here that are cheaper than they are across the street at Wal-Mart. Might as well check to see."

Although many of the booths sell typical flea market items, antiques and novelties, some booths sell palettes of toilet paper or diapers, items that the Peddler's Mall vendor picks up at outlet retail centers that sell overstock on various items for incredibly low prices. "There are also antiques here, and good, well-made secondhand items. People come here if they want an inexpensive dresser made out of real wood, instead of a new dresser from Wal-Mart that you have to put together yourself," says Thompson.

Thompson has lived here off the Preston Highway for twenty-eight years; she moved in long before Wal-Mart did. This was one of the first Wal-Mart stores in Louisville, a city that now hosts twelve stores, including Wal-Mart's Neighborhood Markets. Traffic from

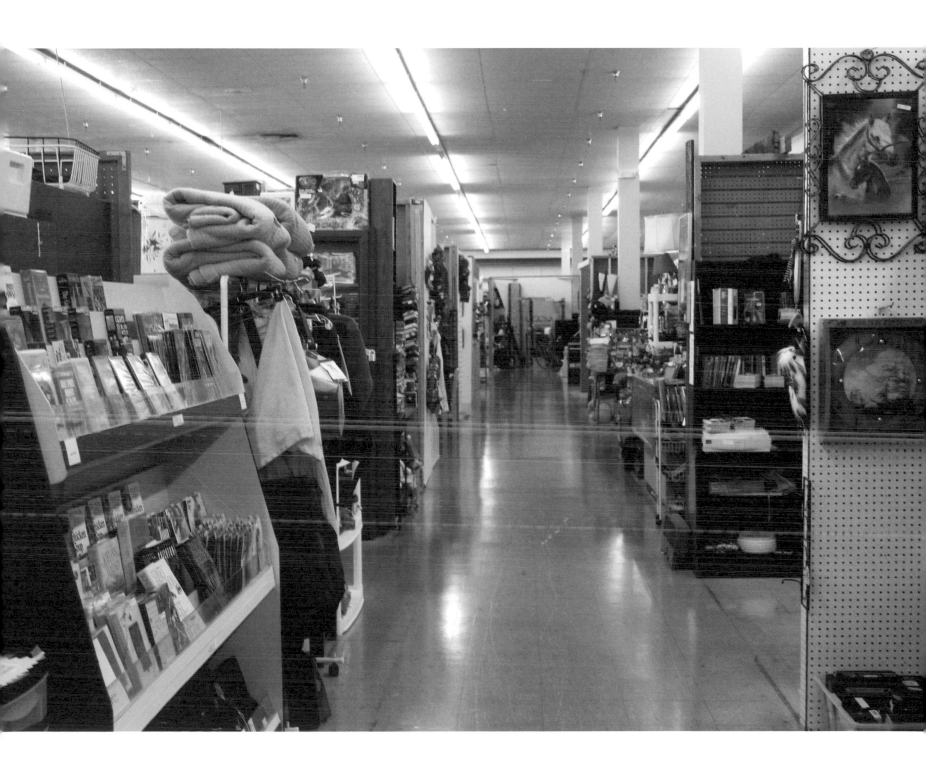

10.3 The new aisles, configured "just like Wal-Mart."

the retailer has completely changed this area of town, which is now a highly developed commercial area. The new Wal-Mart, she says, is inconvenient, is too big to navigate, and attracts too much traffic. "It used to be such a smooth drive from my house to Wal-Mart, and the new store causes me to go through so many new stoplights." Thompson is interrupted by a customer looking for a fireplace liner. She knows exactly which booth he should check.

I drive the forty-five miles to the next stop, the Elizabethtown store. The building is on a long strip of development, and this is apparently a very old Wal-Mart store. Elizabethtown is a small city in the center of several very rural towns: Radcliff is about fifteen miles north, and Fort Knox is about ten miles to the east. This Wal-Mart store had been the only franchise within thirty miles or so before the company expanded to open several stores across central Kentucky; the next one over was in Bardstown, about thirty miles to the east.

Beverly Beavers, the manager at this store, is quick to point out the carpeting on the floor. Half the building's floor is covered in red carpet. She says that when the first Wal-Mart stores came to Kentucky, the clothing and jewelry sections were carpeted. "They save their money today," Beavers says. "No carpets." The racks were low here too, so that you could see over them, and socialization would occur.

Along similar lines, Dixie Hibbs, mayor of Bardstown, once told me, "Those old Wal-Mart stores allowed people to socialize. You could see over the racks and the shelves, people talked to each other. The new supercenter in town is geared for tunnel vision, tunnel shopping. You go in, get what you need. You are only distracted by the other hundred things in your line of sight that you feel like you need to buy."

In that same conversation, Hibbs tells me about the evolution of stores in Bardstown, and while I was visiting these flea markets throughout the state of Kentucky, that conversation kept echoing in my mind. "Downtown," she says, "has gone through cycles with its stores. In the early 1800s, all of the shops were separate. The bonnets were made in one store, the horseshoes were made in another store, people bought tools in another store. Goods were made in back and sold up front. As the supply and demand increased, goods began to be produced off-site. The factory was a block or two from the town square in a larger space, and the goods were brought to the store, which remained right downtown in the shopping district. In the 1850s, stores in Bardstown began to expand to include more than one type of good per store, starting with the drugstores. These were the first shops to carry items other than their main product, medicine. In the late Victorian era, stores began to expand again and include showrooms; items were made in the back

in enlarged backrooms, and the items were shown for sale in the front. This era brought the makers and the sellers back under one roof. Eventually more than one vendor sold items out of the same store."

Stores returned to selling one major good in the early 1900s, with one main store-keeper under each roof. Hibbs fits big box stores into this lineage. "The big box empire marks an era when the major retailers are corporate retailers who are not locally based. These retailers actually sell every kind of good, and those goods were not only made off-site but offshore, in another country altogether."

Traveling around Kentucky to visit these flea markets in the renovated big box stores made me ponder this cycle. While these buildings previously housed the monolithic big box retailer, these new stores house several retailers selling their wares under the same roof—not only retailers, but "peddlers," an archaic term, linking the whole operation to the markets of fairytales. These wares are also not necessarily made locally; many of these booths sell the same items that you can get across the street at Wal-Mart. The memory of their origin has been lost.

My next stop is the Nicholasville store, near Lexington. This is where I meet Kathy Clem, manager of the store since the day that it opened in 2002. "I learn a little more every year about how to run this business," she says. "I have never had a job like this—landlord for hundreds of people, organizing their sales, and keeping the building in shape." Clem's first job was at a Wal-Mart; she worked at the store in nearby Winchester when she was sixteen years old. That store is now a Peddler's Mall, too.

There are 270 booths here, plus twenty cases in the front for vendors who sell jewelry or other small items. When the Peddler's Mall building has a problem, management simply calls up the local Wal-Mart "assets manager," who then sends a local "super" or subcontractor to fix the problem. "Leaky roofs, potholes, the Wal-Mart group comes out and takes care of it," Clem says. The other maintenance issues at the Nicholasville store are taken care of by Clem and her family. "My kids and I keep the place clean."

Clem loves her job. She says that these aisles are filled with memories. "I saw a replica of the very bedroom set I had as a little girl the other day in aisle seven. Gave me goose-bumps." Recently a woman came into the store looking for interesting plates to add to her own collection of antique plates. She got into the hobby because her grandparents also collected plates, and they had a peculiar practice of cutting a little piece out of their clothing and gluing it to the backs of the plates. This plate shopper was going through a box of plates in an antique booth recently when she found her grandparents' plates. As Clem tells it, "The clothing was glued to the back. She came up to the front booth crying

THE PEDDLER'S MALL

221

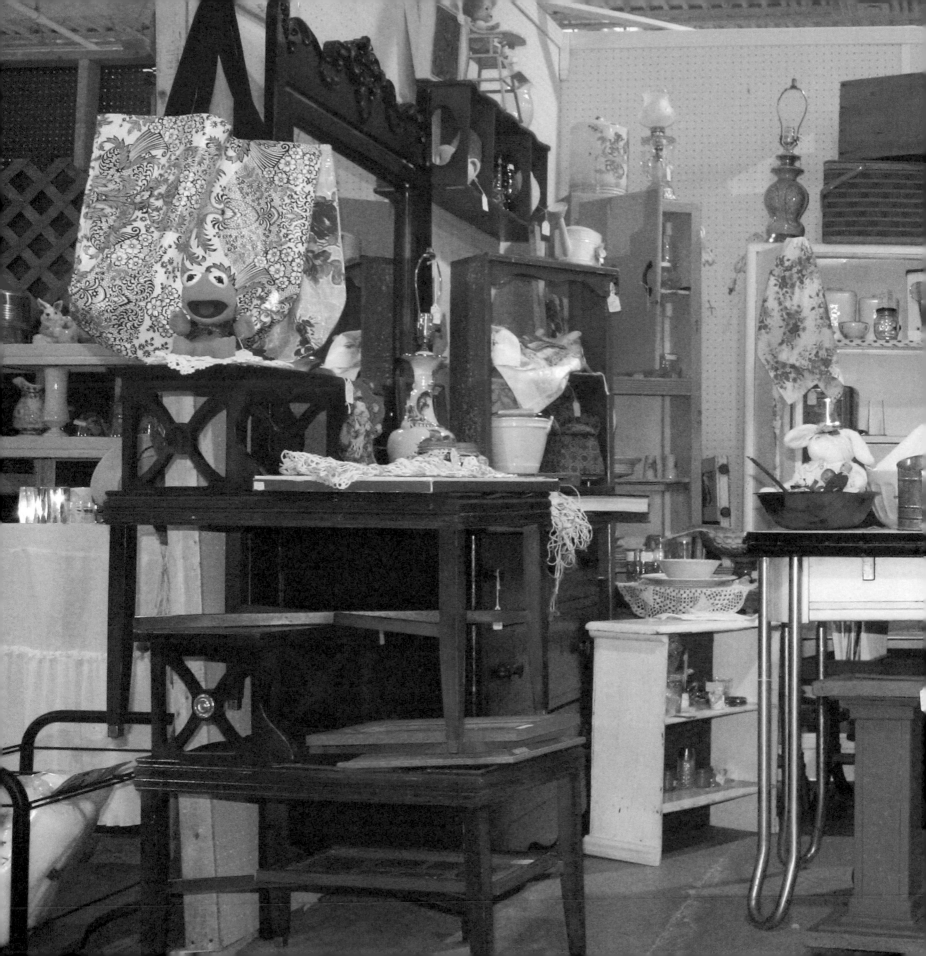

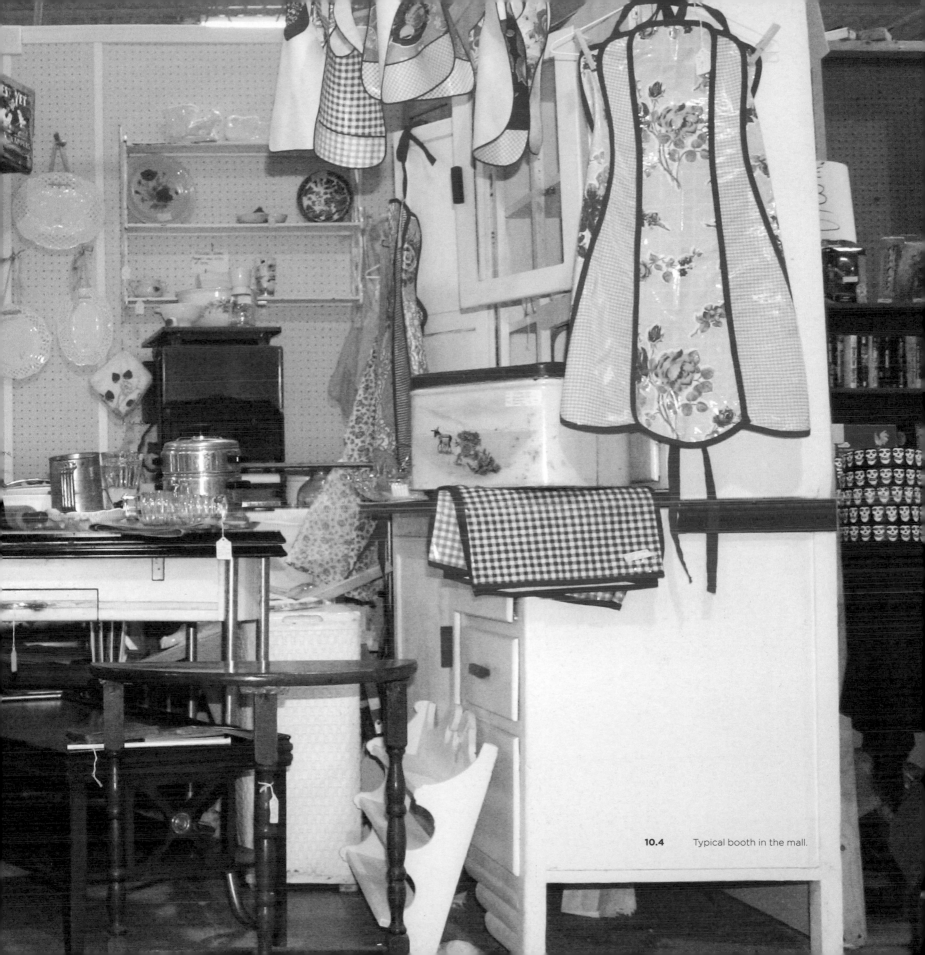

10.4 Typical booth in the mall.

10.5 Typical booth in the mall.

tears of joy. Those plates that she knew when she was little—the very plates that inspired her to begin her own collection—she found them."

Clem claims the moneymaking aspect of the business is exciting. "If you want to make money, you can." Surprisingly, George, the vendors, and the employers are not the only parties privy to the profit—the city makes money, too. Clem tells me, "Each time a vendor opens a booth, they have to pay the city $15 for a business license. Although roughly 60 percent of the booths are mainstays who never leave, 40 percent of those booths turn over almost monthly. Every time there's a turnover, the town makes 15 bucks."

There are endless products for sale here, ranging from nice old handmade Kentucky quilts to plastic toys made in China distributed by a wholesaler. Clem says the most successful vendors are the ones who sell a variety of goods in one booth. If a shopper comes in to buy a record, then sees diapers there and maybe a back-scratcher and a novelty candle, he or she will pick up a little of everything. "People like to do the one-stop-shopping. People grew up in Wal-Mart, they are used to finding all the items in one place, and that carries over to this business too," contends Clem.

She says she reminds people that this place is "just like Wal-Mart" when they are not sure how something works. If a customer asks if he or she can put something on layaway, she says, "It's just like Wal-Mart," meaning layaway is not a service offered by the store. When people ask where the bathrooms are, she says, "It's just like Wal-Mart," meaning the bathrooms are in the back by the employee's break room. The building is completely the same as it was in its life as a Wal-Mart, save for an interior paint job and the destruction of one wall that separated the store from the small storage space. "We want the buildings to be entirely retail," says George. "No storage here at all. Just bring in your goods and put them on the shelf. We want as much space for retail as we can get." Just like Wal-Mart.

While I was driving around the state visiting these buildings, I stopped by Bardstown to visit my family, and one day I met with Kim Huston, president of the Nelson County Economic Development Agency (NCEDA), to hear about the local big box updates.

I tell her about the final chapter in my book, about the Peddler's Mall. She smiles at me, and then tells me, "Remember the Wal-Mart building that we tore down to make room for the courthouse?" Of course I do, the first chapter of my book is about that site. "The last use for that building was George's very first Peddler's Mall. He was there when the roof leaked, and people would go shopping with umbrellas. There were people in Bardstown, however, who felt his business did not exactly fit in with the historical integrity of our town. It was 2002 when he left the Wal-Mart building so that we could get started on the Justice Center."

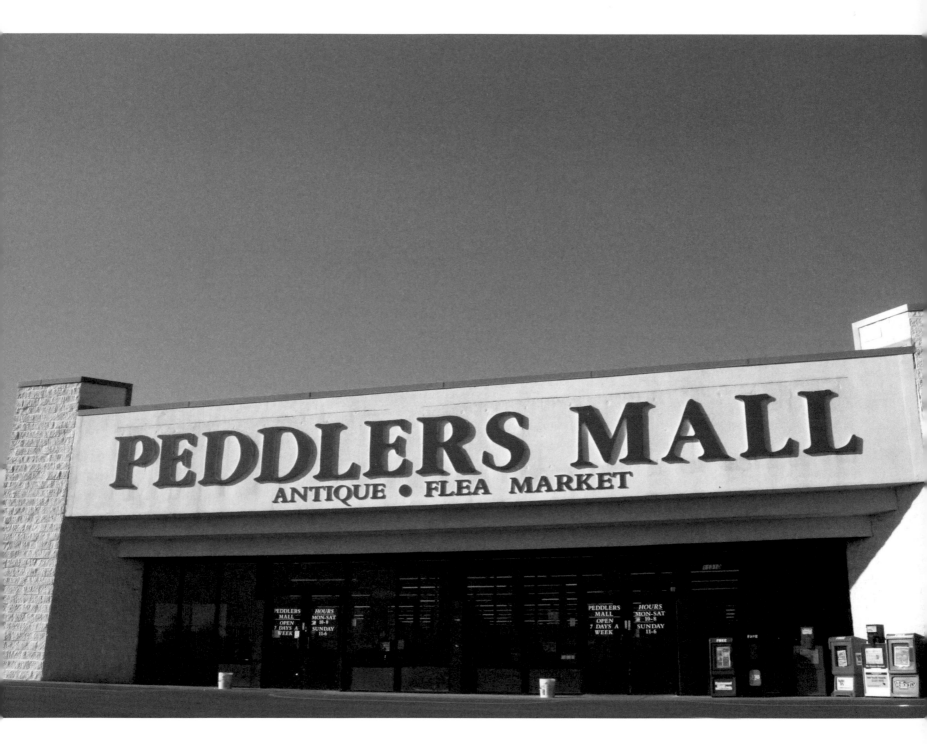

10.6 The Peddler's Mall, "more than just a flea market."

Big box buildings are developing histories right now, despite our warped hope that these structures will just go away once they are vacant for long enough. The reality is that we are developing history every day—even at vacated global retail sites—while our attention span shrinks, and the "now" grows shorter. Our actions will not be hidden from our descendents; rather, we are informing the way they will live too. We are passing down our way of life to them in the form of the built environment that we create and leave behind. There is no easy way out, there are no wormholes for us to jump through. Like it or not, time keeps moving, and we are all a part of what will come next.

In our networked world, where time and space are collapsing under the influence of wires, modems, monitors, and satellites, it is indeed revolutionary for us to look to our local realities, in order to fluidly connect with what is happening around us. It is also revolutionary for us to intervene in the existing built environment, to rethink what is on the ground, to recontextualize the realities in our own backyards.

This trip through the reuse of big box stores, I hope, gives you pause to think about what the future of our landscape is, or rather, what it could be. Taking time to assess what is happening on the ground gives us the power of informed awareness, solid footing with which to make decisions about how we shape our future.

Embracing the continuous passing of time will lead us to perpetuate ground-truths that are congruous with our needs, our desires, our hopes, and our dreams. The future is, of course, imminent every moment. We are evolving into that enigmatic state of time right now, with every word.

This gives us an opportunity, every minute, to be revolutionary.

NOTES

PART I CENTER

CHAPTER 1 THE NELSON COUNTY JUSTICE CENTER

1 Dixie Hibbs, *Bardstown: Hospitality, History, and Bourbon.* The Making of America Series (Charleston, S.C.: Arcadia Publishing, 2002), 8.

2 Hibbs, *Bardstown,* 16.

3 Joseph Gerth, "Preserve or Parish: Buildings' Loss May Threaten Downtowns," *The Courier Journal* (Louisville, KY), August 28, 2002, 1A,

4 Joel Garreau, *Edge City: Life on the New Frontier* (New York: Doubleday, 1991).

CHAPTER 2 THE RPM INDOOR RACEWAY

1 Civic Economics, "Economic Impact Analysis: A Case Study, Local Merchants vs. Chain Retailers, Execu- tive Summary," December 2002, http://ibuyaustin.com/why-shop-locally.html (accessed January 1, 2007).

CHAPTER 3 THE CENTRALIA SENIOR RESOURCE CENTER

1 Antoinette Rahn, "Council to Vote on Senior Project," *Wisconsin Rapids Daily Tribune,* August 30, 2001, 1A.

2 Rahn, "Council to Vote on Senior Project," 1A.

3 Melissa Lake, "2nd Senior Center Site to Be Explored," *Wisconsin Rapids Daily Tribune,* July 19, 2001, 1A.

4 Antoinette Rahn, "Center Plans Change Gears," *Wisconsin Rapids Daily Tribune,* August 29, 2001, 1A.

5 Rahn, "Center Plans Change Gears," 1A.

6 Arlene Van Meter, "Senior Supports New Center: Woman Designates Part of Her Pay for Project, Says Ex- citement Is Contagious," *Wisconsin Rapids Daily Tribune,* May 25, 2005, 1A.

7 Tommie Mann, "New Center Is So Close and Yet So Far," *Wisconsin Rapids Daily Tribune,* April 4, 2002, 9A.

8 Antoinette Rahn, "Gift Boosts Senior Project," *Wisconsin Rapids Daily Tribune,* May 29, 2002, 1A.

PART II NETWORK

1 Bonacich, Edna, and Khaleelah Hardie, "Wal-Mart and the Logistics Revolution," in *Wal-Mart, The Face of Twenty-First Century Capitalism,* ed. Nelson Lichtenstein (New York: The New Press, 2006), 163–187.

2 Charles Fishman, *The Wal-Mart Effect: How the World's Most Powerful Company Really Works—and How It's Transforming the American Economy* (New York: Penguin, 2006), 66.

3 Keller Easterling, "Differential Highways," in *Organization Space: Landscapes, Houses, and Highways in America* (Cambridge, Mass.: MIT Press, 1999), 75–84.

CHAPTER 5 THE HEAD START EARLY CHILDHOOD CENTER

1 Lourdes Gouveia and Mary Ann Powell, "Second Generation Latinos in Nebraska: A First Look," Migration Information Source, http://www.migrationinformation.org/Feature/display.cfm?id=569 (accessed January 1, 2007).

2 Roman L. Hruska U.S. Animal Research Center, http://www.marc.usda.gov (accessed May 10, 2008).

3 Gouveia and Powell, "Second Generation Latinos in Nebraska."

PART III DESIGN

1 Robert Venturi, Denise Scott Brown, and Steven Izenour, *Learning from Las Vegas* (Cambridge, Mass.: MIT Press, 1972).

2 Venturi, Scott Brown, and Izenour, *Learning from Las Vegas,* 3.

3 Stuart Brand, *How Buildings Learn: What Happens After They're Built* (New York: Penguin, 1995), 31.

CHAPTER 6 THE SPAM MUSEUM

1 U.S. Green Building Council, http://www.usgbc.org/DisplayPage.aspx?CategoryID=1306 (accessed January 1, 2007).

CHAPTER 7 THE LEBANON-LACLEDE COUNTY LIBRARY

1 Norm Parry, "Stimulating Growth and Renewal of Public Libraries: The Natural Life Cycle as Framework," ERIC Clearinghouse on Information & Technology, September 9, 2003, http://www.ericdigests.org/2005-2/libraries.html (ERIC identifier ED479844; accessed January 7, 2007).

2 Jeremy Bentham, *Panopticon* (London: Reprinted and sold by T. Paine, 1791).

CHAPTER 8 THE CALVARY CHAPEL

1 Fred A. Bernstein, "Seaside at 25: Trouble in Paradise," *The New York Times,* December 9, 2005.

2 Jane Jacobs, *The Death and Life of Great American Cities* (New York: Vintage Books, [1961] 1992), 29.

3 Suzette Porter, "U.S. 19 Targeted for Unsafe Motorists," *Pinellas Park Beacon,* January 3, 2007, http://www.tbnweekly.com/content_articles/010307_fpg-01.txt (accessed January 13, 2007).

PART IV FUTURE

1 Stuart Brand, *The Clock of the Long Now: Time and Responsibility, The Ideas Behind the World's Slowest Computer* (New York: Basic Books, 1991), 21.

2 Gordon E. Moore, "Cramming More Components onto Integrated Circuits," *Electronics,* April 19, 1965.

CHAPTER 9 THE ST. BERNARD HEALTH CENTER

1 Reuters, "New Orleans Population Still Cut by More than Half," November 29, 2006, http://www.alertnet.org/thenews/newsdesk/N29357330.htm (accessed January 5, 2007).

2 Nelson Lichtenstein, ed., *Wal-Mart, The Face of Twenty-First Century Capitalism* (New York: The New Press), 91.

3 Lichtenstein, *Wal-Mart, The Face of Twenty-First Century Capitalism,* 171.

4 http://www.thenation.com/doc/20050926/featherstone.

5 Meaghan Gordon and Mark Schleifstein, "Corps Issues Call to Close MR-GO: Economy, Not Storm Threat, Cited in Report," *The Times-Picayune,* December 16, 2006, A1.

6 Associated Press, "La. Channel Referred to as 'Ticking Time Bomb,'" *The Washington Post,* December 22, 2006, A9.

CHAPTER 10 THE PEDDLER'S MALL

1 http://www.peddlersmall.net/aboutus.aspx (accessed January 1, 2007).